DADA

MONOGRAPH OF A MOVEMENT

DADA

MONOGRAPH OF A MOVEMENT

(AMB)

Edited by

WILLY VERKAUF

ACADEMY EDITIONS · LONDON / ST. MARTIN'S PRESS · NEW YORK

Co-editors
Marcel Janco
Hans Bolliger

The remarks which the publisher would wish to add have
not ventured into the light till the very last. Perhaps in
the meantime you may have noticed that the attempt to
seize the outlines of the phenomenon DADA has not
proved altogether satisfactory. Yet, after all the discus-
sions that our work on the manuscript has evoked, I be-
lieve I am justified in saying that any attempt to get hold
of a complete definition, to enclose it in a final form,
must fail, else Dadaism would not be what it was —
and is.
At least we now know something of what it was all about.
That's all to the good. But . . . I In this sense DADA!

July, 1957 Arthur Niggli

Amedeo Modigliani: Portrait of Hans Arp.
Drawing

First published in Switzerland

Published in Great Britain in 1975 by
Academy Editions 7 Holland Street London W8

Cloth SBN 85670 275 7 Paper SBN 85670 280 3

© Willy Verkauf and Arthur Niggli 1975

Published in the USA in 1975 by St. Martin's Press Inc.
175 Fifth Avenue New York NY 10010

Printed and bound in Great Britain
at The Pitman Press, Bath

CONTENTS

Preface

I hope this book will help to reveal and clarify the constructive forces that were hidden in dadaism. It is not intended to deal exhaustively with the various artists involved, but rather to determine their relation to dadaism and to describe the dadaist movement as a whole. The bibliography gives details of material for further study. My thanks are due to all those who have had a hand at completing this book, and more especially to Marcel Janco and Hans Bolliger, to Hans Arp, Richard Huelsenbeck, Hans Richter, and Tristan Tzara; to the experts: Kurt Blaukopf, Rudolf Klein, and Hans Kreitler and to the translators for their work which was not always plain sailing; to Georges Hugnet, Bernard Karpel, and Robert Motherwell, for some valuable hints ("The Dada Painters and Poets" — The Documents of Modern Art, vol. 8 — New York, 1951, George Wittenborn); to the Museum of Modern Art and the Sidney Janis Gallery, both of New York.

I am always grateful for additions and corrections and hope to make use of them in a second edition.

Finally I may be permitted to state that the contributions of others do not necessarily represent my own opinions . . .

Willy Verkauf *Zurich, July 1957*

Lorsque je fondis le Cabaret Voltaire, j'étais convaincu qu'il y aurait en Suisse quelques jeunes hommes qui voudraient comme moi, non seulement jouir de leur indépendance, mais aussi la prouver.

Je me rendis chez Mr Ephraïm, le propriétaire de la „Meierei" et lui dis: „Je vous prie, Mr Ephraïm, de me donner la salle. Je voudrais fonder un Cabaret artistique." Nous nous entendîmes et Mr Ephraïm me donna la salle. J'allais chez quelques connaissances. „Donnez moi, je vous prie un tableau, un dessin, une gravure. J'aimerais associer une petite exposition à mon cabaret." A la presse cueillante de Zurich, je dis: „Aidez-moi. Je veux faire un Cabaret international; nous ferons de belles choses." On me donna des tableaux, on publia les entrefilets. Alors nous eûmes le 5 février un cabaret. Mme Hennings et Mme Leconte chantèrent en français et en danois. Mr Tristan Tzara lut de ses poésies roumaines. Un orchestre de balalaïka joua des chansons populaires et des danses russes.

Je trouvai beaucoup d'appui et de sympathie chez Mr Slodki qui grava l'affiche du Cabaret et chez Mr Arp qui mit à ma disposition des œuvres originales, quelques eaux-fortes de Picasso, des tableaux de ses amis O. van Rees et Artur Segall. Beaucoup d'appui encore chez Mrs Tristan Tzara, Marcel Janko et Max Oppenheimer qui parurent maintes fois sur la scène. Nous organisâmes une soirée russe, puis une française (on y lut des œuvres d'Apollinaire, Max Jacob, André Salmon, Jarry, Laforgue et Rimbaud). Le 26 février arriva Richard Huelsenbeck de Berlin et le 30 mars nous jouâmes

deux admirables chants nègres (toujours avec la grosse caisse: bonn bonn bonn bonn drabatja mo gere, drabatja mo bonnoooooooooooooooo;) Monsieur Laban y assistait et fût emerveillé. Et sur l'initiative de Mr Tristan Tzara: Mrs Huelsenbeck, Janko et Tzara interpretèrent (pour la première fois à Zurich et dans le monde entier) les vers simultanés de Mrs Henri Barzun et Fernand Divoire, et un poème simultané composé par eux-mêmes qui est imprimé sur les pages 6—7 du present cahier. Aujourd'hui et avec l'aide de nos amis de France, d'Italie et de Russie nous publions ce petit cahier. Il doit préciser l'activité de ce Cabaret dont le but est de rappeler qu'il y a, au delà de la guerre et des patries, des hommes indépendants qui vivent d'autres idéals.

L'intention des artistes assemblés ici est de publier une revue internationale. La revue paraîtra à Zurich et portera le nom „DADA" Dada

Dada Dada Dada.

Marcel Janco: Portraits of Hugo Ball and Emmy Hennings. Woodcuts from Hugo Ball, *Cabaret Voltaire* (Zurich 1916)

Willy Verkauf

DADA—CAUSE AND EFFECT

Confusion and lack of clarity predominated in the activities of dadaism from the days of its inception at Zurich 1916 until its decay about 1922. Till today that peculiarly dadaist uncertainty has persisted regarding the very origin of the word "dada", which is termed an "infantile sound" by the Concise Oxford Dictionary and a "Cheval, dans le langage des enfants" by the "Nouveau Petit Larousse". Was it Tristan Tzara all by himself, or he together with Huelsenbeck, or Hugo Ball alone, or Hugo Ball with Huelsenbeck, who "discovered" the word in a French-German dictionary and made it serve as a name for the new movement — or was it Ball, Arp, Huelsenbeck, Janco and Tzara, all together? However little importance this may have, it is symptomatic for the almost consistent unreliability of all that dadaists have said of their movement.

As a movement dada existed for but a few years and was a contribution to the undecided problems of our century, many of which the dadaists recognised at their sources, albeit intuitively rather than through reasoning. The difficulty of presenting dadaism as a movement may be gauged from the fact that as soon as one studies it more closely it becomes apparent that it has never actually existed as a movement, neither as an organisation nor as a tendency in art. Nor did it have any clearly circumscribed principles. Dada groups existed, for longer or shorter periods, in Zurich, Berlin, Cologne, Hanover, Paris, New York, in Italy and in the Netherlands, between the years 1916 and 1923; and the only thing they really had in common was their battle-cry "dada", challenging the times in which they were living. To raise the question, what "dada" really was, was usually stigmatized by them as "un-dadaistic". "A person is dada, provided he lives", or "dada is a state of mind", were definitions; better than some of the others, which seemed entirely nonsensical and merely designed to shock. Life in the years 1915—1916 had become nearly intolerable for young artists. Reason appeared to them to have been abandoned by humanity. They thought that anyone who took life seriously must perish. So it was no wonder that these artists, who sooner or later became war resistors, despaired when a man of the stature of Thomas Mann could write in those days:

"It is pusillanimous to believe that thought must dissolve in dishonesty in the face of reality; it is positively vulgar to be proud of the fact that spirit to-day is smothered by reality and banished into nothingness. Spirit, all ye that rub your hands, was 'never closer' to life than right now — life itself says so, and since you pretend that you esteem it so highly, well, then, believe it! I know full well, knew it without a nod or an affirmation from your side, that my thinking and my composing were not and are not without relation to present events. My puny work, however mortal and merely half-good it may be — if there is in its parables some vital share in that which in one of to-day's catch-words is termed 'German Militarism', then it has honour and reality, then reality has something of its honour and of its spirit." (From "Gute Feldpost", Zeit-Echo, Munich, 1914, vol. 1, No. 2, p. 15.)

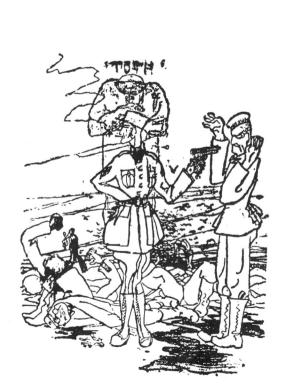

Jacques Vaché: Drawing, 1914

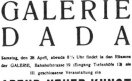

To-day we are no longer surprised that dadaism had to fulfil a mission as "shock-treatment" for a crazed humanity and chiefly for its intellectual protagonists at that particular moment, a mission that was to have repercussions in the arts and in literature for a long time afterwards. Dadaism was the reaction to the blinkers that society had imposed, and it proclaimed "absolute" nonsense as the weapon against any sense imputed to the war. Dada negated all the values until then considered sacred and inviolable, ridiculed fatherland, religion, morality, and honour, and unmasked the values that had been made idols of. The great anguish caused in sensitive artistic natures by the senseless massacres "in the name of the most sacred possessions of humanity" exploded in the dadaist outcry, in the abrupt and uncompromising defiance of bourgeois logic which was blamed for the war and later for the chaos resulting from it. Dada was an outbreak of despair on the part of the artist, who felt the ever-deepening rift between himself and the society of a time which crystallised in senseless mass-murder.

"Iconoclasm", the tearing down of "recognised", "canonised" codes of art, forms and practices; the lampooning of the hypocritical politics and morals of the rulers — these had a cathartic effect, even if it affected only a small and restricted circle. Form and sense, politics and morals, were to be negated and razed to the ground; and something new, something pure and natural was to be created out of their basic elements.

Dadaism turned above all against "follow-the-leader" imitationists and against those artists who, knowingly or unknowlingly, professed "art for art's sake", who, regardless of circumstances, wanted to go on producing what had been "noble" and "beautiful" in the past and who were thus creating spurious, mendacious art, serving to gloss over the crimes of the present. Dada represented the exasperation at disingenuous usages and opinions, a concentrated frontal attack on hollow cultural façades, on rapacious pseudo-patriotism. To proclaim reality at the top of one's voice, to break down forms that had outlived their time, to tear off the masks — these were intellectual protests which seized on current events intuitively, without always, however, clearly recognising historical root-causes and connections. It seemed that all the social inconsistencies brought to light by the times had set up an almost insuperable impasse between civilised existence and the artistic consciousness of these artists.

Although art history has often described dadaism as one of the movements in art and more especially as a precursor of surrealism, which followed it, this definition is not quite conclusive. Dadaism was no new trend in art, but a specific expression of the opposition of artists — poets, painters, sculptors, musicians — to the cultural creations of a society capable of slaughter-

Hans Arp: Woodcut from *Dada*, no. 4-5 (Zurich 1919)

Marcel Janco: Portraits of Hugo Ball, Tristan Tzara and Emmy Hennings

ing millions of people, and that at the beginning of the twentieth century, for purely selfish reasons. Dada was the hectic outcry of the tormented creature in the artist, of his prophetic, admonishing, despairing conscience. It was through magnificent nonsense designed to shock the citizen that these artists found their way back to the origins, to naturalness of expression, which allowed a healthy attitude towards a genuine awareness to be felt. It was no accident that dadaism was born in Switzerland, in the spring of 1916. Besides well-known war resistors, such as Lenin, Romain Rolland and others, young artists yet unknown, from France, Germany, Russia, Rumania and Austria, met there and assembled at the "Cabaret Voltaire" which, founded by Hugo Ball, formed the corner-stone for dadaism with its satirising of the contemporary scene. In his book "Flucht aus der Zeit", Hugo Ball wrote: "Our cabaret is a gesture. Every word spoken or sung here says at least one thing, that these humiliating times have not succeded in wresting respect from us.

What, for that matter, is there imposing or worthy of respect about them? Their cannon? Our big drum drowns them. Their idealism? That has become a prey to ridicule long since, in its popular no less than in its academic edition. The battles on a grand scale, the cannibalist deeds of heroism? Our voluntary foolishness, our enthusiasm for illusions will make short shrift of them." In its tomfooleries the "Cabaret Voltaire" made it known that it was not possible to agree with either of the two parties in the world war if anyone was on the side of right, of truth, and lent an ear to the artistic conscience. One could estimate from this extreme gaiety of the "Cabaret Voltaire" — which was often enough without any meaning whatever — how great the inner distress of European humanity was. Mostly coming from bourgeois homes these young artists had become opponents of the existing order of things both for moral and for aesthetic reasons. They opposed, more especially, both the content and the form of the art and the literature serving that order. This led to the search for new means of expressing the new content, of which Lenin, who was then living at Zurich, said: "I will not admit that the creations of expressionism, futurism, cubism, and all the other kinds of 'ism', are the highest revelations of artistic genius. I do not understand them, and they do not give me pleasure". All he proved with that was that he did not understand that to be a critic of society in advance of his time was the artist's function, which became revealed through "unbeautiful" representations. He overlooked the fact that these "isms" were, in part, stages in the evolution towards a new art, better adapted to reality and that the aim "not to give pleasure" was intentional.

Erich Auerbach says: "A work that has something ghastly to say will be better understood by people who,

Marcel Janco: Frontispiece, 1916

Marcel Janco: Poster for the Ist Dada Exhibition, Zurich, 1917

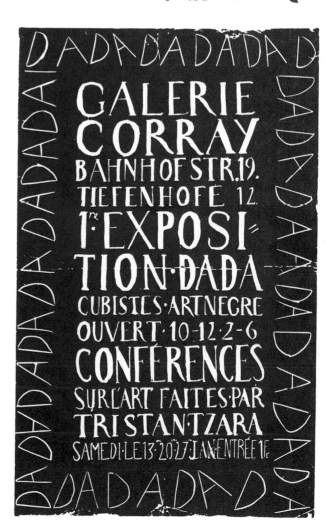

Galerie Dada

Zürich, Bahnhofstrasse 19, Eingang Tiefenhöfe 12.
Neue Kunst und Literatur, Antiquitäten.

Sturm-Ausstellung

II. Serie

9. bis 30. April

Albert Bloch, Fritz Baumann, Max Ernst,
Lyonel Feininger, Johannes Itten, Kandinsky,
Paul Klee, Oscar Kokoschka, Ottakar Kubin,
Georg Muche, Maria Uhden.

Täglich 2 - 6 Uhr, Eintritt Fr. 1,-.

Jeden Mittwoch, 4 Uhr nachmittags
Führung durch die Galerie

Samstag, 14. April, abends 8¼ Uhr

Sturm-Soirée

Literatur und Musik von:
G. Apollinaire, A. Berg, B. Cendrars, A. Ehrenstein, J. van Hoddis,
Kandinsky, F. T. Marinetti, A. Schönberg, P. Scheerbart, Herwart Walden.

Negertanz
getanzt von 5 Personen unter Mitwirkung von
Frl. Clara Walter und Frl. Maya Chruszeck.

Premiere
Sphinx und Strohmann
Kuriosum von O. Kokoschka.
Inszenierung und Masken von Marcel Janco.

Auskunft an der Kasse der Galerie.

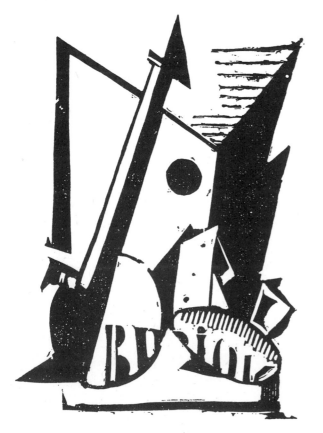

for all their fulminations against it, are thrilled to the marrow by the ghastliness, than by those who emit nothing but expressions of delight at the work of art ... A person who is seized by terror will not speak of a 'frisson nouveau' a mere novel thrill, will not shout 'bravo', and will not congratulate the artist upon his originality."

Hugo Ball, in his diary "Flucht aus der Zeit", compressed his opinion of dadaism on June 18th, 1916: "What we call dada is a clownery out of the void in which all the sublime questions have been entangled; it is a gladiator's gesture, a play with shabby remnants, a death-sentence on posturing morality and fulsomeness. The dadaist loves the absurd. He knows that life will outlast adversity, and that his time like none before it aims at the destruction of all that is generous. He therefore welcomes every kind of disguise, every game of hide-and-seek which has the power to dupe. Whatever is direct and primitive seems to him, in the midst of unnatural surroundings, to be the essence of the unbelievable ... The dadaist is fighting against the agony of the times and against inebriation with death ..."

At the same time as in Zurich, dadaist endeavours evolved in New-York, where some European artists had met. But these efforts were not sustained by the same moral and artistic sense of responsibility. Dada as a movement existed for only a short while in New York, about the year 1920, and its most important American protagonist was Man Ray. After the end of the war in 1918 dada spread to Germany (Berlin, Cologne, Hanover), Paris, and later also to the Netherlands and to Italy. Its modes of expression were very various, and, in retrospect, it is now seen that it was the Zurich dada group that was working out of innermost necessity and profoundly felt experience. When Huelsenbeck, the initiator of the German dada movement, said: "Dada is German bolshevism", he was right for a certain period of time, no matter how silly this may seem. It has always been the talent of Germans to reduce any revolution to a farce, to talk it to death just long enough for reactionaries to take heart again and stamp out the revolution. That is how it was in 1848 and in 1918. It was characteristic of the ultra-left "dada bolshevists" that they did not grasp the impossibility of bringing about a real change in the social order without a fundamental alteration in the productive processes. Georg Grosz, in his autobiography "A Little Yes And A Big No", tried to minimise his part in the German dada movement and to by-pass the whole thing as crazy — but he overshot the mark. It may have been true that the belated appearance of dada in Germany from 1918 to 1922 in the guise of a nihilist left-wing radicalism no longer corresponded to the actual situation, but a certain positive significance cannot be denied in a Germany that offered us the "Kapp outbreak" and people like Noske. But mockery alone could not bar the way to fascism.

Poster for the Galerie Dada, Zurich, 1917

Marcel Janco: Composition. Woodcut

In Paris, dada was rather a movement of writers, who were already lacking in that typical spontaneity which animated the Zurich dadaists. Experiment at all costs, literary chance, scandal for its own sake, all these displaced the original motives more and more.

Frequently the modes of expression of those artists that had an affinity to dadaism were regarded as miscarriages of the human spirit, as whims and the self-will of some ultra-avantgardist confraternity. This may be the case with a few dilettanti who unburdened themselves "dadaistically", but the majority consisted of responsible artists whose seeming buffooneries are to be valued all the more highly.

When dada began its activities in Zurich, it was the "Cabaret Voltaire" and its manifestations, its publications, that were the most eloquent expressions of its intentions, whilst in fine art no own peculiar idiom had yet been found. The modes of creation of all that was ascribed — or ascribed itself — to dadaism, cannot be reduced to one common denominator if one wants to avoid the pitfalls of oversimplification. Dada came into being when all the "isms" of so-called "modern" art were already in existence. Dada-ism was opposed to cubism, futurism and expressionism; it refused them above all as "formalisms", as a degeneration of anti-naturalism, though it used their formal elements for the expression of its own message. At the same time, however, it gave space in dada publications to the representatives of these trends in art and showed their productions in dada exhibitions. The formal descent of what is termed "dada art" from the "collages" of Tatlin, Braque

CABARET VOLTAIRE

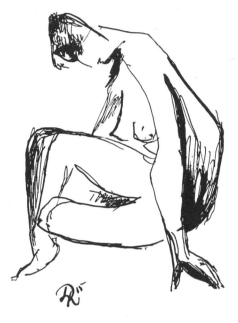

Hans Richter: Drawing, 1915

Hans Arp: Woodcut from Tristan Tzara, *Cinéma calendrier du coeur abstrait* (1920)

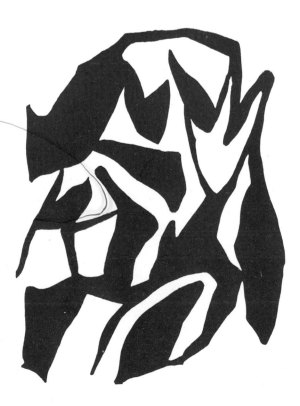

bulletin
à francis picabia

qui saute
avec de grandes et de petites idées de new-york à bex
a b spectacle
pour l'anéantissement de l'ancienne beauté & co
sur le sommet de cet irradiateur inévitable
la nuit est amère 32 hp de sentiments isomères

sons aigus à montévideo âme dégonflée dans les annonces offerte
le vent parmi les télescopes a remplacé les arbres des boulevards
nuit étiquetée à travers les gradations du vitriol
à l'odeur de cendre froide vanille sueur ménagerie
craquements des arcs
on tapisse les parcs avec des cartes géographiques
l'étendard cravatte
perce les vallées de gutta-percha
54 83 14:4 formule la réflexion
renferme le pouls laboratoire du courage à toute heure
santé stilisée au sang inanimé de cigarette éteinte
cavalcade de miracles à surpasser tout langage
de bornéo on communique le bilan des étoiles
à ton profit
morne cortège o mécanique du calendrier
où tombent les photos synthétiques des journées
‹la poupée dans le tombeau› (jon vinea oeil de chlorophylle)
5ème crime à l'horizon 2 accidents chanson pour violon
le viol sous l'eau
et le traits de la dernière création de l'être
fouettent le cri

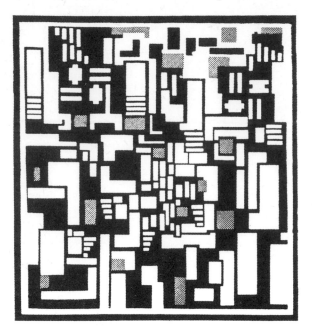

Théo van Doesburg: Composition IX

and Picasso, from the experiments of Kandinsky and the cubists, cannot be denied. And although dadaism occasionally recorded its protest against abstract art, dada stalwarts, such as Hans Arp, created chiefly abstract works. In point of fact, dada art was a synthesis of all the trends in art until then existing and it used them for the expression of whatever it had to say. We find the same principle in literature, poetry, drawings and photo-montage.

Painting as such took up relatively little space. It was literature more than anything else, in which the manifestations, the masks and grimaces of dada made their marks. Graphic art, woodcuts and the typical paste-pictures took up far more space, for they were used as illustrations. And throughout its development, dadaism produced no novel revolutionary form to make up its programme — such as it was. The motive power came from literature, from the cerebration of non-painters and, wherever fine art made its contribution, from artists, who knew how to express themselves no less by the written word than by the brush or the engraver's needle, such as Hans Arp, Johannes Baargeld, Theo van Doesburg, Raoul Hausmann, Ribemont-Dessaignes, Francis Picabia, Kurt Schwitters. It was characteristic of dadaism that the artist in fine art had to have recourse to the written word to make himself quite clear, the means of fine art alone did not suffice in those days. The written or spoken word had to come to their help.

Simultaneous poem from *Cabaret Voltaire* (Zurich 1916)

L'amiral cherche une maison à louer

Poème simultan par R. Huelsenbeck, M. Janko, Tr. Tzara

[Simultaneous poem score with three voices — HUELSENBECK, JANKO (chant), TZARA — plus rhythmic interludes: SIFFLET (Janko), CLIQUETTE (TZ), GROSSE CAISE (Huels). The text is arranged typographically across the page in overlapping columns.]

NOTE POUR LES BOURGEOIS

Les essais sur la transmutation des objets et des couleurs des premiers peintres cubistes (1917) Picasso, Braque, Picabia, Duchamp-Villon, Delaunay, suscitaient l'envie d'appliquer en poésie les mêmes principes simultanés.

Villiers de l'Isle Adam eût des intentions pareilles dans le théâtre, où l'on remarque les tendances vers un simultanéisme schématique; Mallarmé essaya une réforme typographique dans son poème: Un coup de dés n'abolira jamais le hazard; Marinetti qui popularisa cette subordination par ses „Paroles en liberté"; les intentions de Blaise Cendrars et de Jules Romains, dernièrement, ammenèrent Mr Apollinaire aux idées qu'il développa en 1912 au „Sturm" dans une conférence.

Mais l'idée première, en son essence, fut extériorisée par Mr H. Barzun dans un livre théorique „Voix, Rythmes et chants Simultanés" où il cherchait une rélation plus étroite entre la symphonie polyrythmique et le poème. Il opposait aux principes successifs de la poésie lyrique une idée vaste et parallèle. Mais les intentions de compliquer en profondeur cette technique (avec le Drame Universel en exagérant sa valeur au point de lui donner une idéologie nouvelle et de le cloîtrer dans l'exclusivisme d'une école, - échouèrent.

En même temps Mr Apollinaire essayait un nouveau genre de poème visuel, qui est plus intéressant encore par son manque de système et par sa fantaisie tourmentée. Il accentue ses images centrales, typographiquement, et donne la possibilité de commancer à lire un poème de tous les côtés à la fois. Les poèmes de Mrs Barzun et Divoire sont purement formels. Ils cherchent un effort musical, qu'on peut imaginer en faisant les mêmes abstractions que sur une partition d'orchestre.

Je voulais réaliser un poème basé sur d'autres principes. Qui consistent dans la possibilité que je donne à chaque écoutant de lier les associations convenables. Il retient les éléments caractéristiques pour sa personalité, les entremêle, les fragmente etc, restant tout-de-même dans la direction que l'auteur a canalisé.

Le poème que j'ai arrangé avec Huelsenbeck et Jankoi ne donne pas une description musicale, mais tente à individualiser l'impression du poème simultan auquel nous donnons par là une nouvelle portée.

La lecture parallèle que nous avons faite le 31 mars 1916, Huelsenbeck, Janko et moi, était la première réalisation scénique de cette esthétique moderne.

But for the word too, the dadaists were looking for new forms, even new sounds, for also this traditional term seemed to them antiquated, worn out, and banal. The dadaists felt that the means that had been adequate for describing, say, a medieval battle, could no longer be used for a delineation of the frightful experience of organised, mechanised mass-murder. This search for a form commensurate with experience must not be bracketed with formalism, which regards as decisive the means in themselves, not the new reality that must find expression. This is why dadaism cannot be called a formalist trend in art, although the artists professing it experimented a great deal with forms. It was, after all, its intention to express in art what was peculiar to reality, and to supplement reality by art.

Very often the disinclination to use conventional means of expression hardened and took devious ways. Instead there came that immediacy of artistic expression which grew into so-called "automatism", a technique later adopted by surrealism. It would most probably have been unthinkable without Freud's method of psychoanalysis. In lyric poetry this led to a disintegration of the word in the "sound-poem", to an arbitrary concoction of words; in typography traditional forms and compositions were ignored; in music "bruitisme" (noise-music) appeared. But there already purely formalist tendencies made themselves felt. It cannot be denied that the idea of ugliness is far older than that of beauty,

DADA

DIALOGUE ENTRE UN COCHER ET UNE ALOUETTE

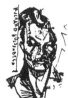

Marcel Janco: Portraits of Richard Huelsenbeck and Tristan Tzara. Woodcuts from *Cabaret Voltaire* (Zurich 1916)

Marcel Janco: Cover for *Dada*, no. 1 (Zurich 1917)

Cover for *Dada*, no. 2 (Zurich 1917)

D A D A 1

RECUEIL LITTÉRAIRE ET ARTISTIQUE

JUILLET 1917

DADA 2

RECUEIL LITTÉRAIRE ET ARTISTIQUE

DÉCEMBRE 1917

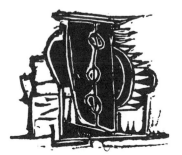

fmsbw tözäu pggiv- ..?mü

DADA 3

Directeur:
TRISTAN TZARA

Bois de M. Janco.

Je ne veux même pas savoir s'il y a eu des hommes avant moi. (De...)

Administration

Mouvement DADA

Zurich

Zeltweg 83

Fr. 1.50

and dadaism utilised ugliness to inspire fear, to frighten a hostile world. The destruction of "beauty", of the "framed rectangular picture", of the symmetrical typographical layout, of "tempered" sound in music; the dissolution of the word, the rejection of traditional materials, of proportions — these were meant to interrupt a social rhythm that was capable of bringing about wholesale murder.

In the writings of Arp, Janco, and others, their deep longing for a creative contact between art and the people is keenly felt. Art, which had become an exclusively private matter, no longer satisfied them, and they wanted once more bring about a harmony of art with man and his work, with pulsating life itself. For them, art was not an end in itself, they wanted to see it "applied" in architecture, in new kinds of homes, in new forms, in the articles of everyday use, in day-to-day life. It is in this light that the vast experiments of men like Hans Arp should be seen. It must, in this connection, once more be stressed that it was the urge for a new content which led to a search for new forms, since there is always the danger of form becoming independent and the content a mere side issue, so that a quest for true reality once again becomes necessary.

Dadaism recognised art as a social necessity. It was clear to the majority of the artists belonging to it that an artist who does not make up his mind about the reality of his own time will not be able in the long run to settle things with pure negation if he wants to avoid falling a prey to hopeless nihilism. They were also aware of the fact that formal revolt by itself did not suffice for the human and artistic development of the artist unless an adequate substance kept pace with it. Otherwise every new form would degenerate into a meaningless façade. It was clear to most of them, too, that the search for new means of expression could derive only from a militant humanism within the artist if it was not to be reduced to a narrow self-sufficiency which was bound to be swept away in the course of time.

A short-sighted judgment on artistic experiments, on the other hand, easily proves to be fallacious, for the dadaists' attempts, often termed "nonsensical" or "mad", are nowadays utilised in architecture, room design and industrial design. They bring art to daily life, make man's workaday existence more beautiful, transform it, as it were; they mean more air, more sunlight, better living-conditions, and more joy. All this, it is true, cannot disguise the inner urge of man for conformity with society, for full recognition of his intellectual and material achievement. Man's happiness cannot be ensured solely through new forms and colours, through art and architecture alone. Only the co-operation of economic, psychological, and artistic factors is able to create that new way of life for which mankind is year-

Raoul Hausmann: Poster for *Dada* (Berlin 1918)

Marcel Janco: Cover for *Dada*, no. 3 (Zurich 1918)

ning, and which would also correspond with the social plane and the technological and scientific achievements of our time.

And thus dadaism, too, exhausted itself as a movement, by increasingly stressing the negative. Spontaneous protest and experimenting no longer satisfied the natural desire of artists who were striving towards functional motives. They wanted art to help man to see reality and to see through it and to steel his determination to make it more worthy of him.

In France the majority of dadaists turned to surrealism about the year 1924, a movement they had helped to found. This was no logical consequence, but rather a reaction from dadaism. Dadaism represented the strictest recognition of reality, while surrealism was a plunge into the unconscious by which psychology was made an end in itself. The surrealist artist was to function merely as an "automation" and thus lost any objective standard for what was essential and what was non-essential. As external happenings were more and more ignored this submersion into the unconscious led to an abject flight from reality.

Still later some of the former dada writers and poets, such as Aragon and Eluard, came to "socialist realism" by way of surrealism as a somewhat paradoxial detour. Though dadaism, as a movement, has had its day and is dead now, there is no doubt that at one particular period it fulfilled a task which has not remained without some substantial effect on the problems and development of modern art.

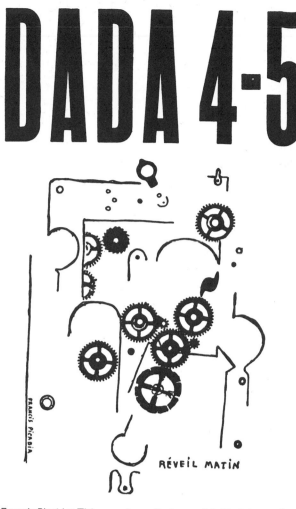

Francis Picabia: Title page from *Dada*, no. 4-5 (Zurich 1919)

Raoul Hausmann: Woodcut from *Anthologie Dada* (Zurich 1919)

Hans Arp: Cover for *Dada*, no. 4-5 (Zurich 1919)

```
LE POÈTE NE METTRA PAS D'OBJETS DANS SON POÈME PUIS
  QUE TOUT DISPARAIT QUAND PARAIT LE TRIANGLE NOIR
    LE TRIANGLE LYRIQUE LE TRIANGLE CENTRAL CHA
     NTE ÉPERDUMENT LA PRESSÉE DU MALE ET LE T
      RIANGLE NOIR AVEUGLE LE DÉSIR QUI LE RE
       GARDE LE DÉSIR CENTRIPÈTE AUX MAINS
        SOUPLES MAIS LE TRIANGLE NOIR EST U
          N DÉSIR SANS MAIN ET LE MALE AS
           SERVIT CE DIEU FRISÉ ET LE T
             RIANGLE NOIR EST DANS
              LA MAIN DE L'HOMME
               ET C'EST A CHAQU
                E INSTANT LA F
                 IN D'UN MONDE
                  EXPLOSANT
                   DANS LES
                    ESPACES
```

Pierre ALBERT-BIROT

Extrait de „*Poèmes à la Chair*" (à paraître).

ANTHOLOGIE
DADA

Splendeurs et misères des débrouillards

Aus der steilen, transparenten Nudel
Quillt ein Quantum Quitten-Quark empor,
Ballt sich (physisch) zum gewürzten Strudel,
Kreist: ein Duft-Ballon aus einem Rohr.

Wann (und wo?) war Schweben delikater?
In der Spannung wird man blass, wie Chrom.
Lehr- und Schüler folgen dem Theater.
Doch der Stern geniesst sich autonom.

Hohe Hirnkraft wallt zu diesem Gase.
Da bestülpt der sachlichste Adept
Das Gestirn mit einem Stengelglase,
Darin dottrig etwas Ei verebbt.

Ferdinand Hardekopf

H. RICHTER

Hans Richter: Woodcut, 1919

Richard Huelsenbeck: **Verwandlungen**

(Roland Verlag München, Mk. 2.50, geb.

Mk. 3.50)

Cacadoufarbige Butzenscheibenohren rennen um Klumbumbus gelber Stern Bauch quer durch Hund zeilen platzen. Gut. Cacadou wird Butter Jamaika Cognac Stahl wird Tanz Butterweg ist Korkenzieher für infantile Oteros in Säcken Chinesen speien jahrelang nach Petrol. Einer aus Confidence mästet einen Strichpunkt rot. Apoplexie. Drachensalat, telegraphisch, wie doch. Toréadore de la verte cravatte sous les yeux gâteaux empaillés au bout des fils névralgiques pette pette dit le poète la tribune du cœur et de Genève par exellence pâques. Es ist nicht leicht, Geschwindigkeiten ein gutes Gewissen zu besorgen. Ueberhaupt heftige Seiten. Ist zu kaufen. H. A. W. S. T. T.

COW-BOY

à Jacques Lipschitz

Sur le Far West
 où il y a une seule lune
Le Cok Boy chante
 à rompre la nuit
Et son cigare est une étoile
 filante
*SON POULAIN FERRÉ D'AILES
N'A JAMAIS EU DE PANNE*
Et lui
 la tête contre les genoux
 danse un Cake Walk
New York
 à quelques kilomètres
Dans les gratte-ciels
Les ascenseurs montent comme des thermomètres
Et près du Niagara
 qui a éteint ma pipe
Je regarde les étoiles éclaboussées
Le Cow Boy
 sur une corde à violon
 Traverse l'Ohio

Vincente HUIDOBRO

Hans Arp and Marcel Janco: Woodcuts from *Dada*, no. 3
(Zurich 1918)

Hans Arp: Drawing from Tristan Tzara, *Des nos oiseaux*

SELS DE MINUIT

arc voltaïque de ces deux nerfs qui ne se touchent pas
 près du cœur
 on constate le frisson noir sous une lentille
est-ce sentiment ce blanc jaillissement
 et l'amour méthodique
PARTAGE EN RAYONS MON CORPS
 pâte dentifrice
 accordéon transatlantique
la foule casse la colonne couchée du vent
l'éventail des fusées

 sur ma tête
 la revanche sanglante du two-step libéré
répertoire de prétentions à prix fixe
 la folie à 3 heures 20
ou 3 fr 50
la cocaïne ronge pour son plaisir lentement les murs
 des yeux tombent encore

38

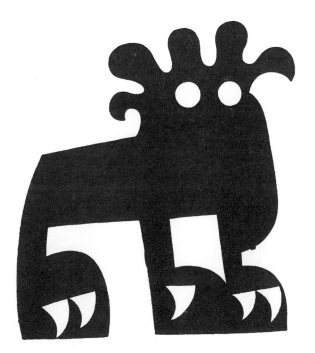

Bois de H. Arp.

GUILLAUME APOLLINAIRE

Sa mort me semble encore impossible. Guillaume Apollinaire est un des rares qui ont suivi toute l'évolution de l'art moderne et l'ont complètement comprise. Il l'a défendue vaillamment et honnêtement parce qu'il l'aimait, comme il l'aimait la vie, et toutes les formes nouvelles d'activité. Son esprit était riche, somptueux même, souple, sensible, orgueilleux et enfantin. Son œuvre est pleine de variété, d'esprit et d'invention.

Francis Picabia.

circuit total par la lune et par la couleur
à marcel janco

l'œil de fer en or changera
les boussoles ont fleuri nos tympans
regardez monsieur janco pour la prière fabuleuse
tropical
sur le violon de la tour eiffel et sonneries d'étoiles
les olives gonflent pac pac et se cristalliseront symétriquement
partout
citron
la pièce de dix sous
les dimanches ont caressé lumineusement dieu dada danse
partageant les céréales
la pluie
journal
vers le nord
lentement lentement
les papillons de 5 mètres de longueur se cassent comme les miroirs
comme le vol des fleuves nocturnes grimpent avec le feu vers la
 voie lactée
les routes de lumière la chevelure les pluies irrégulières
et les kiosques artificiels qui volent veillent dans ton cœur quand
tu penses je vois
matinal
qui crie
les cellules se dilatent
les ponts s'allongent et se lèvent en air pour crier
autour des pôles magnétiques les rayons se rangent comme les
 plumes des paons
boréal
et les cascades voyez-vous? se rangent dans leur propre lumière
au pôle nord un paon énorme déploiera lentement le soleil
à l'autre pôle on aura la nuit des couleurs qui mangent les serpents
glisse jaune
les cloches
nerveux
pour l'éclaircir les rouges marcheront
quand je demande comment
les fosses hurlent
seigneur ma géométrie

tristan tzara

De Prahou: L'affiche des Champs Imélairs ("Lueur") Prix 2,50 fr. En vente au Mouvement Dada.

Dada, no. 3 (Zurich 1918)

REGIE

Opernprobe. (Vor-Börse; Schwellung.)
Gold im Gebiss, Gold im Lächeln, der chef d'orchestre. Skandiert.
Rhythme der Strasse, der Piazza. Ballet fällt nach links
Niedliche Disciplin.
Flöten rühren die Probe auf.
Um die Ecke zacken Blitze, lila;
lila Zig-zags;
happy zig-zags, vom Brandy-Mond;
lila Kuben um die Ecke.
Schwefelpfeile surren durchaus.
Strahl in Bündeln, Licht in Schnitten.
Gelbe Garben rasen.
Gell hetzen die Hellen.
Reflektoren zischen, in der Tat. Lichtgüsse knattern
 O Feststellungen klarer Augen!
Ein Scheinwurf von Mädchenröcken, mäandrisch.
Scheinwerfer im Galopp gebrochner Graden.
Netter Fall nach links, gebräunt.
Diese Oper concipiert Gott als Droguе.
Da: Telegramme, réponse payée -: spitzere Reisen! gehetztere Bahn! frechere Cascaden!
 plärrenderes Rot! Geplärr und Knall in Rot!
Ein Zirpen der Elektro-Mücken, bei Seite, für die Rasta-Rastas.
Tk - wird eingeschaltet Quecksilber-, phtisisches Lila, Motor-keuchen, fliehende Wellen aus Honig
 und Duft.
Exakt rast diese Oper. Sie spurtet, wie sie will.
Auf dieser Scene, knisternd, schneiden sich die Einsamkeiten.
Neuro-Katarakte. Präcisions-Inferno. Sehr dosierter Wahnsinn.
. Blüte der Sessel: „Tausend Aufführungen garantiert!" Kapellmeister's Stirn beperlt
 Notie ungen. Durch mehrere Hirne kribbelt eine Serie triumphierender Ziffern.

Ferdinand HARDEKOPF

H. RICHTER: Gesicht 1 u. 2.

Hans Richter: Woodcuts from *Dada*, no. 3 (Zurich 1918)

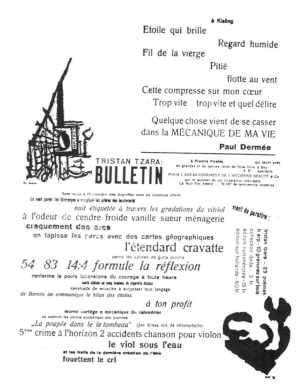

à Kisling

Etoile qui brille
 Regard humide
Fil de la vierge
 Pitié
 flotte au vent
 Cette compresse sur mon cœur
 Trop vite trop vite et quel délire

 Quelque chose vient de se casser
 dans la MÉCANIQUE DE MA VIE
 Paul Dermée

TRISTAN TZARA:
BULLETIN

Sons aigus à Montevideo âme dégonflée dans les annonces offerte
Le vent parmi les télescopes a remplacé les arbres des boulevards

 nuit étiquetée à travers les gradations du vitriol
à l'odeur de cendre froide vanille sueur ménagerie
craquement des arcs
 on tapisse les parcs avec des cartes géographiques
 l'étendard cravatte
 perce les vallées de gutta percha
54 83 14:4 *formule la réflexion*
 renferme le pouls laboratoire du courage à toute heure
 cavalcade de miracles à surpasser tout langage
de Bornéo on communique le bilan des étoiles
 à ton profit
 morne cortège o mécanique du calendrier
 où tombent les photos synthétique des journées
 „La poupée dans le le tombeau" (Jon Vinea œil de chlorophylle)
5ème crime à l'horizon 2 accidents chanson pour violon
 le viol sous l'eau
 et les traits de la dernière création de l'être
 fouettent le cri

Hans Arp and Marcel Janco: Woodcuts from *Dada*, no. 3
(Zurich 1918)

Marcel Janco

CREATIVE DADA

No dadaist will ever write his memoirs! Do not trust anything that calls itself "dada history", however much may be true of dada, the historian qualified to write about it does not yet exist. Dada is by no means a school and certainly not a brotherhood, nor is it a perfume. It is not a philosophy either. Dada is, quite simply, a new conception.

Dada was no mere fiction — its traces are found in the depths of human history. Dada is a phase in the development of the modern mind, a ferment, a virile agent. Dada is unlimited, illogical, and eternal!

A great number of writers, pamphleteers, trash-scribblers, painters, musicians and pederasts, also a very great number of German authors, and even diplomats, all lay claim to the title of dadaist, but without a trace of justification. It might be argued that after the lapse of forty years anyone has the right to this title but I am nevertheless of the opinion that as long as the grand dadas are still alive, dadaism must be defended against all impurities. Conversely I would suggest conferring the title of grand dada on such great men as Chaplin, Voltaire, Satie, Machiavelli, Apollinaire, Napoleon, Picasso, Molière, Jacob, Socrates, and others.

Everything said of dada is true, and yet its history would be veiled in some legendary and mystical haze if it had not been for dada-Tzara, the grand inquisitor. He has in his possession a numbered loose-leaf file of which everybody talks, but which no human eye has ever seen. It contains notes and photographs of all dada events from its inception. Since I was present at that inception and was a witness of so much glory, I take the liberty of contributing some facts taken from my own personal notes, which are, however, in full conformity with the book of said grand inquisitor. Only at the end shall I add a few remarks on the destructive and the constructive aspects of dada, remarks which, for powerful and compromising reasons, have so far remained shrouded in silence.

All around Zurich the war was raging. In 1916 Zurich was a haven of refuge amid the sea of fire, of iron and blood. It was not only a refuge but the trysting place for revolutionaries, an oasis for the thinker, a spy-exchange, a nursery of ideologies, and a home for poets and liberty-loving vagabonds.

Looking for work, one evening I found myself in one of the medieval alleys of old Zurich. In an old night-club, there was music. To my amazement I discovered, seated at the piano, a gothic personality. Ball, the poet, was playing Tchaikovsky, that old bladder rinser, for the entertainment of the few beer drinkers in this smoke-haze of gossiping.

Ball was a very tall man. On a long neck, which the wide collar was powerless to cover, rose a long, unsymmetrical head which looked as if it were distorted by a convex mirror. Interminable legs underneath his elongated

Poster for the 1st Dada Abend, Zurich, 1916

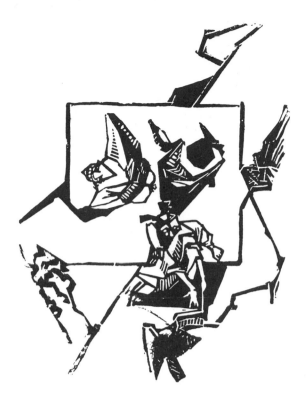

Marcel Janco: Woodcut, 1917

Hans Richter: Composition, 1919

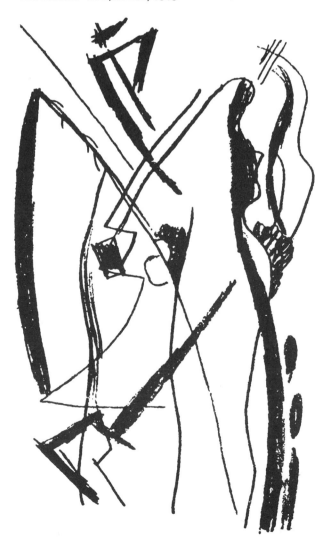

body lent him an uncertain gait that made him wobble like a Praying Mantis. The same uncertainty and the same wobble dominated his mind and thought, which were wholly composed of tenderness, clarity and poetry. A poet, incapable of mastering life and its problems, he had put his hand to all manner of trades, only to give them up again one after the other. Stage director, musician, journalist, soldier and author-poet — he remained the perpetual troubadour, the rebel vagabond and knight errant. His christian name Hugo pointed to his Huguenot origin and indeed he had a very clear latin mind. Despite that misleading grin of his, I have never heard from him anything but words of renunciation or of consolation. In the most heated debate he would never press his point of view, but qualify it with such phrases as "as far as I am concerned" or "I think" or "I suppose".

He was a profound poet, an alchemist with words. The idea of setting up the «Cabaret Voltaire» was his. He was the inspirer and producer of our literary evenings and probably the most inventive of our poets. When he learnt that I was a painter, he at once suggested that I should take part in his project and invited my friends too. So I brought along Arp, a great friend of mine, and Tzara, my little pal. The first pact of friendship was concluded that same evening and that is how our work began.

It began in a small hall with some fifteen or twenty tables and a 100 square feet of stage, the place could hold about 35 to 50 guests. It was packed from the very first evenings. The performances were going strong until late at night, which caused us a good deal of unpleasantness with the neighbours and with the authorities upon the closing hour for public-houses.

It became a meeting place of the arts. Painters, students, revoultionaries, tourists, international crooks, psychiatrists, the demimonde, sculptors, and polite spies on the look out for information, all hobnobbed with one another. In that thick smoke, in the middle of the noise occassioned by declamations or some popular ditty, some sudden apparition would loom up every now and then, like the impressive Mongol features of Lenin, or Laban, the great dancer with his Assyrian beard.

The walls were covered with works of "contemporary art", roving exhibitions of our resident artists and works sent in by our best friends: Modigliani, Picasso, Kandinsky, Klee, Javlensky, Léger, Matisse. We had no end of discussions and spared no effort to initiate our public in the new aesthetics, but it was difficult to keep a straight face when we saw the preposterous reactions of the public, who refused to follow our ideas.

People came not for amusement, but to take part in that wonderful atmosphere of mental regeneration. Intelligence and youth refurbished their resistance and their ideology whilst at the same time taking up the comforting nourishment offered to their palates by the poets and thinkers. It was an unforgettable experience, in an era of shortages of all kinds and in the withdrawn corner of a little Zurich alley, to find oneself in the presence of free thought, the expression of the free conscience of man in face of a culture that had gone bankrupt.

It was not, by any means, a place of rest. Despite the artistic character of the first venture most of our mani-

19

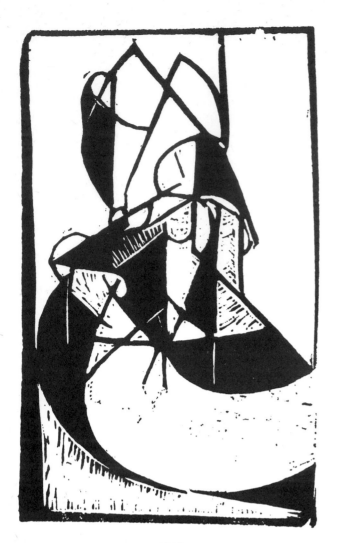

Enrico Prampolini: Woodcut, 1918

Hans Arp: Drawing

festations were imbued with a political aggressiveness and bitterness which were, however, far from unpleasant. Almost every evening there were recitations of new poetry, music was played, there were lectures, dances — everything impregnated with a spirit of protest.

The spirit of revolt, so much relished by the audience, ended up by carrying art with it. In that world — half revolutionary, half artistic — on the eve of great social events, use was made of any means to whip up the emotions and arouse the interest of the spectator, to maintain a living contact with a growing public. Only one among us could utilise this enthusiasm always kindling it afresh with some fantastic experiments.

Tzara knew how to profit by it, and dada exists thanks to his gift of being able to elicit a response and to stimulate the creative flame. Without knowing it, we all had dada in our system.

Ball was the manager of the Cabaret, but Tzara became its strategist and later its publicity manager. He was a small man, a poet by vocation, and he could move people. But he had rather too pronounced a weakness for the jingles he could make out of words.

Tzara and I, having shared artistic experiences, were, so to speak, schoolfellows. He was nervous and very gifted and very ambitious into the bargain. His good manners no less than his smile aided him towards the realisation of his ambitions, and for them he was prepared to pay any price. His walking with short quick steps like a girl was an expression of his distrustful nature. His mocking little eyes, the eyes of a circumspect rodent, shone behind his glasses. Once, to throw his ecquaintances off his trail, he used a monocle. In setting up dada he displayed organisational talent no less than the attributes of a detective. He claimed to combine in his infallible loose-leaf folder a complete register of all dada activities with photographs and a host of cuttings from the world's press. He put himself in the centre of events and could produce any given reaction, which he could then parade for all it was worth. Never did a poet make better use of the resonance of his own voice. For this end he always took up a position fifty feet from the walls. To make sure of his success he had become accustomed to beginning his morning prayer with the words "I don't even want to know whether there has been anyone before me" (after Descartes).

The lively exchange of opinions with our audience went on all the time. Sometimes a young man would get up on the rostrum and read his poetry, sometimes there might be a group asking for permission to give a balalaika concert. We suffered them all in patience and then imperturbably got on with our simultaneous poems.

One evening Tzara rummaged in his pockets and finally produced a small bit of paper, from which he proceeded to read a poem, articulating the words, not according to their meaning, but in accordance with their sound. It was a pasting together of words such as the cubists used to perpetrate, and it preceded the poetry composed by Ball, who would read abstract verses, made up of freely invented words, through a card-board tube. The audience howled, and the uproar caused by our exploits went round the world. We made our good fellow-citizens roar like lions . . .

One evening three motor-cars stopped in front of our cabaret. It was an unexpected invasion: A dozen or so students, with some Viennese professors, had come to study us. Flourishing their notebooks the disciples of Jung and Adler took the particulars of our case: Were we schizoid, or were we simply pulling everybody's leg? When the programme was over we sat down for a drink and to expound our creed, our faith in a direct art, a magical, organic, and creative art, like that of primitives and of children. They threw each other significant glances, then took fright, laid down their pencils and fled. Another evening Ball introduced a friend who had just arrived from Berlin: Huelsenbeck, a poet. Like every poet he affected a slight limp. He had a shock of fair hair and got up on the stage with a slender cane in his hand, brandishing it like a rowdy. He was an expressive, activist poet and flooded the hall with his abandon, flinging out his verses like so much invective.

He was aggressive and quite aware of his power. He looked like a fighting cock and became the antagonist of Tzara. Wherever he was, poetry would flow profusely, the fight was in full progress. He left us one day, much too early, to satisfy his taste for travel, for women, and for a thousand other interests.

At a cocaine-addict bookseller's, who used to sleep among his books, I discovered Nostradamus' "Centuries", which we read aloud one evening to our stupefied poets. After the guests had gone the consternation that had been smouldering broke out, and a free-for-all started. It began with a quarrel about the discovery itself, the right to use certain words, and the interpretation of the verses. The poetry was of the mystic sort, full of suggestiveness, but the abstract side of it, the sound, the associations, the alliteration — it was these that made it a true new poetry which in the final count influenced our poets. It must have been after a quarrel of this kind that Huelsenbeck made good his threat to leave us.

Page from *New York Dada* (New York 1921)

PUG DEBS MAKE SOCIETY BOW

*Marsden Hartley May Make a Couple—
Coming Out Party Next Friday*

———

A beautiful pair of rough-eared debutantes will lead the grand socking cotillion in Madison Square Garden when Mina Loy gives a coming-out party for her Queensberry proteges. Mina will introduce the Marsden Hartleys and the Joseph Stellas to society next week, and everybody who is who will be who-er than ever that night.

Master Marsden will be attired in a neat but not gaudy set of tight-fitting gloves and will have a V-back in front and on both sides. He will wear very short skirts gathered at the waist with a nickel's worth of live leather belting. His slippers will be heavily jewelled with brass eyelets, and a luxurious pair of dime laces will be worn in and out of the hooks. He may or may not wear socks. He has always been known as a daring dresser.

Attire of Debutantes.

Master Joseph will wear a flesh-colored complexion, with the exception of his full-dress tights. He has created a furore in society by appearing at informal morning battles with coattails on his tights. The usual procedure at matinee massacres is for the guest of honor to wear tuxedo trunks with Bull Durham trim-

mings. He will affect the six-ounce suede glove with hard bandages and a little concrete in em if possible. His tights will be silk and he wears them very short.

Before the pug-debs are introduced, Miss Loy will turn a gold spigot and flocks of butterflies will be released from their cages. They will flitter through the magnificent Garden, which has been especially decorated with extra dust for the occasion. Each butterfly will flit around and then light on some particular head. If you get two oleofleas on your dome, try and keep it a secret.

Description of Ring

The ring will be from the Renaissance period with natural wood splinters. The gong will sound curfew chimes at the end of each round. It will be played by a specially imported pack of Swiss gong ringers. The ropes will be velvet and hung like portieres. Edgar Varese, the violinist, has donated a piece of concert resin to be used on the canvas flooring, which will be made in Persia. Incidentally, the tights worn by the fighters will be made by Tweebleham, of London, purveyor to the Queen by highest award.

Master Marsden will give his first dance to his brother pug-deb Joseph, which will probably fill Marsden's card for the evening. Visiting diplomats in the gallery de luxe will please refrain from asking for waltzes.

—With apologies to "Bugs" Baer.

Hans Arp: 7 Arpaden

It was not only the hullabaloo around our cabaret and our tumultuous evenings that acquired for us the friendship and collaboration of so many young minds. There were amongst us older people whose standing and connections served us as support and link. The first among these was my great friend Arp, poet and plastic artist. Of Alsatian origin, his heart was divided, and he avoided political discussions. From the start we recognised his strong personality and loved it.

As the high priest of dada, wearing the great triangle on his forehead, he gave us his blessing whenever the occasion seemed to warrant it. He wore English clothes and shoes designed by himself. He invariably showed the best of good humour. A poet of authentic mysticism and sensuality, he would cut paper into pictures that were always new and of the most surprising forms and colours, wonderful creations of an intrinsic charm. He had a first-class mind, and he was the greatest creator amongst us all — and the least talkative. It was miraculous how the forms would, as it were, make themselves naturally, without anyone seeming to touch the material. Some unknown magic, a new beauty unfolded themselves — a work of the angels and of chance. He said that art grew like the nails on his fingers, and we believed him in all sincerity. He also wrote beautiful verses, quite

different from those of the others by virtue of their curious, surprising abstract construction, full of abstruse or humorous associations. He had been through all the schools and had long since arrived at a purely personal form of creation that was abstract and very pure. Without theorising and without much ado he always succeeded in moving us with his prophetic work.

What Picasso had demonstrated by his "collages", Arp could express by a pure and much more direct technique and with astonishing forcefulness. He had abandoned all tradition and had renewed the painter's profession by proving the new truth in an uncontrovertible manner. A scrap of cloth, a slip of coloured paper, a line! His unpretentious pictures had turned aestheticism upside down together with the aestheticists themselves who tried to understand and to explain us. Like every "authentic" creator he would forget everything when in front of his work, he came out from under it every time like one newly-born, fresh, inspired, pure, and straightforward.

His courage made him risk everything, even a "picture". His inspired and magical work uncovered new horizons to art in a new society.

At his side, but nearly always unseen, was his wife, our great friend Sophie Taeuber. Her part in the work of Arp

Hans Arp: Cover for *Der Zeltweg* (Zurich 1919)

D E R Z E L T W E G

Hugo Ball: Sound poem, 1920

KARAWANE

jolifanto bambla ô falli bambla
grossiga m'pfa habla horem
égiga goramen
higo bloiko russula huju
hollaka hollala
anlogo bung
blago bung
blago bung
bosso fataka
ü üü ü
schampa wulla wussa ólobo
hej tatta gôrem
eschige zunbada
wulubu ssubudu uluw ssubudu
tumba ba- umf
kusagauma
ba - umf

(1917)
Hugo Ball

will probably never be assessed, just as, conversely, Arp's part in hers never will be. They did their work in pairs, and quite frequently I had the impression of collective creation.

Was she nothing but the muse of the high priest? Certainly not. In all her gestures, in her expressive face, in her spiritedness, she embodied something very personal. In her works, which she did not often show, there were always new rhythms, some surprising personal accent, jerky and geometrically syncopated expressions, exactly like the chords of good jazz or the restrained and dignified sadness of American "blues".

In her dances — she was an accomplished dancer — she kept clear of all contrived elegance. By her imaginative talent, by the expressive force and the aggressive abandon of her gestures she gave us a presentiment of the character dance of the future.

The full scope of her work has not yet been acknowledged, nor her positive participation in dadaism sufficiently appraised for the right place to be assigned to her. Moreover, her premature death prevented her from completing her mission.

The war made its ravages everywhere. Armies, empires were engulfed in the disaster. The cause of justice seemed swallowed up by the forces of evil. Mankind was suf-

Samstag, den 14 April, abends 8 ¹/₂ Uhr findet in den Räumen der GALERIE DADA, Bahnhofstrasse 19 (Eingang Tiefenhöle 12) unter der Leitung von HUGO BALL und TRISTAN TZARA als II. geschlossene Veranstaltung eine

STURM-SOIRÉE
statt.

PROGRAMM:

I.

TRISTAN TZARA: Introduction.

HANS HEUSSER: „Prélude", „Mond über Wasser", gespielt vom Komponisten.

F. T. MARINETTI: „Die futuristische Literatur", gelesen von HUGO BALL.

W. KANDINSKY: „Fagott", „Käfig", „Blick und Blitz", gelesen von HUGO BALL.

GUILLAUME APOLLINAIRE: „Rotsoge", „Le los du Douanier", lecteur F. GLAUSER.

BLAISE CENDRARS: „Crépitements", lecteur F. GLAUSER.

MUSIQUE ET DANSE NEGRES: exécutées par 5 personnes avec le concours de Mlles. JEANNE RIGAUD et MARIA CANTARELLI. (Masques par M. JANCO).

H. S. SULZBERGER: „Cortège et fête", exécuté par le compositeur.

JACOB VAN HODDIS: Verse, rezitiert von EMMY HENNINGS.

HERWART WALDEN: August Macke †, Franz Marc †, August Stramm †, gelesen von F. GLAUSER.

HANS HEUSSER: „Burlesques turques", „Festzug auf Capri", gespielt vom Komponisten.

ALBERT EHRENSTEIN: Eigene Verse. Ueber Kokoschka.

III.

PREMIÈRE

„SPHINX UND STROHMANN"
Kuriosum von OSCAR KOKOSCHKA
Masken und Inscenierung von MARCEL JANCO.

Herr Firdusi	HUGO BALL
Herr Kautschukmann	WOLFG. HARTMANN
Weibliche Seele, „Anima"	EMMY HENNINGS
Der Tod	FREDERIC GLAUSER

Auskunft an der Kasse der Galerie. Billets nur auf den Namen lautend.

SAMSTAG, den 28. APRIL, abends 8 ¹/₂ Uhr
III. GESCHLOSSENE VERANSTALTUNG.

Programme for 'Sturm-Soirée', Zurich, 14 April 1917

Hans Arp: Cover for *Die Wolkenpumpe* (Hanover 1920)

arp
die wolkenpumpe
copyright by paul steegemann

Hans Arp: Drawing

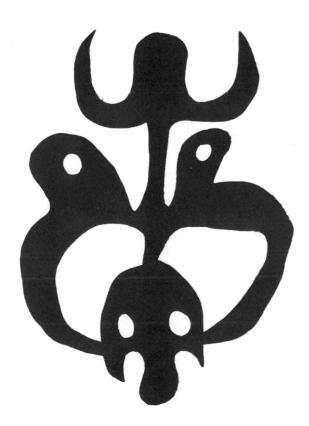

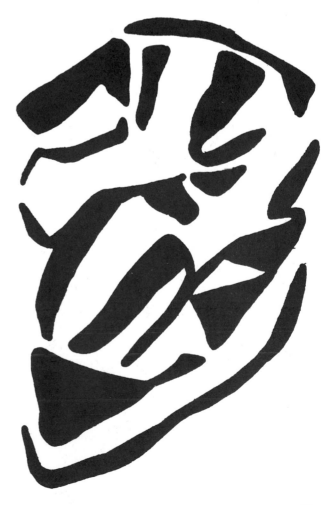

Mopp: Drawing from *Cabaret Voltaire* (Zurich 1916)

fering, and its fetishes — or symbols — collapsed one after the other. Bestiality burned in the veins, unleashing visions of the Apocalypse.

We already had dada in our systems, but in a quite different manner. It is true that the word was discovered in a Larousse dictionary and vested with all its power at a Café in Zurich. Tzara had got up on a chair, and proclaimed himself leader. The following morning he set in motion that apparatus that was soon to make the round of the world. The time for its propagation had come and Tzara was off on his dada, his hobbyhorse. In the big crash of a culture and its aestheticism it rained manifestoes, dadaist pamphlets. Everyone was looking for a way out. Everything had to be destroyed, purged.

Who was still a believer? Common-sense — for the blind; good manners — a source of disgust; respect — for corpses; logic — without rhyme or reason; and aestheticism — nothing but perversity!

Art is a great adventure, but it is by no means a necessity. The coarse is nearer the truth than the delicate; an insult more effective than a compliment; a smell acts more surely than a perfume, the art of the uncivilized cave-dweller is grander than to-day's; ugliness is more beautiful than "beauty"!

Who on earth, in those days of collapse, was still ready to believe in "eternal values", in the "canned goods" of the past, in the academies, the schools of art? The cry of "dada" became universal — to hell with beauty! In those days dada was in the air everywhere. A spark, and all was afire: New York, Amsterdam, Barcelona, Berlin, Hanover, Paris and so on. All that dada did was to sanction and to propagate the experiments that had preceded it. Criticism, dissatisfaction were general no less than anguish and doubt.

Everybody was ready to scoff at good taste and "bon ton", to make war on dandyism, on pedantry, on all aestheticism, on all that was washed up.

Marcel Janco: Woodcut, 1918

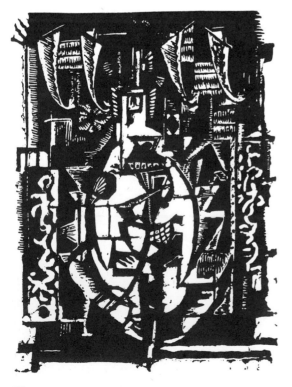

Marcel Slodki: Woodcut, 1916

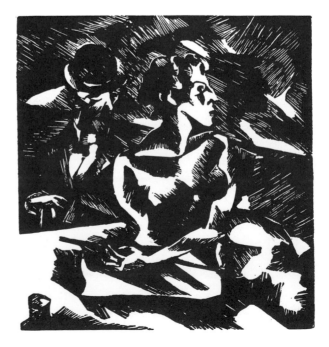

The loose-leaf book of the director and inquisitor general was growing visibly, stuffed with notes on dada manifestations from all over the world. His glory and his pride could be heard shouted aloud, and heaven help whoever dared to contradict — or tried to have a look at that famous folder. It was quite simple: his name was erased from history.

After the "Cabaret Voltaire" Tzara and his "disciples" entertained the public sporadically by means of gorgeous literary and artistic evenings which ended up in mystifications, bad jokes, and gross sarcasm.

Negative manifestions were the rage everywhere. In Switzerland even the public began to break up the old Moloch and acquired some taste. It took the new humour for its own, the puns und plays upon words, the more or less clever sarcasm and that gross cynicism that had seized art and artists.

All the same, it got tired of manifestations, and while still relishing the sarcasm and the surprises it began to return them, throwing bad eggs into the poets' faces. For how much longer after all, could one live on a diet of scandal? For a good while already dada had been on the look-out for a new audience.

At just that moment Ball once more entered the lists, to organise the "Galerie Dada" right in the heart of the city. The dadaists, at peace with each other, got together again, and organised exhibitions and collective centres. This time there were generous contributions from great artists living abroad who, without taking an active part

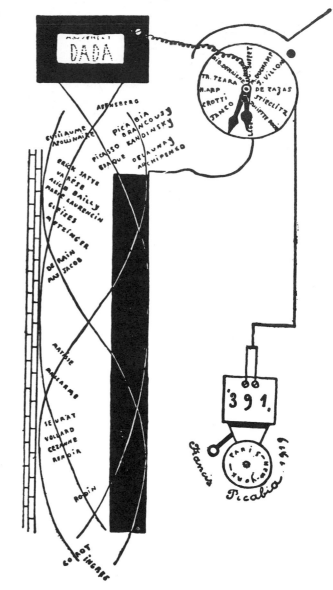

Francis Picabia: Drawing, 1919

Hans Arp: Cover for *Die Schammade* (Cologne 1920)

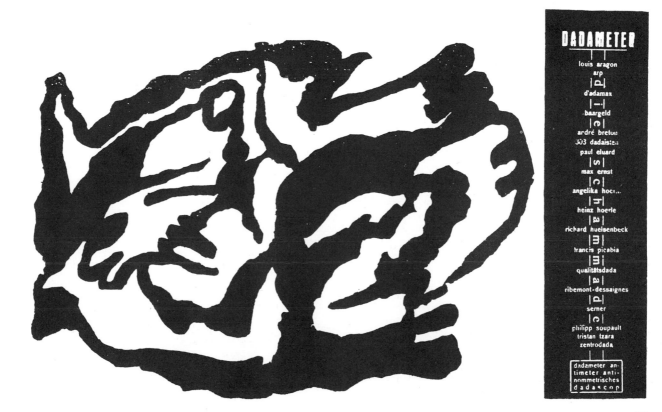

DADA

ausstellung

DADA-VORFRÜHLING

Gemälde
Skulpturen
Zeichnungen
Fluidoskeptrik
Vulgärdilettantismus

die urne des dadaisten max ernst
erfreut sich außerordent-
licher beliebt- heit wiewohl
Ich mir selber die größte
mühe ———— gebe
———— baargeld ————
(Ich habe kein kissen für meine urne).

Pages from *Katalog der Dada-Ausstellung* (Cologne 1920)

in our movement, were still sympathizers: Kandinsky, Kokoschka, Javlensky, the German expressionists, Delauney, Modigliani, and the Italian futurists.

At one of our performances there appeared a pleasant, young man, who introduced himself: "Richter, Berlin." He looked like a businessman on the grand scale, or like the son of a millionaire, but we soon saw through him. He contributed to the latest dada publications, but he already felt the wish to take part in the positive experiments our plastic artists were just then carrying out. He had a revolutionary mind; he was a socialist, had personally taken part in such activities in Germany, and he was dreaming of a new social art. A feverish and very lively creator, he dazzled us with a beautiful exhibition of series of pictures, which he must have painted in a few weeks, for he had come to Switzerland empty-handed.

Richter, sincere, brave, and highly inspired, soon succeeded in winning our confidence. In the end he assiduously took part in the positive dada representations that were at least as important to art as the purges and the destruction had been. The great event of the Galerie Dada was the Paul Klee exhibition organised by a friend of ours, Jollos, the art critic. It had an enormous success.

Klee had heard of dada and of our gallery. He may also have been a chance guest at the "Cabaret Voltaire". In his beautiful work we found all our efforts to unravel the soul of primitive man, to delve into the unconsicious and the instinctive forces of creation, to discover the pure, direct, creative sources hidden in children. This exhibition was a revelation to all of us.

His little pictures of those days were named after poems. For us he was an elder brother, but his health and his inclinations would not let him stay with us.

Ich bin nicht mehr in der Lage meinen sattel zu sättigen baargeld

für dreigliede-rung des dada-istischen orga-nismus

was die zeitungen mir vor-werfen, ist unwahr. Ich habe noch niemals bauchdecken-reflexe zur erhöhung der licht-wirkung meiner bilder ver-wendet. Ich beschränke mich lediglich auf rinozerisierte rülpspinzetten. max ernst

— besuchen Sie DADA?
— Ich habe kein BEDÜRFNIS
— dada ist keine BEDÜRFNIS-ANSTALT.

jeder besucher dieser ausstellung ist prädestinierter dadaist entweder lächelt er freimütig man kann ihn sodann als edeldadaist ansprechen oder er fällt dem irrwahn des antidadaismus anheim zu spät bemerkt er die personalunion von metzger und opferlamm in sich er ist dadaist schlechthin

כשר
חברת גמילת חסדים
חברת אהבת רעים
חברה הכנסת כלה
חברה גמילת חסדים
כשר על פסח

ich grüße nur noch simulanten

der wecker mit schluß für erstgebärende
von Dr. Val. SERNER läuft mit der geburt ab
 baargeld

die liebe auf dem zweirad ist die wahre nächstenliebe
 baargeld

dadamax ernst

Katalog

arp

1. relief der arp ist da
2. zeichnung
3. zeichnung
 baargeld gen. zentrodada
4. antropofiler Bandwurm (relief)
5. die familie ist der ursprung der familie (relief)
6. der sportsmann max ernst beim training am 100 m-Ständer
7. ausgießung des urohämatins auf aufgeregte expressionisten
8. vergebliche verleumdung und inthronisierung des dada baargeld
9. dadaisten, leere gefäße und bärte spielen miteinander.
10. der bruder präses der a b k bei verrichtung der brüderlichkeit
11. inauguralgaumen und fruchtverknotungen am primärporiemonnaie
12. fluidoskeptrik der Rotzwitha von gandersheim
 max ernst (gen. dadafex maximus)
13. ein lustgreis vor gewehr schützt die museale frühlingstoilette vor dadaistischen eingriffen (l'état c'est MOI) (monumentalplastik)
14. falustrafra (plastik)
15. große dadaisten werfen ihren schatten voraus (plastik)
16. unerhörte drohung aus den lüften (plastik)
17. knochenmühle der gewaltlosen friseure (relief)
18. sämtliche quer- und längsschnitte (relief)
19. originalaufrelief aus der lunge eines 47 jährigen rauchers
20. bitterkeit der matraze (relief)
21. noli me derigere (relief)
22. erectio sine qua non
23. 3 minuten vor dem sündenfall

roll nicht von deiner spuhle
sonst bricht dein backsteinzopf
sonst picken dir die winde
die flammen aus dem kropf
sonst fließt aus deinen röhren
der schwarze sternenfisch
und reißt mit seinen krallen
die erstgeburt vom tisch arp
 aus „die schwalbenhode"

Klee was a modest man. He was of medium height and tanned like the inhabitant of some southern country. His face was framed by a black beard, yet he gave the impression of a big child. He was anything but talkative and was seen but rarely in our company.

He would participate in all our positive experiments but, when dada set foot on a tight-rope, he fled. He was ready to swap works with us, but when he was called to Weimar as a professor soon after his exhibition, he left us. I have never seen him again.

Although his participation in dadaism consisted only in an exhibition of works he had created outside the dadaist circle, and despite his aversion to the noisy and destructive dada manifestations, a great many critics and writers assigned him a place in the dada movement, and quite rightly so.

His brilliant art, imaginative and poetical, full of spontaneity, of naïveté and freshness, does not belong to cubism, nor is it expressionist or futurist. His abundant imagination, his free poetry testify to his affinity to dadaism, to the true, creative kind of dadaism. The war was nearing its end. For lack of fighters Tzara, as commander-in-chief, sounded the retreat. All over the world newly recruited dadaists were looking for a leader.

Tzara had succeeded in making an art out of a game of effrontery and mystification. He had become famous, as a master of puns and bad jokes, and he was sought after everywhere. At the same time his insistence on his particular path to fame had estranged a number of artists from dadaism.

At first dada had, to be sure, fulfilled the useful function of a purgative, but soon a number of us began to feel the need for new experiments and set to work. The imperative demand for a new, more conciliatory attitude, in harmony with our positive idea of dada, weighed heavily on our minds.

At that juncture there was some comfort for dada in the person of Viking Eggeling, who had come from the Ticino with his wife. He was imbued with a fanatical belief in art and in his own artistic vocation.

Viking Eggeling had the face of a thinker. After long years of study and research in pure plastic art he had retired to Switzerland, in order to execute his first abstract film and to check his theory of "plastic counterpoint".

The film introduced the time factor to plastic art, while the sense of rhythm became measurable in the composition of the picture and the movement. He would spend whole nights drawing hundreds of sheets forming a sequence and correcting them continually in accordance with the laws of counterpoint, which he wanted to be as clear as those of music.

As all his financial means had to serve the realisation of his film project he was dismally poor, but he had great dignity. For days on end he would look for work so as to be able to burn the midnight oil in his immense undertaking. The Eggelings were a very austere couple and were leading a hard life. Their entire diet consisted of nuts which they always carried with them in their pockets, ceaselessly cracking them. They had neither home nor children and spent long evenings discussing the future of art in the new society to come. There had

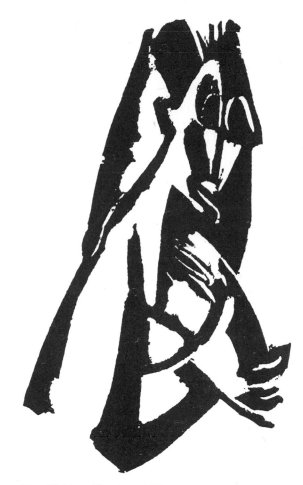

Hans Richter: Woodcut, 1918

Hans Arp: Woodcut from *Die Schammade* (Cologne 1920)

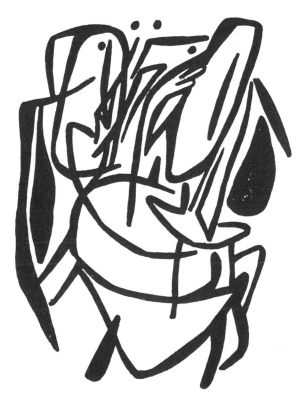

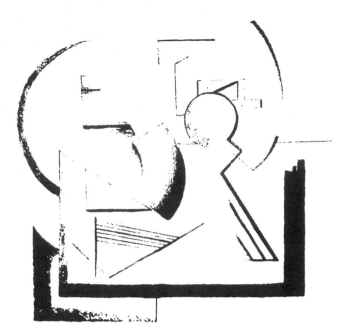

Viking Eggeling: Thorough-bass of painting. Lithograph, 1919

(left) Page from *291*

(right) Francis Picabia: Drawing from *291*

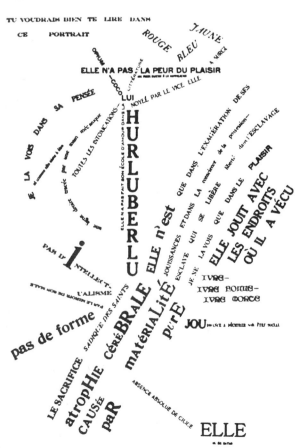

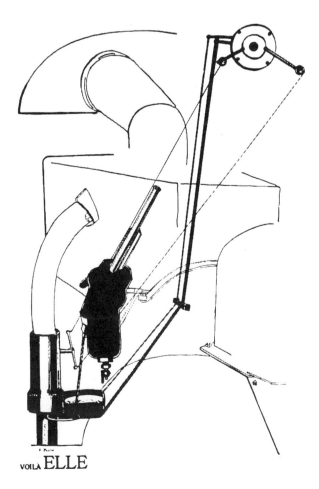

been differences of opinion for quite a time in the camp of dada sculptors. We no longer agreed on the significance of dada, and the misunderstandings grew in acerbity.

For our group dada had already acquired a positive meaning, which was to make a fresh start, beginning with the babble of infants, and to construct a new plastic language. Moreover dada, to all of us, was an affirmation of the forces of the subconscious, an organic creation, which, as Arp put it "grew on him like the nails on his fingertips".

Our group proclaimed its independence by publishing a periodical called "Zurich, 1919". We were termed "radical dadaists", for we had a programme and had already published a manifesto which was well received. This was its wording:

"Clear and uniform vision must prevail when facts over a wide range are decided upon. Spiritually and materially we demand our right: As an essential part of culture we, as artists, want to take part in the ideological evolution of the state, we want to live in the state as part of its very life and want to share all its responsibilities. We hereby proclaim that the artistic laws of our time have already been formulated on general lines. The spirit of abstract art represents an enormous widening of man's sense of liberty. We believe in a brotherly art: this is art's new mission in society. Art demands clarity, it must serve towards the formation of the new man. It must belong to all, without class distinctions. We want to gather up the conscious creative force of every individual, to help him to accomplish his mission for the

benefit of the common task. We are fighting the lack of system, for it destroys forces. It is our highest aim to bring about a spiritual basis of understanding for all mankind. This is our duty. This work assures to the people the highest degree of vitality. The initiative must be with us. It is our duty to direct the currents, to lend expression to the desires and at the same time to rally contending forces."

Just as in the old days the dada writers had transplanted the cubist's "collages" into their poetry, so the plastic artists, through a misunderstanding and under the influence of some "renown through scandal", introduced this literary method into their art.

And whilst invective against dadaists was hurled about in the German Reichstag, whilst at exhibitions a Mona Lisa with a moustache was shown as a work of art along with framed lavatory seats and other "readymades", the radical dadaists made their experiments in silence. After the Galerie Dada of Zurich had closed its doors they tried to put their prophetic ideas into practice. To-day, thirty-seven years later, these preliminary conditions for a new life have not yet been achieved: Abstract art is the art of brotherhood.

To return to life the sculptor must become an artisan.

Rejecting a compromise between a work of art and the open market the artist must no longer create work of commercial value.

A new, rejuvenated architecture must bring about a synthesis of all the plastic arts in the widest sense.

Plastic art — painting, sculpture, reliefs — must be made for incorporation into the architectural wall.

Hans Arp: Drawing, 1916

Christian Schad: Woodcut, 1916

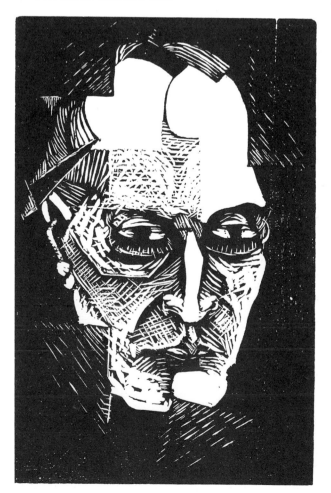

Marcel Janco: Woodcut

29

The teaching of art must be refashioned in accordance with the principles of the free development of the student, who must learn to discover himself.

Group working, collective, and even anonymous, work must be learnt, so as to increase power and reduce pride.

Under the name of "New Life" this group of creative dadaists worked, exhibited and developed until 1922. What we still need is a great treatise on that "dada spirit" that had afforded us a special mental climate, a belief in the purity of man, a source of art welling up from the depths of the subconscious. While it was flabbergasting and mystifying, dada also succeeded in creating pure poetry. While it was tearing down, dada also experimented and created the foundations for a new social aestheticism to serve the artist — at least in its last, positive, phase. It is a problem which is still awaiting its solution.

Dada will last. Not so much because of the experiments and the literary excesses that gave birth to surrealism, but rather because of the creation of the prophetic spirit found in the works of Arp, in the poetry and the art of Klee, in the picturesque illustration-series of Richter, in the abstract films of Eggeling and Richter, in our attempts in mural paintings and abstract plastics, and in the beautiful tapestries of Sophie Taeuber.

Dada was anything but a hoax; it was a turning on the road opening up wide horizons to the modern mind. It lasts, and will last as long as the spirit of negation contains the ferment of the future.

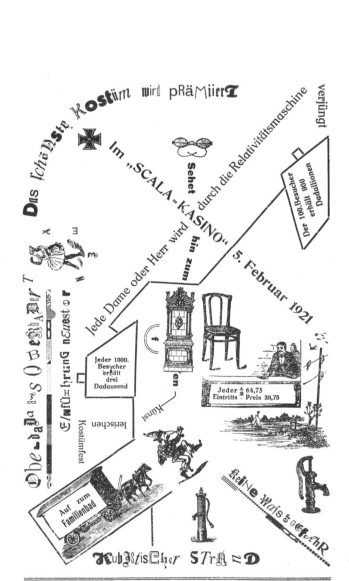

Marc Slodki: Portrait of Tolstoy. Woodcut

Karten für das künstlerische Kostümfest »Familienbad«
in den Räumen des „Scala-Kasino". Lutherstr. 22-24 sind in folgenden Stellen zu haben:

»Atlanta« Verkehrsbüro, Joachimsthalerstr. 5 — Café Josty, Bayrischer Platz 1 — Im alten Café des Westens — Odeon-Bar, Joachimsthalerstr. — Café Islam, Tauentzienstr. 20 — Theaterbillet-Verkauf am Zoo, Joachimsthalerstr. 1 — Theaterkasse Kaiserhotel, Kaiser-Keller — Theaterbillet-Verkauf Bayrischer Platz 11 — Reiseverkehrsbüro »Globus« Aschaffenburgerstr. 19 — Tauentzienkabinett, Tauentzienstr. 7 — Musik-Tempe, Nürnbergerstr. 27 und in den Restaurationsbetrieben des »Scala-Kasino« sowie an der Abendkasse.

Richard Huelsenbeck

DADA AND EXISTENTIALISM

Cover for Richard Huelsenbeck, *En Avant Dada: Die Geschichte des Dadaismus* (Hanover and Leipzig 1920)

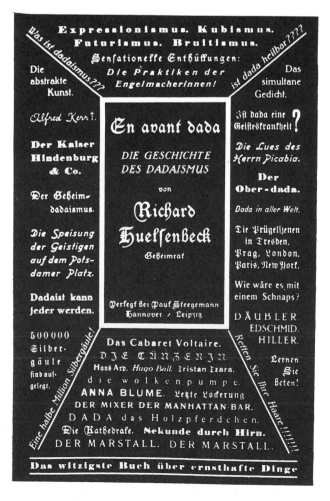

In the many years since its foundation at the "Cabaret Voltaire" in Zurich in 1916, dadaism's fortunes have been varied: The reaction of the Swiss was not exactly friendly, as might have been foreseen, but in retrospect it seems that they were actually our most benevolent critics, for all they did was to take us for a bunch of rather crazy cabaret employees. Later developments were far worse, from political threats in Berlin to supercilious rejection in America.

In the United States dadaism was thought to be some kind of psychosis with artistic intentions, until it suddenly acquired — as it possesses until this day — an international reputation. When poeple realised that there was more to it than just fun and games they grew wary, for there is nothing worse than that form of ignorance which can be interpreted as backwardness. So it came to pass that dadaism is enjoying a somewhat paradoxical esteem in the U. S. A. Its deeper meaning is now accepted as a psychological rebellion, a nonconformism, something that is generally demanded here, but rarely observed. Be that as it may, the Americans have become conscious of the most serious danger to civilisation, the tendency towards a general levelling, and there is great admiration for the audacity of a handful of writers and painters who as much as forty years ago, dared to shout down most vehemently all, literally all, cultural values.

It seems to me worth while to understand the meaning of dadaism from what has remained, which is, I think, its philosophical content. When Sartre, in one of his essays on his existentialist philosophy, loudly proclaimed: «I am the new dada», people pricked up their ears. Why did he not hesitate to profess to be the descendant of a small group of painters and writers who were smiled at by all intellectuals? Where is the spiritual connection between Sartre, existentialism, and dadaism? This is what we want to investigate in the present essay, for in it is contained the historical acceptance — or rejection — of dadaism. In other words: Either dadaism fits into some trend of modern thought, or it will soon be forgotten.

I am quite conscious of the fact that I am treating dadaism as a living idea, as if it still existed. I have often given expression to this, for example in an essay I wrote for the periodical "Transition", shortly after emigrating to the United States. "Dada lives" was the title of that essay and I believed then, as I do now, that there exists a kind of a dadaist man, a dadaist fundamental way of life, which is not only characteristic of our time, but is congruent with many assertions of modern thought.

Outside observers of our movement, like everybody else, first of all looked for results and cared little about dadaist philosophy and less about the men who stood for it. This meant, that they cast about for works of art. What was dadaist art? What had the dadaists, who had once caused such a hullabaloo, achieved in their own spheres?

It was obvious that the yield of their quest was not commensurate with expectations and that the critics returned from it burning, as it were, with a holy wrath. They were convinced that the dadaists had been nothing but arrogant amateurs, who had stolen the voice

Dadaisten gegen Weimar

Am Donnerstag, den 6. Februar 1919, abends 7½ Uhr, wird im Kaisersaal des Rheingold (Bellevuestraße) der

OBERdADA

als

Präsident des Erdballs

verkündigt werden nach dem Wort der Zeitung:

„Wir werden in diesem Jahre wahrscheinlich noch einigemal wählen, den Prxsjdentrx, das V lkshaus. Und dann wollen wir uns nicht mehr bloß mit dem Instinkt, der mechanischen Zielsicherheit der unbewußt ahnungsvollen Masse bescheiden, sondern das persönliche Genie s ch n geha ª, das wir in irgend einer Schichte unseres Volkes endlich doch und doch hervorgebracht haben müssen, wenn wir nicht schon jetzt eine abgestorbene Rasse sein sollen!"

(B. Z. v. 27. l. 19.)

Zu dieser Suche werden alle geistigen und geistlichen Arbeiter, Volksbeauftragte, Bürger und Genossen beiderlei Geßchlechts (Soldaten ohne Rangabzeichen) erscheinen, denen an dem Glück der Menschheit gelegen ist.

Wir werden Weimar in die Luft sprengen. **Berlin** ist der Ort ˈɐp·· ɐp·· Es wird niemand und nichts geschont werden.

Man erscheine in Massen!

Der dadaistische Zentralrat der Weltrevolution.

bAA ER, HAUSMANN, TRISTAN TZARA, GEORGE GROSZ, MARCEL JANCO, HANS ARP, RICHARD HÜLSENBECK, FRANZ ONNI, EUGEN ERNST, A. R. MEY ER

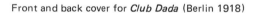

Dadaisten gegen Weimar (Berlin 1920)

of genius and the thunder of the prophets. "Epater le bourgois!" had been their intention, so the critics said, a wicked, an overweening, perhaps even a criminal intention.

A nation like the Germans, which can associate in the oddest fashion materials of low provenance with lofty idealism, must, it would appear, reject out of hand an existentialist movement like dadaism. Indeed, Alfred Kerr, a noted German critic, wrote in 1919, after we had given a performance at the Berlin "Tribüne": "When Huelsenbeck absconds with the cash, that is dadaism . . .». In those days the Secret Police, with their methods of torture, were still in a primitive stage of development, but they had heard of dadaism and took it to be a movement that was implacably opposed to the German soul (which, so it was claimed, was to bring salvation to the world at large). The opposition was certainly a fact and thus, oddly enough, the judgment of policemen was nearer the mark, than that of the learned men of the arts. Here were our adversaries and we knew what we had to think of them, whilst the journalists in their papers and art periodicals were writhing and screaming as though we had given them poison.

Sartre once said, that the French were freest when occupied by the Germans, a remark, that seems to be as harmful to the state as it is paradoxical. Later I grasped its meaning — when I better understood Berlin dadaism. In Berlin, at the time of the revolution, into whose cauldron of hate and revolt we threw dadaism like a

Front and back cover for *Club Dada* (Berlin 1918)

block of marble, one could voice one's opinion. The people had lost much — the war, their fathers and sons, their money, their obesity — but they also had gained something: The chance for a free decision. They had once more become their own masters in the sense that they knew the enemy to be not at some far-away frontier but in their own homes, so to speak. Friend and foe stood eye to eye. The question called for a simple yes or no. The fact that the dadaists said no was less important than the manner in which they said it.

What people so much took offense at was that we no longer believed in art. Ever since the Germans had found out that even Dr. Martin Luther's "Safe Stronghold" had become little more than a birthday anthem in honour of a money-making average society, they laid greater stress on the idealist significance of art, which they identified with love for beauty. At the time when we dadaists were performing in Berlin expressionism was as little known as the love for a free order of public life. The general public laughed at the jokes and gaped at the blaze of colours of Liebermann, the old painter, who was sitting like a walrus forsaken by its herd on the banks of the Wannsee. Grützner's beer-swilling monks populated the seats of learning at the academies in Berlin and Dresden, and the classic ideals, so long the pride of German Christmas-gift tables, lived on ineradicably in the dutiful hearts of the November revolutionaries, no matter what Worringer may have written.

Selbstbildnis von George Grosz

Was ist dada? Eine Kunst?, Eine Philosophie? eine Politik? Eine Feuerversicherung? Oder: Staatsreligion? ist dada wirkliche **Energie?** oder ist es **Garnichts**, d.h. alles?

Page from *Der Dada*, no. 2 (Berlin)

George Grosz: Cover for *Die Pleite* (Berlin 1919)

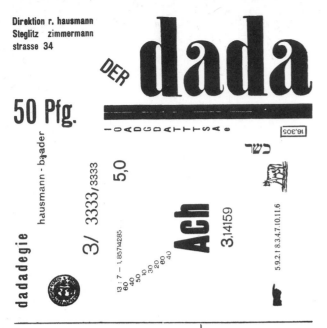

Cover for *Der Dada*, no. 1 (Berlin)

And then came the dadaists, endowed with the acuteness of sleep-walking alcoholics, to attack the arts, that last refuge of idealism. Even critics favourably inclined to modernism had to admit sorrowfully that here a capital crime was being committed. The "most sacred possessions", of which the Kaiser had spoken in the old days, were being desecrated, drugged and poisoned. The ideal of beauty was brought up against life, ugly life, earth, being, even not-being. It was worse than what Rimbaud had done when, at a soirée given in his honour, he had punctuated the recitation of every verse of his "Parnassiens" with the loud call of "merde alors".

At the first dada evening, at the Neumann gallery, Berlin, when the proprietor was about to call the police, I said that the war was not bloody enough by far. Horror! An invalid with a wooden leg got up and the audience rose to their feet and accompanied his exit with applause.

At that time a case of lynching almost happened in Germany. The audience not merely rose to their feet but moved towards the rostrum in order to hurl themselves at me. But as is usual in such situations (I went through many like it in my dada time) public fury was checked by a kind of awe. What manner of people were these dadaists daring to risk with verse and word the many-headed attack of a multitude?

It was that absolute audacity which brought dadaism so close to existentialism in those days, the fantastic heroism of a group fighting it out with symbols; propa-

Advertisement of Dada Advertising Company from
Dada-Almanach (Berlin 1920)

gating war, but not war as commonly understood. Rather it was a better fight, the revolt against conventionalism, against a sated middle class crammed full of victorian half-values, the war against spiritual death, against satiety, against the liberalism of intellectuals, against good people, against rabbit-fanciers in philosophy, against the members of church-women's organisations. In New York a shrewd theologian, Professor Tillich, wrote a book entitled "The Audacity Of Being". Simple existence, the restitution of the rights of instincts, the praise of sexuality, the adoration of strength, even (to my shame I must admit it) the adoration of brute force from Rimbaud to Mickey Spillane, brutality as shown in the films of Hitchcock — all that, horrible dictu, was part of our programme.

A wild tangle of contradictions and paradoxes which was, however, held together by its very discrepancy. It was that two-sided, perhaps even double-tongued form of existence taken from life itself, which despises ideals. It was dadaism in its existentialist version.

The existentialist attitude, as we know it from Leon Chestov, Berdeyeff, and Sartre, this creative tension face to face with life, creative irrationalism which assigns the same place to both good and bad — these were brought into the open in our dispute with Kurt Schwitters.

Kurt Schwitters, of Hanover, living amongst the remnants of a military society of the lower middle class, in a town in which Hamann, the sexual murderer, lived and wrought not far from the super-father Hindenburg — this Kurt Schwitters discovered the symbolic meaning of his movement in a syllable of the "KomMERZbank", on a neatly-painted sign-board not far from his home, where he was leading a normal existence with his wife and child. Since that monumental event, which befell him one day as he was walking about town, he called his art "MERZ-art".

The principle of chance, which played such a large part in the dada movement and which had insinuated itself into our life through the discovery of the word "dada" in a dictionary, had become revelated to Kurt Schwitters in his "MERZ"-adventure. This would have been to our complete satisfaction, but there arose an antagonism between Schwitters and the Berlin movement on account of the difference in our conception of the meaning and value of art. To us art — as far as we admitted its existence — was one expression of human creative power, but only one — and one in which a person could but too easily become entangled. Art, to Schwitters, was as important as the forest is to the forester. The remodelling of life seemed to us to be of prime importance and made us take part in political movements. But Schwitters wanted to have it expressed only by means of artistic symbols. His predilection for the "pastepicture", for "foreign» materials (stones, cork-stoppers, matches, scraps of cloth, love-letters, pages from prayer-books, income-tax returns) showed that he had recognised the deep hankering after the primitive, the simple form. He wanted to get away from the complicated, overcharged, perspectively seen present.

At the same time he lived like a lower middle class Victorian. He had nothing of the audacity, the love for adventure, the forward push, the keenness, the personal

Cover for *Freiland*, no. 1 (Potsdam 1921)

thrust, and the will born of conviction, that, to me, made up most of dadaist philosophy. To me, at that time a very unruly and intolerant fellow, he was a genius in a frock coat. We called him the abstract Spitzweg, the Kaspar David Friedrich of the dadaist revolution.

When I went to Hanover for talks with Paul Steegemann, my late publisher, regarding my book "En avant, Dada", I called on Schwitters at his home in the Waldhausstrasse. It was shortly before Christmas, and the Christmas-tree was already decorated in the living-room. Mrs. Schwitters was giving her son a bath in a huge old-fashioned tub. We, thinking the desert, or a barracks, or empty space the most suitable place to be in, could not help poking fun at Schwitters. Here we had the German forest, and a wooden bench complete with hearts carved on it. I obviously overshot the bounds then, and a tension soon developed between Schwitters and myself which led to hostility. He disliked my fighting ways, and I liked his static, snug middle class world even less. I also thought that «Anna Blume», the very successful poem that my publisher, Steegemann, had brought out for Schwitters, was rather silly. It represented what I had always chosen for a special point of attack, a kind of German humour such as is found in Bavarian farces: Ludwig Thoma mingled with dadaism.

Since then the question of what dadaism is and who may be called a dadaist has occupied me more than ever. If dadaism is nothing but a trend in art, a trail-blazer, say, for surrealism, then there is little to be said about it to-day. Abstract art, brought to life by synthetic cubism, found rich confirmation in the persons of Janco and Arp. Breton extended the field by adding automatism to painting. Chance, structural form, the neo-plastic aspect of the new art, simplification, primitivism (used by Schwitters, Hausmann, and myself, in the "soundpoem") — all these, it seems to me, acquire value and gain recognition only when seen in the light of modern thought and together with the problems of philosophy and physics.

Dada, in other words, is but one symptom in the great spiritual revolt of our time. It may be called the existentialist revolt, for all its elements can be understood through human existence, by means of psychology. What dada wanted in its heyday, and what it still stands for to-day, is the re-forming of man in a new world, exactly as I put it in my manifesto "Der Neue Mensch" ("The New Man"), published by the Malik-Verlag, Berlin, in 1920.

But what kind of man do the dadaists want to shape? When Sartre says that man wants to be God, it means no more than that he has realised that the creative force within him is identical with the universal creative force. In other words, man is no longer the product of some conventional morality. He can no longer suffer himself to be pushed this way and that by political, economic, or religious catchphrases. He is what he is because he has become aware of his own value.

When we organised a grand dada exhibition at the Janis Gallery in New York, I frequently had the opportunity to talk with Marcel Duchamp. He turned out to be a man of great shrewdness and deep insight into the world of dadaist problems. He had long since abandoned art and, so he claimed, replaced it by chess-playing. When I

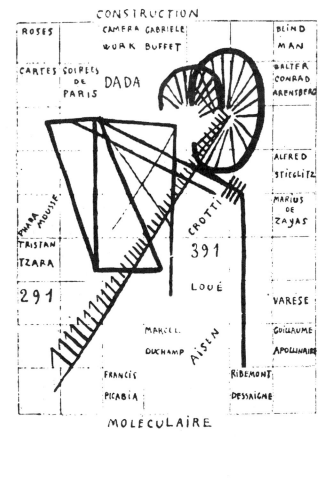

looked him up one day at his little flat in Fourteenth Street he showed me a chess-table he had built himself, equipped with every conceivable gadget — built-in clocks, electric bells, hand rests, and foot rests. This table resembled nothing so much as an electrical computer, a machine that might, perhaps, solve the most intricate chess problems without human aid.

Duchamp, called the dadaist prototype by the American press, is a true existentialist. His personal conflicts are the conflicts of our time at large in which, as Duchamp hinted, art is overrun by mechanics and made impossible. When Duchamp showed his "ready-mades" about 1910, at a time that is when the world was still fast asleep in its pre-war slumber, he was animated by one thought which, to me, is of the greatest significance for the existentialist conception of dadaism. What he wanted to show symbolically is now most readily recognisable in the United States, and in this country more than elsewhere contributes to the sense of suffocation, of the insignificance of the individual, of frustration and neurosis. It is the idea of the finished and complete, of the perfect product, of machine-like capability. What is shown here symbolically and condemned, is the inferior situation forced upon man by a society that has still to learn what freedom really means.

The contempt for art, which Rimbaud had, and which Duchamp also demonstrated, our dadaist re-interpretation of art, indicates the true character and existentialist scheme of the Berlin dada movement. This character is so hard to define, and so essentially spiritual, that even here I have difficulty in speaking about it. It is THE GREAT SECRET in itself. Not the end-product, be it a motor car or a "collage" by Picasso or Kurt Schwitters, is the essential thing in the creative spirit, in the movement of forces, in the universal trend upward, in which man and beast take part. In all my Berlin manifestos, I have stressed the immaturity of the movement, the amateurish creativeness of all human efforts. Decisive is the volcano and not the lava, the symbol-making power and not the rigid symbol, the ethical will and not the conventional morality, the individual in the mass and not the mass around the individual.

In our hands, then, dada became a problem of personality. It was fighting for a creative life, for growth and becoming, for what may only be divined, not what may be calculated in advance. In this divination, art was but a part, just as existence, in the judgment of Heidegger, is only one possible form of being.

Front and back cover for Walter Serner, *Letzte Lockerung* (Hanover 1920)

SERNER
LETZTE LOCKERUNG
manifest dada

PAUL STEEGEMANN VERLAG HANNOVER
LEIPZIG / WIEN / ZÜRICH

DIE Original DADAisten
GEBEN DAS COPYRIGHT IHRER WERKE DEM VERLEGER PAUL STEEGEMANN IN HANNOVER DER IN LEIPZIG WIEN ZÜRICH DADAFILIALEN HAT
HERR KURT SCHWITTERS
AUS HANNOVER WALDHAUSEN SETZTE ALS ERSTER DADAIST AUF EINEN DOPPEL SILBERGAUL 39/40 DIE JETZT WELTBERÜHMTE
ANNA BLUME VIER MARK
10 000 EXEMPLARE SIND IN DREI MONATEN VERKAUFT ANNA BLUME KANDIDIERT FÜR DEN ERSTEN DEUTSCHEN REICHS-TAG NACH DER KLEINEN REVOLUTION UND HOFFT NOCH VIEL GELD ZU VERDIENEN JA
DIE KATHEDRALE VIER MARK
IST DIE SEHNSUCHT ALLER ZEITEN HERR SCHWITTERS HAT SIE AUF SILBERGAUL 40/41 AUFGEBAUT
DIE WOLKENPUMPE VIER MARK
HAT UNS SCHON LANGE GEFEHLT ALS CACADOU SUPERIEUR KNALLT SIE AUF SILBERGAUL 52/53 ALLE BÖSEN GEWITTER AUS DEN GEMÜTERN DER DEUTSCHEN MENSCHEN SIE SPENDET RAT UND HILFE IN UNGLÜCKSFÄLLEN HERR ARP AUS ZÜRICH IST DER NOBLE HERSTELLER
DIE LETZTE LOCKERUNG SECHS MARK
IST DAS ENDE ALLER FILOSOFIE DAMENSTRÜMPFE GAUGINS UND DADA BALANZIEREN DIE KAFFEEMÜHLE WELT DER BE-RÜCHTIGTE DR SERNER AUS GENÈVE HAT DIE LETZTE LOCKE-RUNG GELOCKERT BAND 62/64
SEKUNDE DURCH HIRN SECHS MARK
DER PRACHTVOLLSTE SCHUNDROMAN ALLER ZEITEN DAS LIEBLINGSBUCH DER LITTERARICH GEBILDETEN BAND 59/61 DIESES WERK DES HERRN VISCHER AUS PRAG STROTZT VON GEMEINHEIT UND UNZUCHT SIE MÜSSEN ES LESEN
EN AVANT DADA VIER MARK IST
DIE GESCHICHTE DES DADAISMUS
BAND 50/51 VERFASST VON GEHEIMRAT RICHARD HUELSENBECK DEM BESITZER DES ZENTRALAMTS DER DADABEWEGUNG IN DEUTSCHLAND BERLIN HIER ERFAHREN SIE DAS GEHEIMNIS DES DADA SENSATIONELLE ENTHÜLLUNGEN AUS DEM LIEBESLEBEN DER DADAISTEN DIE PRAKTIKEN DER ENGELMACHERINNEN DIE LUES DES HERRN PICABIA DIE SPEISUNG DER GEISTIGEN AUF DEM POTSDAMER PLATZ KUBISMUS FUTURISMUS EXPRESSIONIS-MUS REVOLVER UND LITTERATUR DIE PRÜGELEI IN DRESDEN DADA IN ALLER WELT BRUITISMUS JEDERMANN KANN DADAIST WERDEN
FASST EINE HALBE MILLION SILBERGÄULE TRABEN AUF DER ERDE HERUM
DER DIREKTOR PAUL STEEGEMANN HAT DAZU SOZUSAGEN ALS VORBEREITUNG
DEN MARSTALL
DEN ANTIZWIEBELFISCH ÖFFENTLICH ERSCHEINEN LASSEN DA WERDEN DIE SILBERGÄULE MIT POLEMIK UND ELAN VORGE-RITTEN FÜR ZWEI MARK DIE NUMMER

X-Beelden (1920)

hé hé hé
hebt gij 't lichaamlijk ervaren
hebt gij 't lichaamlijk ervaren
hebt gij 't li **CHAAM** lijk er **VA** ren

On

— ruimte en
— tijd
verleden heden toekomst
het achterhierenginds
het doorelkaâr van 't niet en de verschijning

kleine verfrommelde almanak
die men ondersteboven leest

MIJN KLOK STAAT STIL

ZIG – ZAG uitgekauwd sigaretteeindie op't
WITTE SERVET

vochtig bruin
ontbinding
GEEST
346 **VRACHT AU TO MO BIEL**

DWARS trillend onvruchtbaar middelpunt

caricatuur der zwaarte
uomo electrico

rose en grauw en diep wijnrood

de scherven vàn de kosmos vind ik in m'n thee

Cover, with drawing by Raoul Hausmann, for *Mécano*
(Leyden 1923)

Cover for *Mécano* (Leyden 1922)

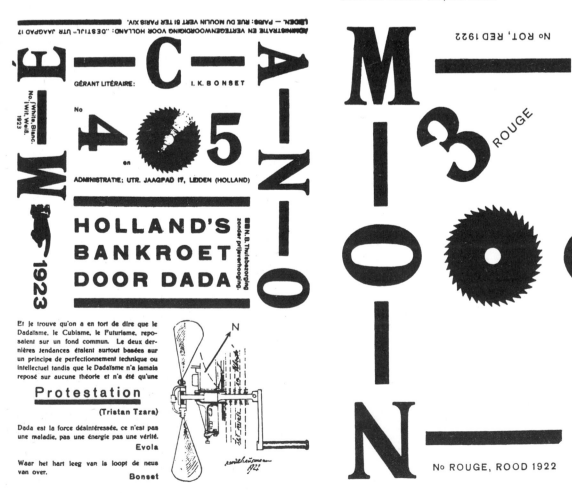

Hans Richter

DADA AND THE FILM

Art historians and critics have recently discovered dada. They have decided the movement to be something like a glorified practical joke that had some useful destructive function at the time.

This definition has now been sanctioned by repetition and has become a «historical fact». But we, who were all together there when it happened look at it from another angle, not from the big noise we made at the time to «épater le bourgeois» but from the ideas and problems with which we, the artists, were then concerned and which were the bone and flesh, though not necessarily the skin of this movement. The nucleus of the artistic endeavour of dada as it appeared in Zurich 1916/19 was abstract art. Abstract art was at that time a fighting proposition not a four-lane highway on which everybody travelled who was faced with an empty canvas. Abstract painting that **was** dada. When Arp and van Rees had painted and been paid for two abstract frescoes in the hallway of a school in Zurich, the school board, sustained by public opinion, insisted that these dadaistic (in fact just plain abstract) ventures be immediately painted over with normal human figures. And they were.

Even before I joined dada in 1916 I had lost more and more interest in subjects like apples, nudes, madonnas, guitars, and concentrated upon this realm in which color and form, a line and surface started to become meaningful by themselves: abstract art.

In these years 1913/17 I found myself attracted on one side towards uninhibited freedom and spontaneous expression and on the other side fascinated by the problem of gaining an objective understanding of fundamental principles which might govern and control these heaps of fragments which we had inherited from the cubists. One day at the beginning of 1918, Tristan Tzara knocked at the wall which separated our rooms in the Hotel Limmatquai in Zurich and introduced me to Viking Eggeling. Our complete agreement from the very first moment on aesthetic as well as on philosophical matters, a kind of enthusiastic identity led spontaneously to a collaboration and friendship which lasted until Viking Eggeling's death in 1925.

This collaboration led us over a small bridge from painting to scrolls and finally in 1920 into an adventure none of us had ever dreamed off: film. In these years between 1918 and 1920 our research led us to study the «behaviour» of line and surfaces towards or against each other. We deducted from these exercises a kind of method which allowed us to «orchestrate» a line and a form from the very simplest to the most complicated expression. Eggeling called it «Generalbass der Malerei». We used these drawings on small pieces of paper to study the relationships of simple and complicated forms, arranged them and rearranged them on the floor till one day we discovered a kind of continuity evolving from these lines of drawings. It was then that we decided to make purposely a continuous development of forms and form groups on long scrolls of paper: our first scrolls. Eggeling's was «Horizontal-Vertical Mass», mine «Preludium».

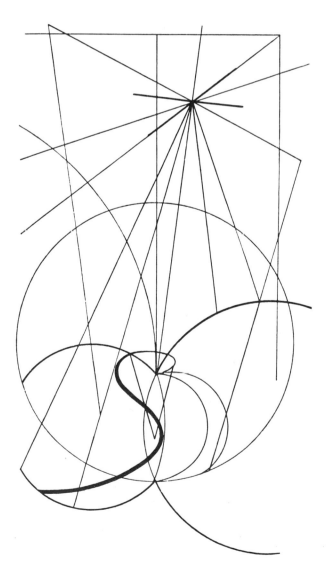

Raoul Hausmann: Drawing, 1922

These scrolls, when we looked at them, imposed upon us the wish to realize the «movement» they implied: real movement: that meant film and that is how we came to make films.

It is therefore no accident that the first abstract films were made by two members of the original dada group, Eggeling and myself. And they certainly did not demonstrate the officially acknowledged spirit of dada: the Mona Lisa with a moustache, the toilet-seat or the nail flatiron ... but they grew nevertheless straight from the art-, and -nothing-but-art problems which had drawn us into them. I remember very well though, that I had kind of a row with Tzara, the publisher of our dada magazine about this point. He was against reproducing Eggeling's classic abstract drawing in «Dada» (Giorgione, Renaissance and all that), and I had to use all kinds of protest, pressure and arguments to convince him.

Sure, we were all for the law of chance, but if there were a law of chance, then there should by the same logic also be a law of «rule». And to approach, to discover this «Rule» seemed to make the law of chance meaningful: the just balance «between heaven and hell» (Arp). It was the obvious question which this new liberated form of expression (abstract art) had put before us.

After I have stated this fact: Dada = abstract art, I hap-

Francis Picabia: Catalogue for the Exposition Dada, Paris, 1920

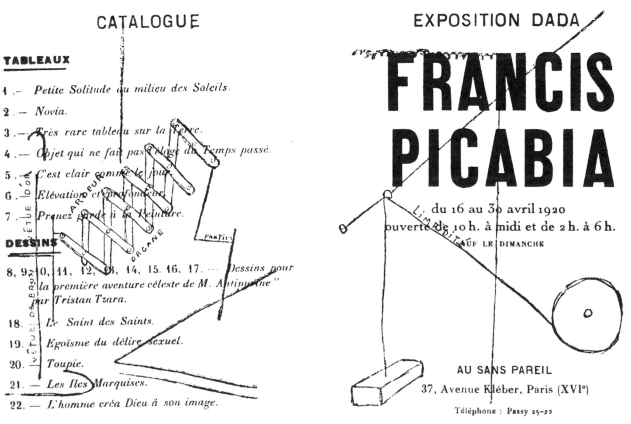

CATALOGUE

TABLEAUX

1 .— Petite Solitude au milieu des Soleils.

2 .— Novia.

3 .— Très rare tableau sur la Terre.

4 .— Objet qui ne fait pas l'éloge du Temps passé.

5 .— C'est clair comme le jour.

6 .— Elévation et profondeur.

7 .— Prenez garde à la Peinture.

DESSINS

8, 9, 10, 11, 12, 13, 14, 15. 16, 17.— Dessins pour la première aventure céleste de M. Antipyrine " par Tristan Tzara.

18 .— Le Saint des Saints.

19 .— Egoïsme du délire sexuel.

20 .— Toupie.

21 .— Les Iles Marquises.

22. — L'homme créa Dieu à son image.

EXPOSITION DADA

FRANCIS PICABIA

du 16 au 30 avril 1920
ouverte de 10 h. à midi et de 2 h. à 6 h.
SAUF LE DIMANCHE

AU SANS PAREIL

37, Avenue Kléber, Paris (XVI°)

Téléphone : Passy 25-22

pily wish to insist on the other point: Dada = non-abstract art. And that is also true — if not truer and is documented by a different series of films. «Entr'acte» 1924 after a story by Francis Picabia produced by René Clair: a funeral, a hearse led and drawn by a slow- and fast-moving camel, a dancing girl with a flowing beard, and the whole story ending in the reappearing of the dead and the magic dissolution of the mourners. It bends over backwards to laugh over and with the paradoxical happenings, dada! Nothing abstract there except the tension between the overly fast or overly slow rhythm of the action itself.

Fernand Léger's «ballet mécanique» also 1924: An integration of abstract forms, rhythms and objects (kitchenware) with a bit of a story («On a volé un collier de perles de 5.000.000»). The zeros become pearls, abstract form and part of the story again. They dance, split and transform, become round and sharp, disappear. Though Léger was never a dadaist, the film is 100%. It is one of the most imaginative of this kind. It is just that Léger had sensed the ambiguity in the ordinary: serious beauty turns into laughter and laughter into abstract beauty, without denuding the one or the other of their inherent meaning and integrity.

More abstract in the proper sense of the word are my «Filmstudy» and Man Ray's «Emak Bakia», both 1926.

Programme, with drawing by Francis Picabia, for Manifestation Dada, Paris, 1920

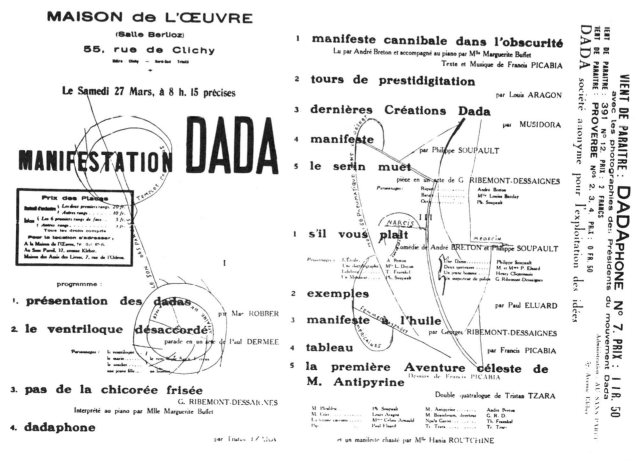

The pre-surrealistic poem «Filmstudy» uses floating heads and eyes connected with luminous circles like moons rising from the surface of the screen in gentle ripples and exploding waves. Abstract forms, objects on the same rhythmical level relieved of their explainable and useful function, talk their own sensitive but irrational language. «Emak Bakia» is a beautiful poem created by a string of objects, abstract symbols dancing in the nude, shirtcollar slowly turning one way — turning the other, moving, measuring the time of a studio-locked universe.

Though these two films were at that time already called surrealistic (after the fashion) they are more dada. I wonder, if the distinguishing line between the two can be drawn exactly as surrealism jumped out of the left ear of dada fully equipped and alive, making dadaists = surrealists overnight. Anyhow in these two films there is no «moral» issue involved as surrealism demands, nor a Freudian party line drawn. Though interpretations in the Freudian direction are never lacking. The same goes for my film «Vormittagsspuk» (1927). It is really simple: Four bowler hats, some coffeecups and neckties «have enough» (are fed-up) and revolt from 11.50 to 12 a. m. Then they take up their routine again. (Darius Milhaud and Hindemith are actors in the film, the original score was composed by Hindemith, but later destroyed by the Nazis.) The chase of the rebellious «Untertanen» (objects are also people) threads

Cover for *Littérature* (Paris 1920)

2ᵉ Année : Nº 13 REVUE MENSUELLE MAI 1920

LITTÉRATURE

VINGT-TROIS MANIFESTES DU MOUVEMENT DADA

PAR

Francis PICABIA, Louis ARAGON, André BRETON,
Tristan TZARA, ARP, Paul ELUARD, Philippe SOUPAULT,
SERNER, Paul DERMÉE, Georges RIBEMONT-DESSAIGNES,
Céline ARNAULT et W. C. ARENSBERG.

Cover for *Bulletin D* (Cologne)

BULLETIN D

the story. It is interrupted by strange interludes of pursuit which exploit the ability of the camera, to overcame gravity, to use space and time completely freed from natural laws. The impossible becomes reality and reality, as we know, is only one of the possible forms of the universe.

To accept the paradox that the genuine and sincere can walk hand in hand, foot to foot, foot in mouth, and hand to foot with the spoofy, nonsensical, that is what makes the understanding of dada difficult.

But just there new avenues are opening, and the chase after the self-freed independent bowlerhats, flying through the landscape, becomes symbolic: the rebellion of the objects against their daily routine in a too-well regulated world. (The social critics discovered in it a satire against the Nazis.) The psychoanalysts found it a story of the libido on a weekend spree.

The spirit of dada, whatever it is called, is bitterly needed today. Is needed to brace us against the fatal world we presume to understand when we blow it to pieces; is needed against the topheavy symbolists who know the numbers of all the missing pieces in their subconscious attic; against the impotent Eliot-frame-of mind imitators; against the new mystics and the older nonmystics; against the serious concrete-blockbuilders and against the busy cloud magicians; against the world planners and the plumbers, the cheaters and the humorless in art, in film-art, in everything.

Invitation to the Salon Dada, Paris, 1922

Dada soulève tout (Paris 1921)

PROCLAMATION

sans prétention

DADA 1919

L'art s'endort pour la naissance du monde nouveau. "Art" — mot cacadou — remplacé par DADA

Plésiausaure

ou mouchoir. Le talent qu'on peut apprendre fait du poète un droguiste.

Aujourd'hui la critique balance ne lance plus des ressemblances. Hypertrophiques peintres hyperesthésiés et hypnotysés par les hyacints des muezzins d'apparence hypocrite,

consolidez la recolte des calculations exactes.

Hypodrome des garanties immortelles:

Il n'y a aucune importance il n'y a pas de transparence ni d'apparence.

Musiciens cassez vos instruments aveugles sur la scène.

En ce moment je hais l'homme qui chuchote avant l'entr'acte — eau de cologne — théâtre aigre. Le vent allègre. Si chacun dit le contraire c'est qu'il a raison.
La seringue n'est que pour mon entendement. J'écris parce que c'est naturel comme je pisse comme je suis malade. Cela n'a pas d'importance que pour moi et relativement.

L'art a besoin d'une opération.

L'art est une prétention chauffée à la timidité du bassin urinaire. L'hystérie née dans l'atelier

Nous cherchons la force droite

PURE SOBRE UNIQUE

nous ne cherchons RIEN nous affirmons la VITALITE de chaque INSTANT l'anti-philosophie des acrobaties spontanées. Préparez l'action du geyser de notre sang — formation sous-marine d'avions transchromatiques, métaux cellulaires et chiffrés dans le saut des images

au-dessus des règlements du "BEAU" et de son contrôle.

Ce n'est pas pour les avortons qui adorent encore leur nombril

TRISTAN TZARA.

Tristan Tzara: Proclamation Dada, 1919, from *Die Schammade* (Cologne 1920)

Page of advertisements from *Die Schammade* (Cologne 1920)

Page from *La Pomme de Pins* (St. Raphael 1922)

Page from *Die Schammade* (Cologne 1920)

Tout ce q'il y a de mystérieux

le combat de Coqs de Jérôme
une rupture de bans suivie de prospectus
sable noir
moulur de paradis
inspection solaire puis fraicheur réelle
je songe à l'été dans le dortoir
on m'a dit Qu'avez-vouz à la place du cœur

André Breton

5 Moyens pénurie DADA

Vous déchirez une feuille de papier, de préférence la page 35 — 36 — de poésie Ronron: vous l'allumez.

tous les livres DADA sont bien imprimés cela doit tenir aux procédés DADA, qui existent.

La rue pavée de becs de gaz, les corridors à coulisse fournissent DADA

DADA, au dernier moment, depuis longtemps pour d'autres n'a ni fournisseurs ni procédés

mais on en fait courir le bruit activement, les instruments de chirurgie étant catalogués.

Paul Eluard

Vous pouvez vaincre en trois jours l'habitude de manger de la poésie, prolonger votre vie et améliorer votre santé.
Plus de troubles d'estomac, plus de mauvaise haleine, plus de faiblesse de cœur. Recouvrez votre vigueur, calmez vos nerfs, éclaircissez votre vue et développez votre force mentale. Que vous mangerez des poèmes en proses ou des poèmes en vers ou bien que vous vous intoxiquiez avec les dissertations philosophiques plus redoutables que la peste, demandez mon livre si intéressant pour tous les malades et vous êtes tous malades. Si, si, croyez moi mettez votre urine dans un verre et vous verrez.

Louis Aragon

else lasker-schüler legte am 12. febr. 1920 däubler folgenden grabstein
in die nabelhöhle: vous qui passez priez pour cette dame qui en petant
par le cul rendit l'âme. der nabelmund däublers antwortete: ein reh? —
dein weh: — du hund.

 der plampe Roßläuscher.

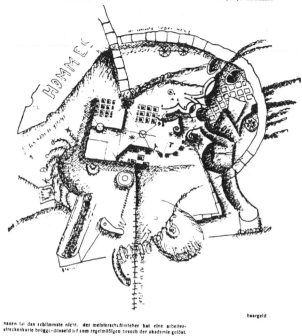

baargeld

naden ist das schlimmste nicht. der meisterschaftsfischer hat eine arbeiter-
streckenkarte brügge-düsseldorf zum regelmäßigen besuch der akademie gelöst.

Johannes Baargeld: Drawing from *Die Schammade*
(Cologne 1920)

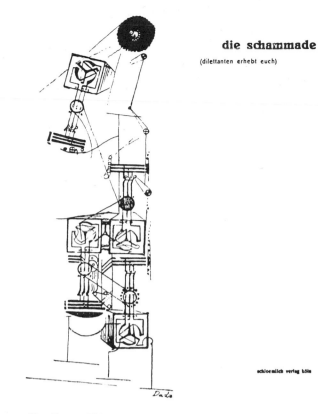

die schammade

(dilettanten erhebt euch)

schloemilch verlag köln

Max Ernst: Title page from *Die Schammade* (Cologne 1920)

Paysage

Le soir on se promènera sur des routes parallèles

L'ARBRE
ETAIT
PLUS
HAUT
QUE LA
MONTAGNE

La lune
ou
tu te regardes

MAIS LA
MONTAGNE LE
 FLEUVE
ETAIT SI LARGE QUI
 COULE
QU'ELLE DEPASSAIT NE
 PORTE
LES EXTREMITES PAS
 DE
DE LA TERRE POISSONS

ATTENTION A NE PAS
JOUER SUR L'HERBE
FRANCHEMENT PEINTE

Une chanson conduit les brebis vers l'étable

Vincente HUIDOBRO

Hans Kreitler

THE PSYCHOLOGY OF DADAISM

When Hugo Ball and his friends — the circle of artists around the "Cabaret Voltaire" then about to be founded — were looking for a name to give to their artistic endeavours, all their aims were still far too hazy, far too much in the initial stage to be closely analysed by those sharing them. It would, moreover, have run counter to their general attitude to give a theoretical foundation to what they were doing. They did not believe in the value of human thinking. "Intellectual criticism had to fall. Neither tradition nor laws of any kind were to be valid." They complained that "art had become reasonable" and wanted to break at last the dominance of this inadequate rationalism. In this they unconsciously followed the trend of the time against which they thought they were protesting; they were its victims no less than the soldiers of the first world war.

True, the statesmen of the belligerent nations made programmatic speeches which seemed sensible, inasmuch as the commonly accepted rules of grammar and syntax were observed; but the direct outcome of those speeches was a holocaust which, viewed from the trenches, looked quite different from the neat ordinance maps that struck you as being slightly cubistic: The screaming of an assaulting platoon, the desperate cruelty with which the soldier, blindly pressing on and intoxicated with fear and lust for blood, stuck his bayonet into his unknown foe's belly — these no longer sported the already rather threadbare mantle of reason with which the generals tried to envelop the madness. And now if we try to visualize the bloody scene in front of Verdun while at the same time the sonorous verses of a "noble" patriotic war-song were being recited, we shall have a simultaneity, an entirely warranted and sensible juxtaposition of two concepts linked by time and cause, a picture of the times with no less chaotic and abrupt an effect than the performances at the Cabaret Voltaire. Not for nothing did the cabaret come into being in Zurich, a town close to events yet untouched by the war. The unreasonableness of the Cabaret Voltaire was the unreasonableness of the period.

But what, to the artists and their audiences, appeared as a mere reflection of the day's events, shows to the psychologist that hidden forces were at work. The dadaists believed in all seriousness that only by their methods they could get closer to visible reality. Huelsenbeck wrote about their new material: "The sand pasted on, the pieces of wood, the wisps of hair lend it the same degree of reality as that possessed by an idol of a moloch, into whose red-hot arms infant victims were placed". W. Wolfradt said of George Grosz that "he held up a cruel mirror to the impudent times". Grosz himself, moreover, thought that "we simply scoffed at everything, nothing was sacred to us, we spat on everything and that was dada ... our symbol was the void". Still, he and other dadaists with him had some premonitions of other forces at work, the forces of the subconscious. "The essential thing was to work in profound darkness, so to speak; we did not know what we were doing".

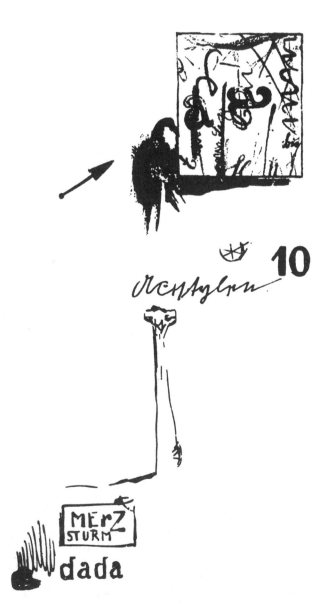

Kurt Schwitters: Lithograph from *Die Kathedrale* (1920)

The profound darkness was the darkness which reigns wherever primitive urges are given free scope to unfold. As early as 1917, Freud observed that the unforeseen cruelty of the soldiers in the trenches, which was so disappointing to every worshipper of progress, was only possible because the primitive man in us had not yet been entirely subdued. Blind xenophobia and unthinking destruction of the enemy are attitudes of the primordial man. A retrogression of the nations, a development back to the childhood of mankind was brought about by the war. Individuals, however, are capable of this retrogression, because in their own childhood they have, in a rudimentary fashion, gone through the various phases of the common cultural progress. They relapse — though only partially — into that age, in which the monitory voice of conscience and the regulating power of reason neither guided nor restrained their urges, into the period of the first four years of their lives.

It was no accident, then, but a symptom of the retrogression that, like children, the artists of the Cabaret Voltaire left the choice of a name to chance or a spontaneous arbitrariness, instead of seriously thinking of a suitable name for their movement. They simply took a dictionary and turned over the leaves. "But there is far less freedom and wilfulness in the life of the soul, than we are inclined to suppose..." Of the thousands of words in the dictionary, they chose "DADA", a word from the language of childhood. Riffling through a dictionary approximately corresponds with the system of free associations used in psychoanalytic therapy. Thus the result was characteristic of the psychological dynamism of those taking part; but beyond that it was symptomatic of the trend of urges in those days. Unless the word "DADA" had not corresponded with a common need of the times it would not have acquired its enormous popularity.

Names like pointillism, expressionism, or cubism, were as a rule only used when the particular school of art was being spoken of. DADA, on the other hand, became a slogan that for several years tripped one up everywhere. "For many years there has been no word in Europe, no idea, no political catchword, no sect, of which it could be said that it had irrupted with such catastrophic vehemence into the imagination of a civilised society" (Hugo Ball). Most of those who used it knew nothing of the trend in art which was designated by it. For them it was the name for a crazy sign of the times, at once attractive and repellent, like everything primitive; a tendency of which everyone had his own notion.

But only a few years later the psychological element of dadaism was already quite clear to Hugo Ball who had by then become an apostate and was judging more critically. He employed expressions like "procreative hankering after the perambulator", or expatiated on "a sect of gnostics whose adepts were so stirred by the picture of the childhood of Christ, that they lay down, squalling, in a cradle and let themselves be suckled and swaddled by women. The dadaists are similar babies of modern times". And of the effect of dadaist performances on their audiences he said "... they struck a chord in the primordially playful, but submerged being of the listener".

UNE BONNE NOUVELLE

CHER AMI,
VOUS ÊTES INVITÉ AU VERNISSAGE
DE L'EXPOSITION MAN RAY (CHARMANT
GARÇON) QUI AURA LIEU LE 3 DÉCEMBRE
1921 DE 2 H. 1/2 à 7 H. 1/2
A LA LIBRAIRIE SIX
6, AVENUE LOWENDALL - PARIS VII°
SOUS LA PRÉSIDENCE
DU MOUVEMENT DADA

ni fleurs
ni couronnes
ni parapluies
ni sacrements
ni cathédrales
ni tapis
ni paravents
ni système métrique
ni espagnols
ni calendrier
ni rose
ni bar
ni incendie
ni bonbons

N'OUBLIEZ PAS

Invitation card for the Dada exhibition of Man Ray, Paris, 1921

Johannes Baargeld: Beetles, 1920

WATCH YOUR STEP!

25c

Page from *New York Dada* (New York 1921)

Francis Picabia: Cover for *Le Coeur à barbe* (Paris 1922)

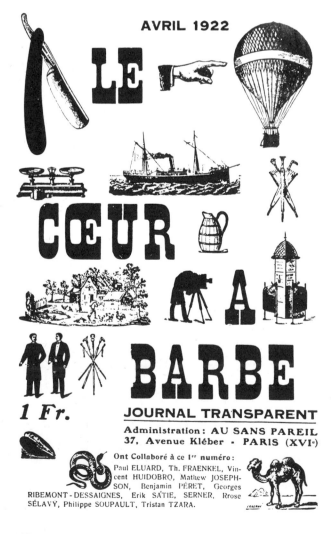

AVRIL 1922

LE CŒUR A BARBE

1 Fr.

JOURNAL TRANSPARENT

Administration: AU SANS PAREIL
37, Avenue Kléber · PARIS (XVI·)

Ont Collaboré à ce 1·· numéro:
Paul ELUARD, Th. FRAENKEL, Vincent HUIDOBRO, Mathew JOSEPHSON, Benjamin PÉRET, Georges
RIBEMONT - DESSAIGNES, Erik SATIE, SERNER, Rrose
SÉLAVY, Philippe SOUPAULT, Tristan TZARA.

What was the reason for this reversion to primitive times and to childhood, in the trenches on the one hand, and in centres of culture such as Zurich and Berlin, on the other? Psychiatry, which must constantly deal with regressions, has come to the conclusion — since Freud and Bleuler, who was inspired by Freud — that they are likely to happen when a person suffers a number of severe disappointments and cannot make his peace with external reality. To guard against further disappointments he makes use of existing fixations and reverts to an age in which he thinks he was happier. For the desperate, regression is, therefore, a protest directed at the outer world, and an inward self-defence; what seems to be gained in pleasure is a primitive gratification of the urges unrestrained by the reason and conscience of the adult.

The tendencies of dadaism correspond largely with this psychological dynamism, with the qualification that the essentially social difficulties of the epoch replace the spiritual difficulties of the individual. Those taking part were fully aware of their protest against their time. "Every word that is sung here or spoken, at the very least proclaims that this humiliating period has not succeeded in gaining our respect" (Hugo Ball). But the dadaists themselves already felt the spiritual protection that the protest afforded. They interpreted it quite correctly: "To carry simplemindedness and childishness to excess is, after all, still the best defence" (Hugo Ball), a defence which is needed to protect oneself from a state of reason that leads to complete despair. The irrational chaos in the pictures and poems of the dadaists was not only a reflection of that despair, it also constituted the first step towards overcoming it. "A visionary advent had come over us ... Poisons were to break through the sterility of life ... From where should calm and simplicity come, if no undermining, no clearance, and no spring-cleaning of the warped base preceded it?" (Hugo Ball)

A child breaking a toy does not merely destroy; it also perceives something and with this perception it is later enabled to reconstruct. The dadaists' process was similar. While noting this positive side of dissolution and destruction, the pleasure engendered by the act of destruction itself must not be overlooked; this pleasure is occasionally met with in the excesses of the sane, and often enough in children and the insane. It is an infantile lust backed by dark memories of the primordial times of unristricted freedom, with no inhibitions of the natural urges.

In this direction, too, Ball has penetrated deeply into the mental processes. As an artist he has adduced comparisons which, had they been made by a psychologist, would have been denounced as "psychologizing", as an affront to art and to artists. He wrote: "The childlike ways in question border on the infantile, on dementia, on paranoia. They derive from a belief in some arch-memory, from a world that has been displaced and submerged until it is no longer recognisable; in the arts this world is liberated by unfettered enthusiasm, in the lunatic asylum by disease". The comparison with children and lunatics is cogent and suitable, especially if one does not forget — as another observer of the

times remarked quite correctly — that the material difference between artists on the one hand, and children and lunatics on the other is, "that artists are aware of the difference between the world of fancy and that of reality; but children and lunatics often are unable to make this distinction". The dadaists knew that they were infantile. Thus they remained above what they were doing, had strength und reason to control it and to break it off; they must not be put in the same category as maniacs, no matter how brilliant they might be. All the comparison does, is to illustrate the psychological interplay of forces.

The schizophrenic splits himself, and often his world, in order to escape the voices of his over-severe conscience. This partition, which has its origin in escape, also enables him to give free rein to his emotions. Thus he is severe and wild at one and the same time, both inhibited and unrestrained, always displaying two faces. This too is one of the most obvious distinguishing marks of dadaist production, where we find obscene or senseless words in formally correct verses and rhymes; sober, austere geometrical patterns wildly mixed up in primeval chaos. Austerity and emotions — we find them overt or concealed in all the works of the dadaist circle. We would point out, merely as a remark by the way, that the fragmentation, the emotional significance of which we have just hinted at, would, without psychic dyna-

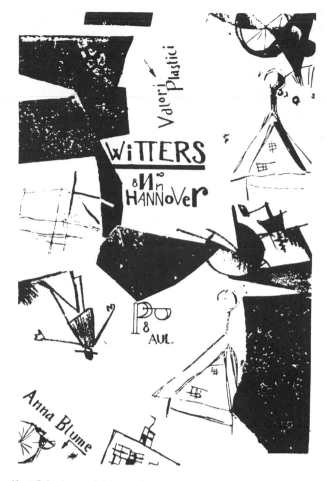

Kurt Schwitters: Lithograph from *Die Kathedrale* (1920)

Kurt Schwitters: Cover, 1920

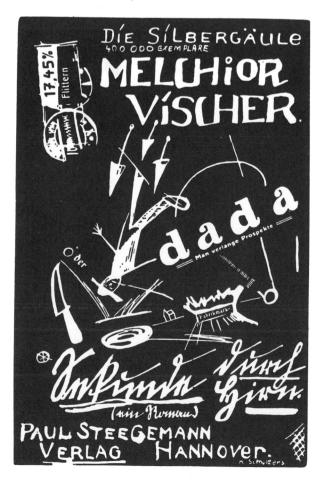

Marcel Duchamp: Cover for *The Blind Man* (New York 1917)

DER STURM

MONATSSCHRIFT / HERAUSGEBER: HERWARTH WALDEN

DREIZEHNTER JAHRGANG / DRITTES HEFT

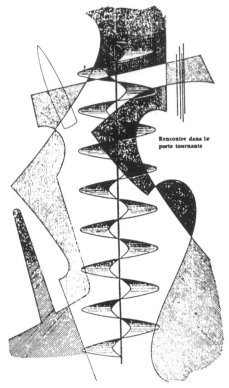

Rencontre dans la
porte tournante

Man Ray: Drawing for the cover of *Der Sturm*, no. 3
(La Vrai Jeune France) (Berlin 1922)

mism, be characteristic of a certain stage in the development of the child, namely the one in which it has not yet grasped the real connections between things, but in looking for such an order, arrays objects with what seems to be arbitrariness — just like some dadaist "sculpture". The next stage in the child's development is that of games of illusion, when fancies and wishful dreams originating in the natural urges rule everything. Bearing in mind this sequence, the fact that surrealism immediately followed dadaism may be regarded as inevitable. Since the childhood and the schooldays of all dadaists occurred in an era which saw a climax of prudishness and mendacious repression of urges such as has not yet been surpassed in the history of mankind, and considering further that these same children with their severe upbringing became adults at a time when all the powers until then predominant were tumbling about their ears, the double-facedness would appear to be sufficiently motivated, both from a psychological and a sociological point of view. Arbitrariness and chaos were meant to enable them to do justice to the demands of their urges as well as to the demands of their strict upbringing. Psychoanalytically speaking, the demands of the super-ego found their satisfaction in the strict upbringing, a fact that was recognised by men like Huelsenbeck, who spoke of an "identification with the various bourgeois moralists". The condensation noticeable in the thought and speech of schizophrenics, and the absolutely unintelligible concatenations of words — both derive from the same tendency: they are the outcome of two incompatible demands to which justice is done at one and the same time. Winkler rightly points out that this kind of accumulation recalls the montages of Max Ernst.

No matter how close the resemblance between morbid symptoms and works of art may be at times, there is a decisive difference in their formation and their social purpose. The lunatic cannot control his symptoms, he produces them involuntarily without considering their effect on his surroundings; they only serve the conflict from which they are engendered. The artist, on the other hand, labours at his work, forms it, and wants it to be effective, even if he is not addressing a clearly defined public at any given moment. It may happen that symptoms and works of art contain the same pregnant symbols derived from times primeval, but only in the work of art are the symbols effective. Here they are substantially free from the slag of the creative process and have become part of that alternation of dissonance and harmony, of tension and relaxation that is the essence and basic law of all art.

The dadaists began their career with a vociferous protest against all laws, and thus it came about that they, if only on the concious level, offended against the law of tension and adequate relaxation and negated, or thought they negated, its multifarious rules. A necessary consequence of this was that only a very few of their products achieved any artistic effect — and in these exceptional works the synthesis of tension and relaxation can invariably be demonstrated. The masseffect of dadaism lay not in its artistic output but, as we hinted above, in the movement's psychological background.

It found adequate expression in the very name DADA, that significant symbol of infantile retrogression with its rich psychological implications.

The protest against all laws — whether outmoded or indispensable — was, in itself, a childish enterprise and it brought dadaist production uncomfortably close to the way the insane develop their symptoms. This, as Sedlmayr hints, is a development already foreseen by Dostojevsky, who made a character in one of his novels say: "And if they claim . . . that the mere possibility of precalculation can arrest everything in its course and that there is no escape from reason, then a man may intentionally become demented in order to be rid of reason and yet insist on his own will".

It is this very proximity of dadaist art and insanity that makes it necessary to emphasize that proximity and similarity do not imply identity. Even the craziest productions of dadaist art have a social justification, for they reflect a period of crisis no less crazy. But they also represent human values by giving expression to the eternal conflict of urge and conscience, of "want" and "must".

Because of the stratification of human personality and the complicated structure of human society, every action, even the most humdrum — and how much more so a historical or artistic movement — has manifold

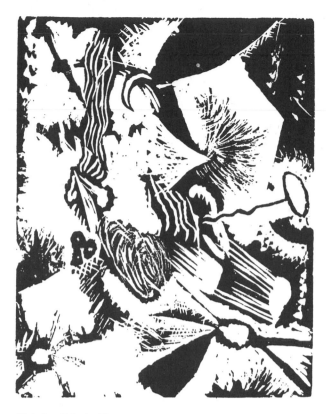

Christian Schad: Woodcut, 1919

Hans Schwitters: Woodcut, 1919

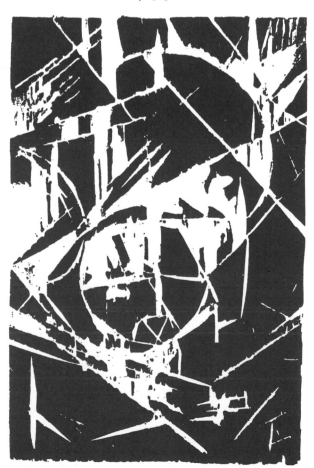

Marcel Janco: Cover for *Der Komet* (1919)

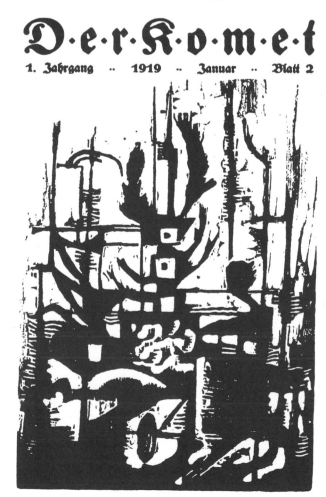

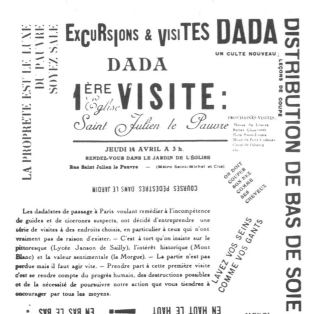

Invitation for Dada excursions, Paris, 1920

psychological and sociological motives. To enlarge on every single psychological factor that was instrumental in creating dadaism would fill volumes. A brief exposition, necessitating the selection of but a few important motives can only give a biased point of view. Bearing in mind this limitation, forced upon us by brevity, we may sum up by saying that mankind's permanent readiness to escape from crises and decisions by withdrawing back into childhood, made dadaism possible as a reaction to the events of the first world war. Retrogression into a period of slackened attachments, when rational control was absent, created the opportunity for letting loose long suppressed primitive desires. The demands of a conscience that had been based on the exigencies of school and home were swept aside. No need for any new synthesis was felt, this, moreover, would merely have imposed more renunciations. But the adult world, with its overpowering demand for practicality exacts compromises and renunciations. The child, therefore, cannot remain a child and dadaism, germs of which can be shown to exist in many epochs as occasional attempts, had to cease to exist as a tendency in art even before it could find a unifying style.

Programme for the Festival Dada, Paris, 1920

Cover for *Le Pagine* (Naples 1917)

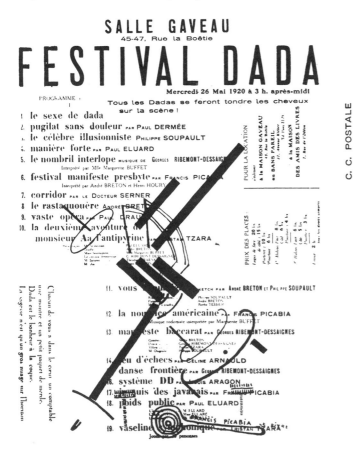

LE PAGINE

RIVISTA MENSILE

ANNO II 15 aprile 1917 N. 8

NAPOLI - Vomero, Parco Antonina, Villa Giovene - NAPOLI

Ripresa: Maria d'Arezzo - *Apparizione; Semplicità:* Titta Rosa - *Incisione:* Marcel Janco - *Gioielleria notturna; La cartapesta s'infiamma:* Nicola Moscardelli - *Correnti:* Ugo Tommei - *Arcobaleno; Tre cose:* Maria d'Arezzo - *Serraglio:* Nicola Moscardelli.

RIPRESA

Oh, lo so lo so — ci si rifà ci si ripiglia ci si crea un' anima nuova, sempre. Che spavento e che freddo ieri e ier l'altro ancora, ricordi? — e stamani è uno scoppio di vitalità divinamente senza ragione — è così bella la vita ed io sono guarita guarita — e le punture sottili del mio male che m'erano ieri un terrore, stamani — oh, stamani me ne son tanti brividetti di voluttà, un po' trepida un po' implorante (lasciami vivere, fammi questo piacere) ma ardita e fiduciosa, anche (io devo vivere, *devo*).

Tanti giorni che non m'era piovuta sul capo la grazia del sole? tanti giorni che non avevo ritmato il mio passo sulla solida terra paziente? Son viva son viva — che gioia! Il gesto della mano che levo ad accarezzar l'aria non hà la significazione simbolica d'un rito? Se mi volgo indietro non vedrò — son sicura — la mia ombra allungarsi sulla strada scabra di ciottoli lucenti — ma il sole mi permea tra

Rudolf Klein and Kurt Blaukopf

DADA AND MUSIC

Letterhead for the Mouvement Dada, Paris, 1920

MoUvEmEnT

DADA

BERLIN GENÉVE MADRID NEW YORK ZURICH

PARIS.

CONSULTATIONS : 10 frs

Libraire de Sourières
6 RIBEMONT-DESSAIGNES
18 Rue Fourcroy, Paris 17e

DADA
Directeur TRISTAN TZARA

D,O'H'
Directeur
G RIBEMONT DESSAIGNES

LITTÉRATURE
Directeurs
LOUIS ARAGON,ANDRE BRETON
PHILIPPE SOUPAULT

M'AMENEZ'Y
Directeur CÉLINE ARNAUD

PROVERBE
Directeur PAUL ELUARD

391
Directeur FRANCIS PICABIA

'Z'
Directeur PAUL DERMÉE

Dépositaire
de toutes les Revues Dada
à Paris Au SANS PAREIL
37 Av Kléber Tél PASSY 25 7.

In music dadaism did not play anything like the part it did in literature or the fine arts. One reason for this may have been, that among the initiators and propagators of the movement, there was not one single musician of note. On the other hand, of course, dadaists must have been aware of the fact that the work of distruction, the revolt against fossils and shopworn goods was nothing new in music. Whatever they put their hands to in music all they could do was to continue what others had started before them.

There were certain contacts even in the early beginnings of the dada movement as a cabaret. Hugo Ball, himself a pianist, was faced with the necessity of providing the guests of the Cabaret Voltaire with musical fare as well. In the first stages of the cabaret there was nothing provocative about the works performed, and the programme was made up of such items as French chansons, Reger's "Humoresques" (op. 20), a Rhapsody by Liszt, piano pieces by Debussy and Rachmaninoff.

In addition there congregated at the cabaret — its principle, proclaimed by a notice in the press, was to provide "musical performances and recitations of such guests as were artists" — Russians and Serbs, who contributed folk music and songs and even founded a balalaika-band.

As soon as the dada gallery was opened, this activity, social rather than artistic, came to an end. Music branded as late romanticism was banned and a different type, either very, very ancient or very, very new, was patronised. Of the first, there was, for instance, Jacapone da Todi (13th Cent.), while Arnold Schönberg, whose works were performed by Mme. Perottet, represented, among others, the most recent trends in music. Young Swiss musicians, too, had an opportunity of making their works heard at the gallery's soirées. The names of Samuel H. Sulzberger and, foremost among all, Hans Heusser, have been mentioned in this connection, the latter actually becoming resident composer of the gallery. The titles of his piano pieces, which he himself played, even to the extent of once having an entire soirée to himself, were still tainted with the spirit of "characteristic" pieces, such as "Mond über Wasser", "burlesques turques", "Festzug auf Capri", "cortège exotique", etc. Music acquired a more particular interest for the dadaists only when it came to be the handmaiden, as it were, of other kinds of art. It was in these functions that it could do without what normally was a material element of its constitution, namely fixed pitch. When this was waived, that is to say when musical sounds were done away with, only noise remained in rhythmic formation. And it was noise and rhythm that formed the basis on which Ball and his friends founded the incidental music to their "chants nègres".

Hugo Ball recognised quite clearly the deeper cause of the tendency towards the primitive: "It may be imperative to strive with all one's might for chaos and the ruthless extirpation of faith before a thorough reconstruction can be made on a changed basic faith. Elementary, demonic things thus come to the fore, ancient names and words fall." Thence, it seems, the predilection for everything primitive, African. "chant nègre" no. 1 was performed to the accompaniment of little side drums "like a vehmic court". "The melody to 'chant nègre'

no. 2 was supplied by our esteemed host, Mr. Jan Ephraim" — in another context he was called "our worthy grill-room superintendent and hostel-father" — "who long ago spent some time in African parts, and who, in his rôle of instructive and enlivening prima donna, exerted his best endeavours for the benefit of the performance." The cult of the primitive in that circle was not, it is seen, without a certain ethnological backing of some significance.

The renunciation of a fixed pitch had necessarily to result in a closer relation to the spoken word and to literature, on condition that the latter on their part renounced any mental content and only kept the sound-shape, the sonority. On this basis Ball arrived at the "sound-poem", a sequence of syllables devoid of sense or content, freed from any symbolic meanings, nothing but audible material. This, approximately, is what such a sound-poem was like:

> gadji beri bimba
> glandridi lauli loni cadori
> gadjama bim beri glassala
> glandridi glassala tuffm i simbrabim
> blassa galassasa tuffm i simbrabim

Again it was Hugo Ball who demonstrated with great clarity the close relationship between such lyrics and music, writing this of a recitation of the sound-poem entitled "Elephants Caravan": "The heavy rows of vowels and the dragging rhythm of the elephants had only just afforded me a last climax. But how was I to bring it to a conclusion? It was then that I noticed that my voice, left with no other alternative, had slipped into the age-old cadence of priests' lamentations, the style of chant that is still wailing in the catholic churches of both orient and occident. I do not know what inspired me to this music. Anyhow, I began to chant my series of vowels in the manner of a recitative church-style, and I tried not merely to remain serious, but to impose seriousness on others."

Eugen Egger, in his monograph on Hugo Ball, has pointed to the remarkable parallel existing between these semi-musical sound-poems and the type of vocalisation used in jazz known as "scat" or "bopvocals". These are meaningless syllables substituted by the jazz vocalist for song texts. The practice dates back to the twenties, and Louis Armstrong was probably among the first to introduce it. No proof, however, can be adduced of a connection between these two phenomena.

A certain remote connection can also be seen through the two elements of improvisation and dance common to both factors now being discussed. Both, improvisation and dance were derived by Hugo Ball from the optical impression brought about by masks of Janco's creation

Programme for the Soirée Hans Heusser, Zurich, 1917

(see Dada Dictionary): "The mask not only demanded a costume, it also dictated well-defined pathetic gestures that often came close to madness ... the masks quite simply demanded that their wearers assume the movements of some tragically absurd dance ... we evolved from them a number of dances for which I invented short pieces of music on the spur of the moment. One of these dances we called 'Fly-Catching'. Only clumsy, tentative steps and a few hastily lunging, snatching poses would fit this nervous, shrill music."
It should be noted in passing that abstract or expressionist dances appeared quite frequently on the programmes. Their accompaniment usually consisted of drums or gongs. The figures were as a rule designed by Sophie Tacuber. Dance as practised by the dadaists as well as its particular kind of incidental music has probably exerted some influence on Rudolf von Laban and Mary Wigman, who are both mentioned as having been among the visitors of the Cabaret Voltaire.

There was but the merest step from the sound poem to "bruitisme" (see Dada Dictionary), the noise music, originated by Marinetti and Russolo a few years previously. Huelsenbeck was expressly acknowledging these antecedents when he wrote: "From Marinetti we take over bruitism, 'le concert bruitiste ... le bruit', noise, it seems, was intended at the beginning only as a forcible reference to colourful life itself ... It is clear that every movement produces noise. Whilst the number — and with it the melody too — is a symbol and thus presupposes the power of abstraction, noise is the direct pointer to action. Music, whichever way you look at it, is a matter of harmony, an art, an activity of reason — bruitism is life itself on which no judgment can be passed. Wagner has demonstrated the utter mendacity of a pathetic power of abstraction — the noise made by a brake could at least induce a toothache. The same tendency that, in the United States, made a national music out of tap dances and rag-time, was, belatedly in Europe, cramp and tendency towards 'bruit' ..."
The important point in this evaluation, apart from another reference to jazz, is above all the fact that Huelsenbeck drew attention to the essential incompatibility of the conceptions of music and dada, and that he made it clear why it was, of all things, "bruitisme" that was the only "attitude to life" that could go with dadaism. Music is something "abstract", noise, on the other hand, something entirely "concrete". There can be no doubt that the Parisian, Pierre Schaeffer, the latest exponent of "bruitisme" and "inventor" of "musique concrète", takes his cue from here, even in his terminology, without, however, so much as mentioning his predecessors.

There was no skimping of noise by the dadaists around Hugo Ball. To them was ascribed "the existence of an energy superior to that of the human voice"; and the performances, above all the "poèmes simultanés", were spiced with rrr's drawn out for minutes on end, with the sound of heavy things tumbling or the howl of sirens, not to speak of drums, gongs, etc. Hugo Ball composed a complete "concert bruitiste", "a nativity play" for which he carefully selected the musical instruments, such as shawms, little bells specially attuned for the purpose, and babies' rattles. Some of the instru-

ments he made himself. This performance, executed behind a white screen, made a particularly strong impression" (Emmy Hennings-Ball).
Noises played an increasingly important — and decreasingly musical — part, especially as the Zurich performances assumed a more and more provocative character. "On the stage keys and tins were knocked together to make music until the audience, nearly driven to distraction, protested" (Georges Hugnet). In 1919 Paris made the acquaintance of Tzara and dadaism when it was already in this provocative phase: "Following the title of a poem Tzara recites a newspaper article while a hellish noise accompanies him made by bells and rattles. It goes without saying that the audience does not keep still but whistles ..." ("Littérature", January 23rd, 1920).
And yet it was in Paris that perhaps the most important contact between the dadaist spirit and music took place. This contact was made in the person of Erik Satie. Stress must be laid on the term "esprit dada", for although Satie took part in dada manifestations, a substantial influence from that direction seems ruled out, since dadaist ways of thought were found as early as 1913, seven years before, in a piece called "The Trap of Medusa" with text and music by Satie. As in many other respects, here too, Satie must be regarded as a precursor.
However, this precursorship can be proved only as far as literary and programmatic concepts are concerned. Jean Roy, in the "Revue Musicale, 1952", named Satie together with Alphonse Allais, Alfred Jarry, Léon-Paul Fargue, and the surrealist avant-garde. As early as 1912, in his "Mémoires d'un Amnésique" ("Memoirs of a Forgetful Person") he had found a style that was closely related to the dadaist climate of later years. Moreover his numerous publications, among them some that were contributed to "391" and "Paris-Journal", as well as many aphorisms in his musical works, demonstrated the complete seclusion in which a spirit was being cultivated that anticipated the dadaist atmosphere. His later collaboration with Picabia ("Relâche», 1924) did not materially add to this originality.
In pure music It seems impossible to detach the ele-

Programme

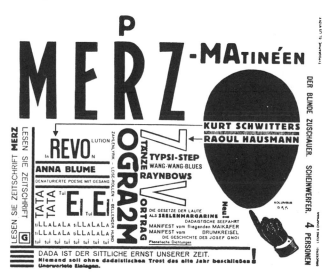

ments of style that are of a marked dada spirit. Stanislas Fumet, in "Revue Musicale, 1952", said of Satie's music that it had led French composition from the lyrical to the critical phase. The revolt against illusionism of the Debussy kind is perhaps the most important hallmark of this transition, a revolt that manifested itself musically in especially lucid construction, clear-cut contours, transparency of the musical phrase, and a certain directness of effect, without detours of deep pondering on the part of the listener about "meaning" and "profoundity". But these qualities were a sign of the times, part and parcel of the anti-romantic tendency and the resultant movement "back to the classics". In Satie's particular case this revolt used ironical and dadaist means, but this could be gauged, not so much from the music itself, but rather from the "programme", the titles and the written instructions. Thus the historic scandal caused by "Parade" in 1917 was due much more to Cocteau's text and Picasso's sets than to Satie's music, which taxed the audience more than it could bear. All the same Satie used noise instruments in his orchestra.

In two cases, however, it seems that Satie's music was imbued with "l'esprit dada", and possibly not just with one of his own devising but with that of the movement. These two cases were, first, the so-called "musique d'ameublement" for a play by Max Jacob, first performed on March 8th, 1920, and, secondly, music for the "Entre'acte" to "Relâche", on November 29th, 1924. In both the relationship to dada is the more interesting for the lasting influence they exerted on the development of film music, an influence that affected, according to Wilfred Meller ("Revue Musicale", 1952), even Hanns Eisler, Aaron Copland, Jean Wiener, and Charlie Chaplin ("Modern Times"). It may be mentioned that in that film we also find the recitation of meaningless syllables.

In the "musique d'ameublement" the dadaist spirit may be discerned inasmuch as this music renounced its function of music. It was played in an interval of the play, simultaneously, but not synchronously, by four small bands. The result was what is nowadays called a sound-coulisse, a medley of sounds that is heard not as music but merely as a background, "something like a good armchair", as Matisse put it. The experience thus gained was translated into practice in René Clair's film "Entre'acte", which was inserted into the ballet "Relâche". And whenever nowadays a film is shown in which music is not "listened to", acknowledgement is due to the ancestors of this tonal psychology, to Erik Satie and the Paris dada movement.

Did it leave its mark elsewhere? On the "Ecole d'Arceuil", perhaps, or on the group of "Les Six"? On Satie's "disciples"? But these "disciples" did not have the benefit of regular lessons from their "bon maître". What they did, however, was to carry on his critical and anti-romantic tendencies, thus materially affecting the whole aspect of modern (not only of French) music. Artists mentally akin to Satie may have taken part in one or the other of the dada manifestations, but their works show no lasting traces of this. In "Dada" No. 6 (Paris, 1920) Tristan Tzara went so far as to describe Stravinsky as a participant in dada. In the United States, too, the activities of the New York group were not without some influence on the youngest generation of composers (Carpenter, Varèse, Henry Cowell, George Antheil). "Bruitist" tendencies are found in some American composers, and as late as 1955 Varèse, who was close to the New York dada group, made his own contact with the Paris "musique concrète" through his "organised sound".

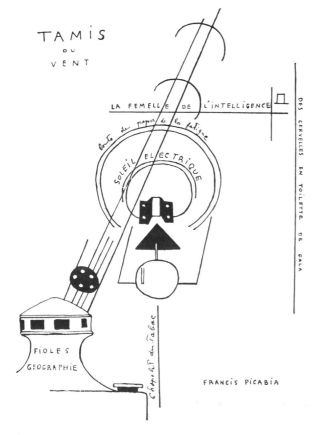

Francis Picabia: Drawing from *391*, no. 8

George Grosz: Drawing, 1917

THE PLATES

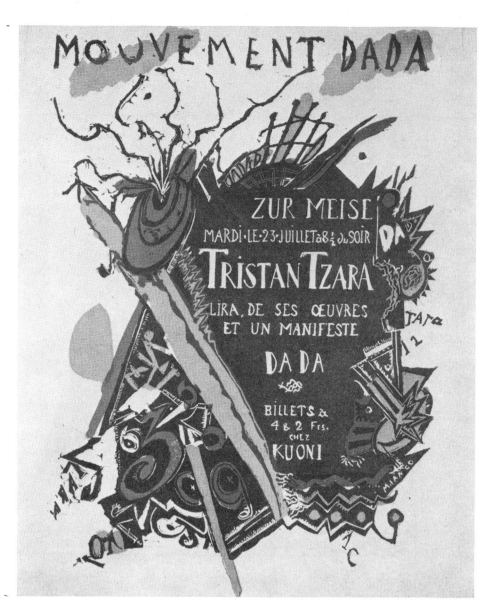

Marcel Janco: Poster for a Tristan Tzara
reading, Zurich, 1919

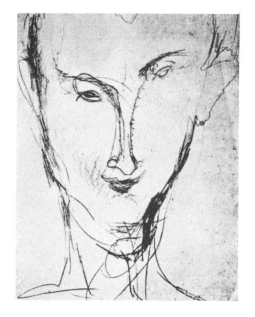

Amadeo Modigliani: Portrait of Hans Arp.
Drawing

Hans Richter: Portrait of Hans Arp.
Drawing, 1917

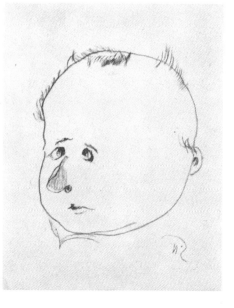

Hans Richter: Portrait of Arthur Segal.
Drawing, 1916

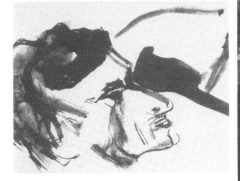

Hans Richter: Portrait of Ferdinand Hardekopf
Drawing, 1917

'Die Neue Kunst' Exhibition, Galerie Wolfsberg,
Zurich, 1916. From left: Marcel Janco,
unidentified, Hans Arp

At the lakeside, Zurich, 1916. From right:
Tristan Tzara, Marcel Janco

Emmy Hennings

Tristan Tzara

Hugo Ball

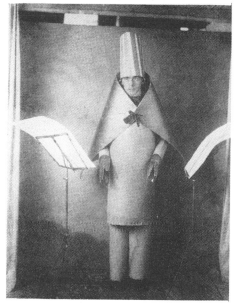

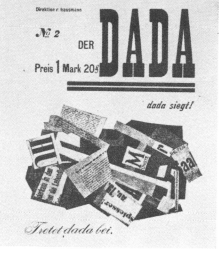

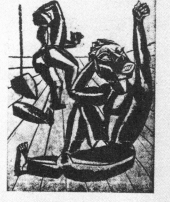

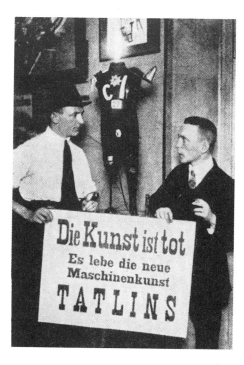

Cover for Richard Huelsenbeck, *Dada siegt* (Berlin 1920)

(above left) Hugo Ball

(above right) Cover for *Der Dada*, no. 2 (Berlin 1919)

(left) Marcel Janco: Poster for Galerie Dada, Zurich, 1917

(right) George Grosz and John Heartfield, Berlin, 1920

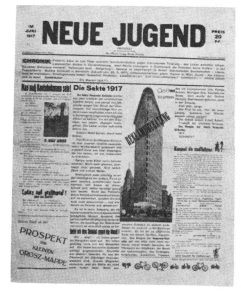

(left) Viking Eggeling

(right) Cover for *Neue Jugend* (Berlin 1917)

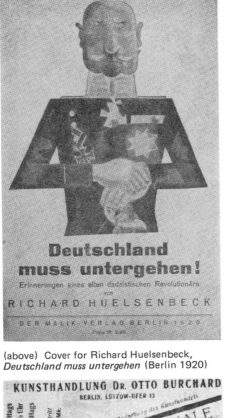

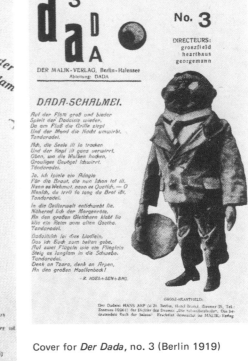

(above) Cover for Richard Huelsenbeck,
Deutschland muss untergehen (Berlin 1920)

Cover for *Der Dada*, no. 3 (Berlin 1919)

Catalogue of the First International Dada Fair,
Berlin, 1920

Page from the Catalogue of the First
International Dada Fair, Berlin, 1920

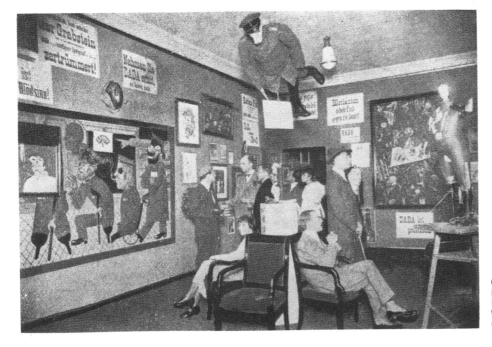

Opening of the First International Dada Fair,
Berlin, 1920. From left: Raoul Hausmann,
Hannah Höch, Dr Burchard, Johannes Baader,
Wieland Herzfelde, Mme Herzfelde, Dr Oz,
George Grosz, John Heartfield

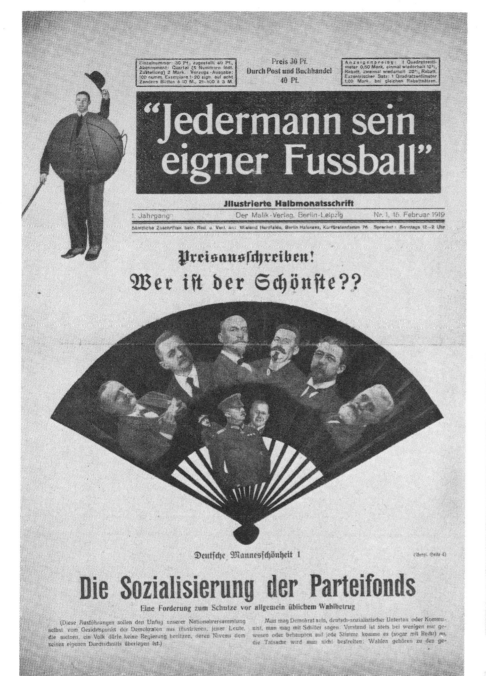

Cover for *Jedermann sein eigner Fussball*
(Berlin 1919)

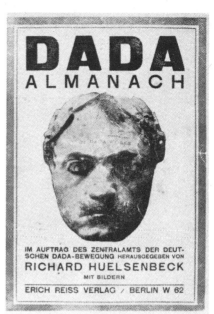

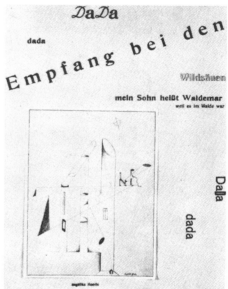

(above) Cover for *Dada Almanach* (Berlin 1920)

(middle right) Angelika Hoerle: Drawing from
Die Schammade (Cologne 1920)

(right) Francis Picabia: Oeuil rond. Drawing
from *Die Schammade* (Cologne 1920)

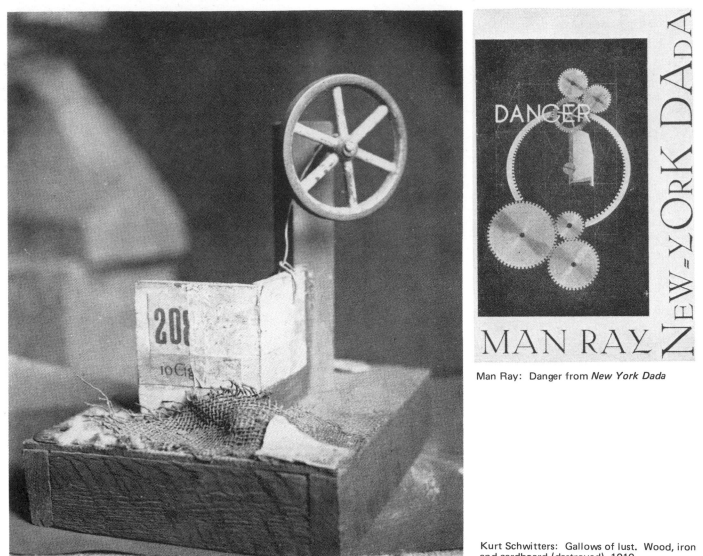

Man Ray: Danger from *New York Dada*

Kurt Schwitters: Gallows of lust. Wood, iron and cardboard (destroyed), 1919

Kurt Schwitters: Cover

Hans Richter: Portrait of Johannes Baader. Drawing, 1915

Johannes Baargeld: Antropotiler Bandwurm from *Die Schammade* (Cologne 1920)

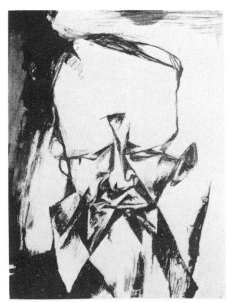

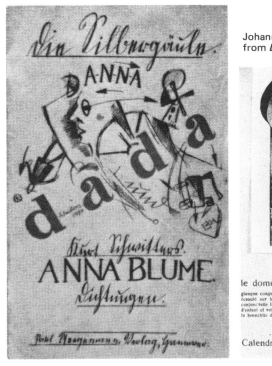

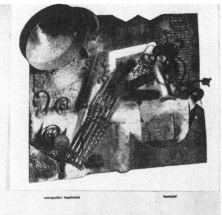

Man Ray: Photogramme

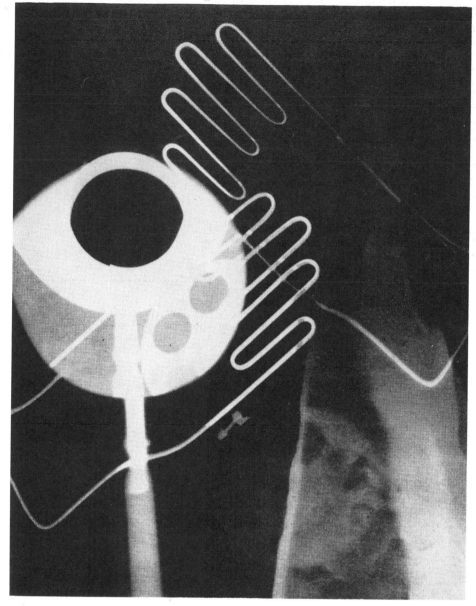

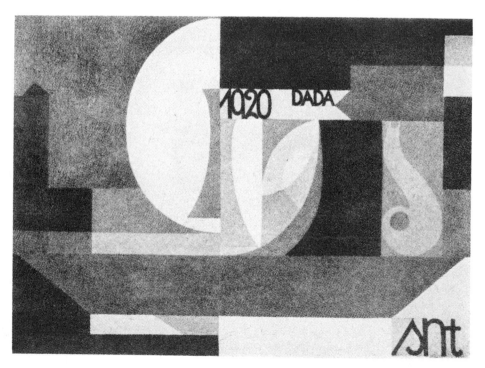

S.H. Taeuber: Dada 1920. Oil

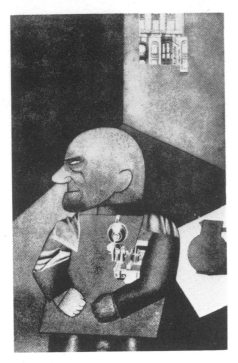

George Grosz: Der Monteur Heartfield.
Photomontage, 1920

Hannah Hoch: Von Oben. Photomontage

Hans Richter: Rhythms 1921. Film study

Man Ray: Film composition

Hans Richter: Dada-istic film study

Viking Eggeling: Diagonalsymphonie, 1920

67

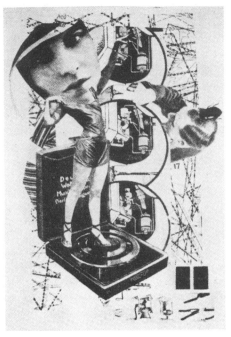

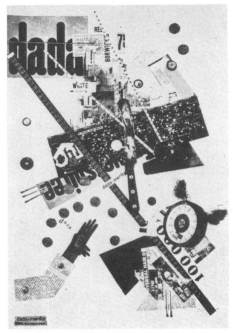

Raoul Hausmann: Photomontage, 1920 Hannah Höch: Photomontage, 1920 George Grosz and John Heartfield:
Dadamerica. Photomontage, 1920

Hans Arp: Collage, 1916

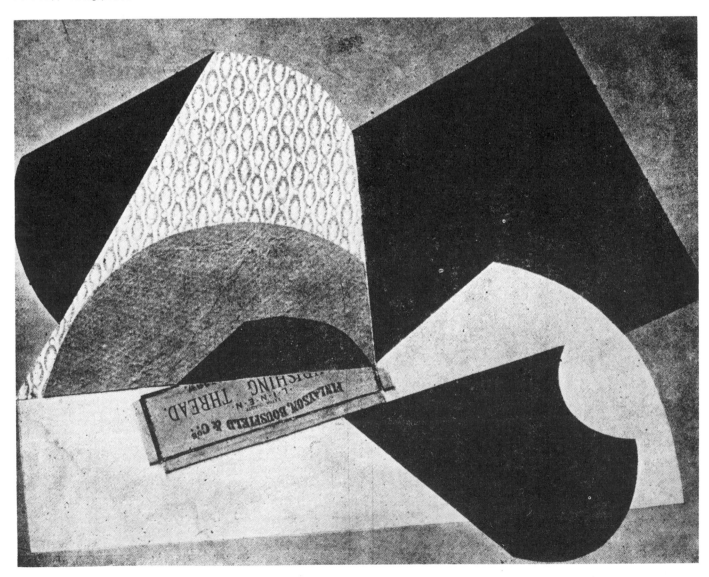

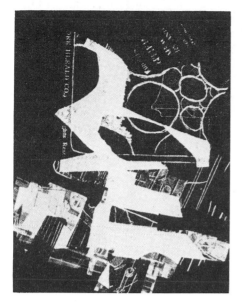

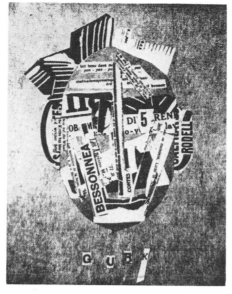

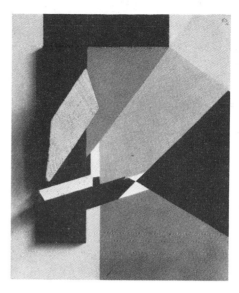

Christian Schad: Schadograph, 1918 Raoul Hausmann: Head. Collage, 1919 Kurt Schwitters: Picture with a yellow chunk

A.C. van Rees-Dutilh: Tapestry, 1915 Marcel Janco: Composition 676. Oil, 1919

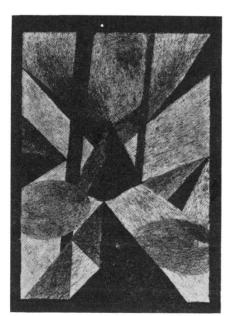

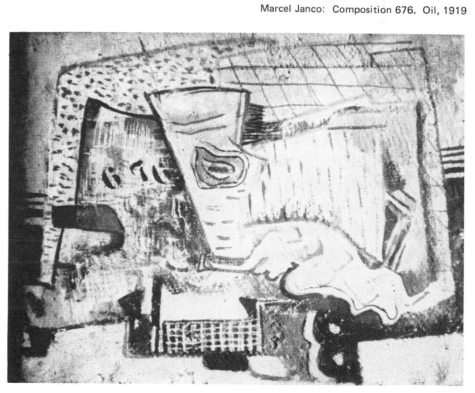

(left) Marcel Janco: Design for a room, 1916

(right) Hans Richter: Head. Oil, 1918

(below) Marcel Janco: Moment musical. Painting on glass, 1920

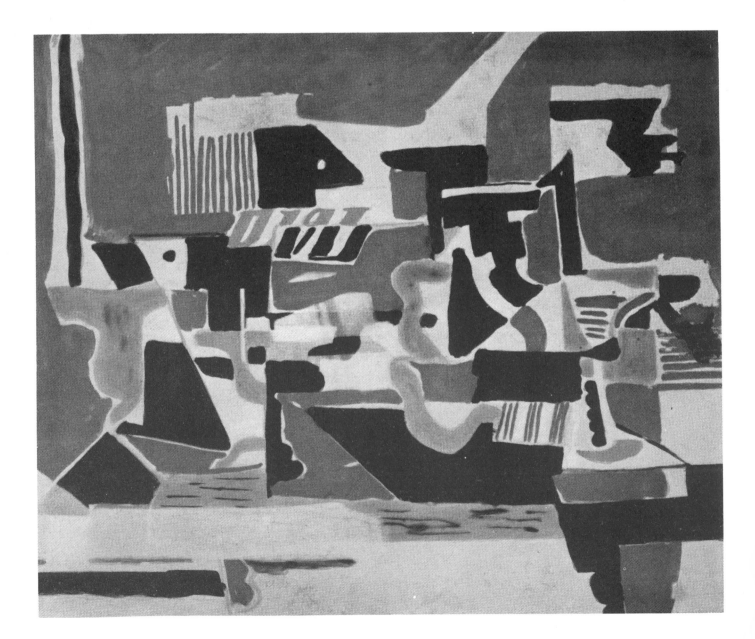

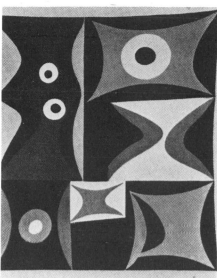

Sophie Taeuber-Arp: Formes élémentaires en composition verticale-horizontale, 1917

Hans Arp: Selon les lois du hasard, 1916

Paul Klee: Zahlenparadies. Watercolour, 1918
(Collection Marcel Janco)

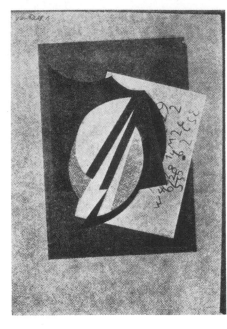

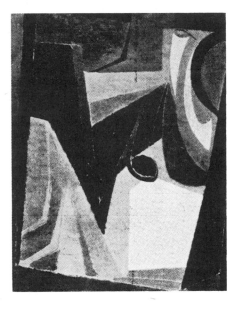

(above left) Otto van Rees: Adya. Collage, 1915

Otto van Rees: Composition, 1916

(middle left) Otto van Rees: Intérieur. Oil, 1917

Kurt Schwitters: Green spot. Collage, 1920 (Collection Eduard Neuenschwander)

Marcel Duchamp: Neuf moules malic, 1914

Marcel Janco: Les heures de nuit. Oil, 1920

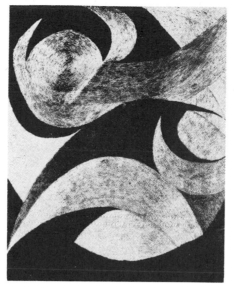

A.C. van Rees-Dutilh: Composition in silk, 1918

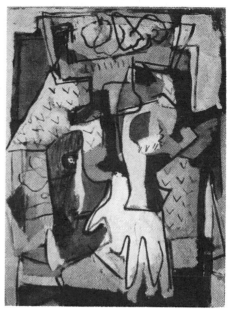

Marcel Janco: Souvenir. Oil, 1918

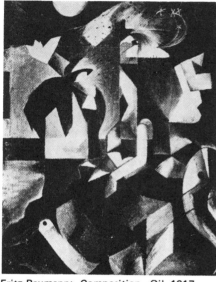

Fritz Baumann: Composition. Oil, 1917

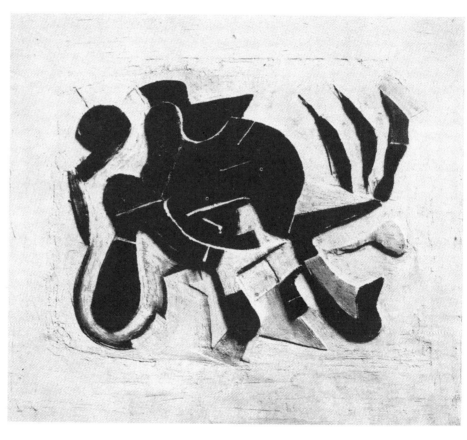

Fritz Baumann: Composition, 1917

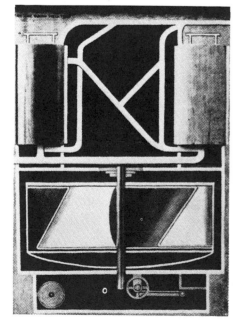

Francis Picabia: Très rare tableau sur la terre. Oil

(left) Marcel Janco: The Dance. Oil, 1916

Marcel Janco: Petite achitecture. Painted relief, 1919

(below) Marcel Janco: Construction, 1917

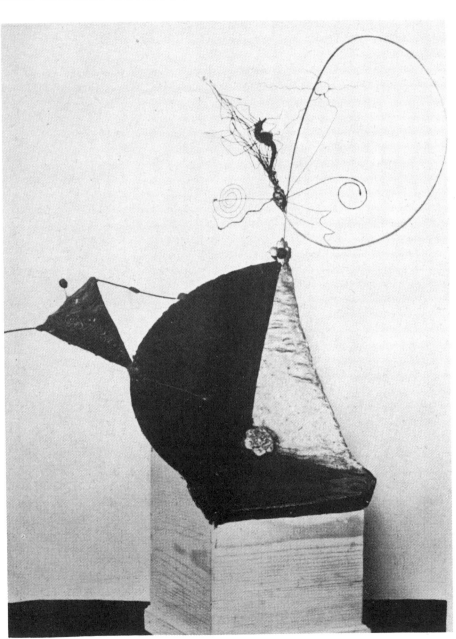

Marcel Janco: Petite architecture, 1916

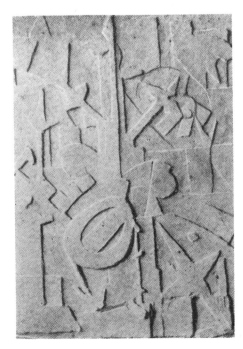

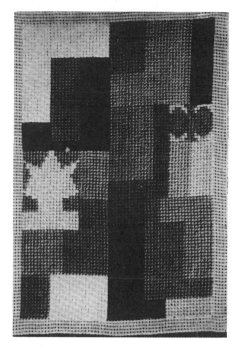

Sophie Taeuber-Arp: Carpet, 1916

Hans Arp: Relief

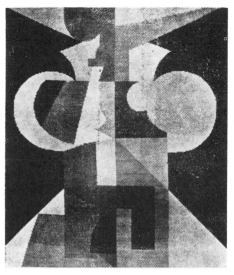

Hans Arp: Design for a carpet, 1915

Hans Arp: Embroidery, 1917

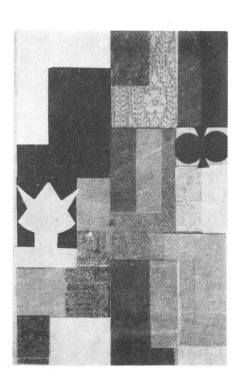

Hans Arp: Collage. Design for a carpet, 1916

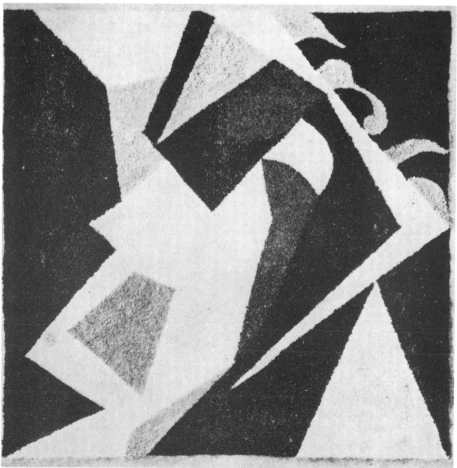

Raoul Hausmann: Mechanical head. Wood and other materials, 1919

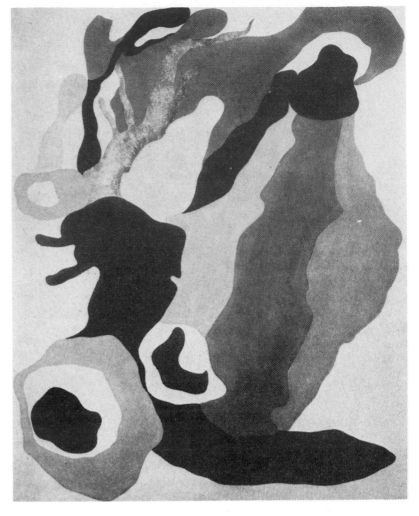

Hans Arp: Composition

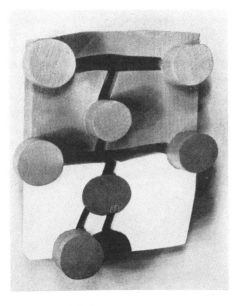

Hans Arp: Wood relief

Fritz Baumann: Relief

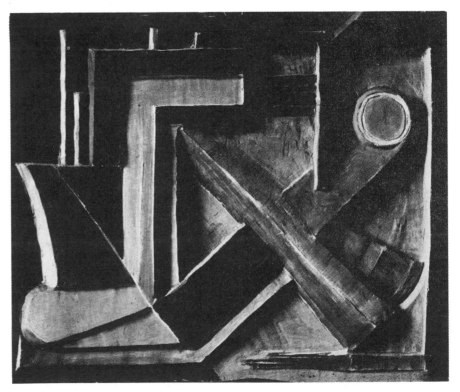

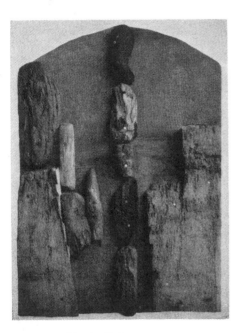

Hans Arp: Relief

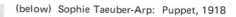

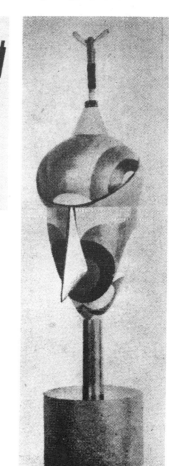

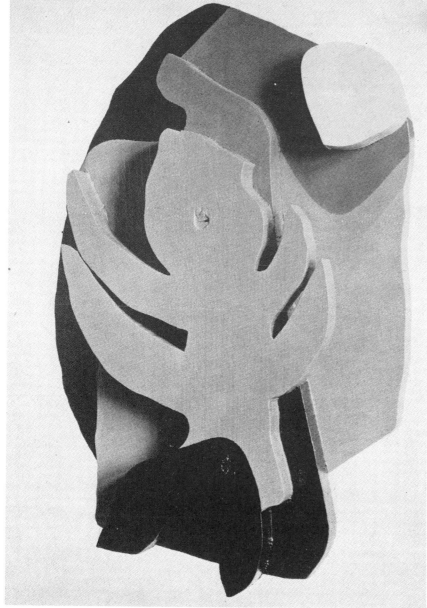

Sophie Taeuber-Arp: Dada head, 1919

Hans Arp: Relief

Hans Arp: The Mask. Wood relief, 1918

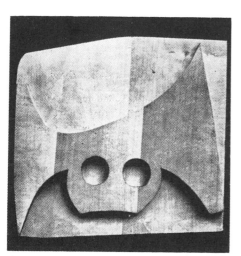

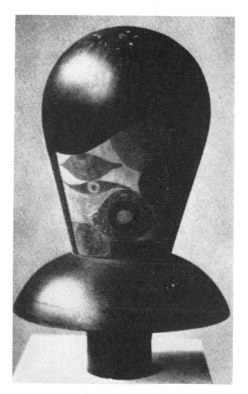

Sophie Taeuber-Arp: Dada head. Painted wooden hat block, 1920

Max Ernst: Dada sculpture from *Die Schammade* (Cologne 1920)

Max Ernst: Revolution at night. Oil, 1923

Max Ernst: Paysage d'hiver-carburation de la financée en fer volcanisé, 1919

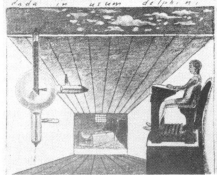

Max Ernst: Dada in usum delphini. Collage, 1920

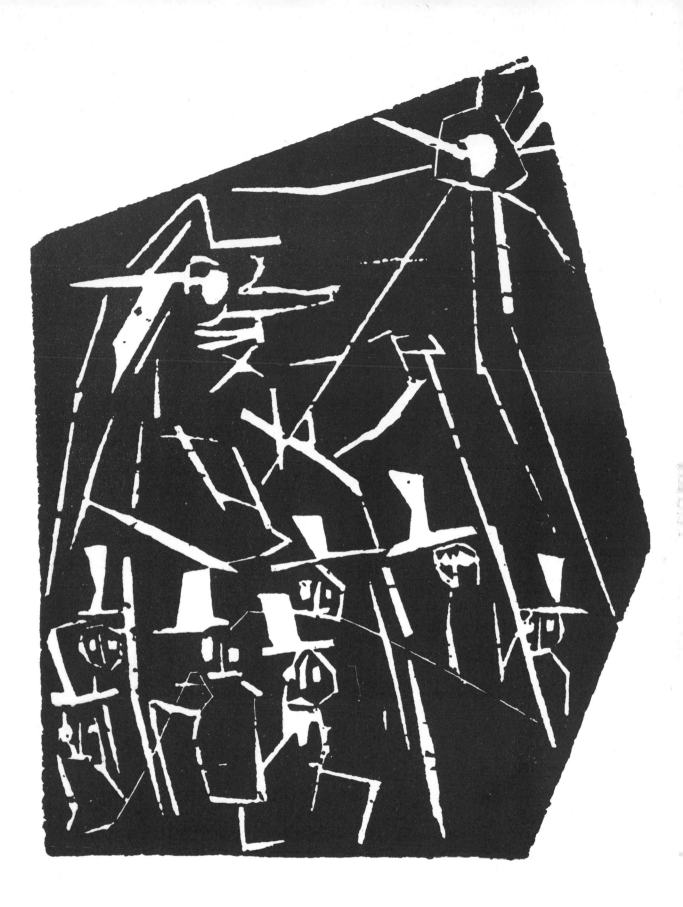

Lyonel Feininger: Woodcut from Adolf Knoblauch, *Dada* (1919)

1914

The competition in armaments between the great powers provokes the first world war. PARIS: Arthur Cravan attacks, in his journal "Maintenant", the aesthetics of modern art. Marcel Duchamp's first "Ready-mades" ("Pharmacie" and "Flaschenhalter").

1915

Italy declares war against Austria. Isonzo-battles.

NEW YORK: The artistic atmosphere is influenced by the presence of foreign artists, such as Marcel Duchamp, Albert Gleizes, Edgar Varèse, Francis Picabia and others. Marcel Duchamp becomes the mental father of the New York dada-group, consisting essentially of the Stieglitz-group with its journal "291" (Arensberg, Picabia, Man Ray, de Zayas).

ZURICH: Switzerland, neutral during the world war, becomes a place of refuge for all kind of refugees. She becomes the centre of various movements against the war and jingoism. Zurich becomes the meeting-place of Russian revolutionaries, with Lenin at their head, and of many anti-war poets and painters. Pacifistic publications appear. The future dadaists: Arp, Ball, Janco, Tzara reach Zurich.

November: Exhibition of works by Arp, van Rees, Mme. van Rees at the "Galerie Tanner". Arp writes in his introduction of the catalogue: "These works are constructions of lines, shapes, forms and colours. They sought to approach the ineffable above us, the eternal. They are a revulsion from human selfishness. They are the detestation of the shamelessness of human morality, the hatred of pictures and paintings. The illusionistic works of the Greeks, the illusionistic painting of the Renaissance led man to overestimate his own species, led to separation and disunity. Instead of being able to use the hands of our brothers as we use our own, we became their enemies. Anonymity was displaced by the celebrity, the trick. Wisdom died. Wisdom was the feeling for high, great, wide, sharp, even, heavy, deep, bright, colourful. And instead of just showing these feelings, they were replaced by themes and a thousand other things and stifled by everyday trivialities and personal platitudes. Wisdom was the feeling for common reality, for mysticism, for the undefined indetermination, for the deepest definiteness. Illustration is imitation, spectacle, rope-dancing. No one will deny that there are rope-dancers of different talents. But art is reality, and common reality must be expressed above the peculiarity. "New Art" is as new as the most ancient vessels, towns, laws; it was employed by the ancient peoples of Asia, America and Africa, and finally in the Gothic style."

1916

Rumania joins the "Entente". Battles for Verdun.

NEW YORK: The residence of Walter C. Arensberg is the meeting-place of Marcel Duchamp, Picabia, Man Ray, de Zayas for preparing the "Independent Exhibition". American artists as Walter Pach, Glackens and George Bellows take part in it.

PARIS: Publication of "SIC", a journal showing dadaist tendencies, edited by Pierre-Albert Birot.

ZURICH: Foundation of the "Cabaret Voltaire" by Hugo Ball. Foundation of the dadaist movement by Hans Arp, Hugo Ball, Richard Huelsenbeck, Marcel Janco and Tristan Tzara.

February: Huelsenbeck arrives in Zurich.

The word "dada" is discovered in a dictionary.

First performance of the "Cabaret Voltaire" on February 5th.

June: The publication "Cabaret Voltaire" appears.

Exhibition at the "Cabaret Voltaire", showing works by Hans Arp, Marcel Janco, August Macke, Modigliani, Eli Nadelmann, Max Oppenheimer, Picasso, O. v. Rees, Marcel Slodki, Arthur Segal and others.

July: On the occasion of the first "Dada Evening" (July 14th) in the "Zunfthaus zur Waag", Tzara reads aloud his first "Dada Manifesto". Tristan Tzara's book "La première aventure céleste de Mr. Antipyrine", with coloured wood-cuts by Marcel Janco, is published in the "Collection Dada".

September: Huelsenbeck's "Phantastische Gebete" (Fantastic Prayers), with wood-cuts by Arp, are published in the "Collection Dada".

October: "Schalaben Schalomai Schalamezomai" by Richard Huelsenbeck, with 4 drawings by Arp, appears in the "Collection Dada".

1917

Russian February revolution. The United States of America declare war against Germany. Germany's truce with Russia and Rumania. October revolution and Soviet Republic in Russia.

NETHERLANDS: Foundation of the "Stijl-group".

NEW YORK: Duchamp publishes his journals "The Blind Man" and "Rongwrong". Picabia publishes together with Walter Arensberg the first number of the journal "391".

Picabia leaves New York.

Man Ray creates his first "Rayogrammes".

On the occasion of the first "Independent Exhibition" in New York, Duchamp presents a urinal made of china and called "Fontaine" (Fountain), signed with "R. Mutt". This bowl symbolizes his protest against art.

PARIS: Paul Reverdy publishes "Nord-Sud", a journal showing dadaist tendencies. On the 18th of May, the Russian ballet shows "Parade" in the Châtelet-theatre; scenery by Picasso, music by Erik Satie.

BERLIN: **January:** Huelsenbeck returns from Zurich to Berlin.

BARCELONA: Publication of the journal "391" by Picabia.

ZURICH: **January 28th:** The "Neue Zürcher Zeitung" writes among other things: "At the moment, there are works of abstract art to be seen in the Salon Corray (Bahnhofstrasse 19) . . . We have already . . . met . . . the artistic couple van Rees. Their tapestries show excellent taste for the colourful-decorative, special attention ought to be paid to the piece with the red-clad man. Hans Arp too . . . we met before; the embroidered tapestry he exhibits, has got his undoubtedly colourful beauty. In his pictorial compositions (in which, of course, no concrete presentation can be sought) he also uses coloured paper strips and fragments of tapestries. Other Zurich cubists . . . J. v. Tscharner, Hans Richter . . . An interesting representation of gifted, most expressive movement is Janco's picture of dance (1915): Tango is danced in presence of spectators, somewhere at the upper margin of the picture, a band can be suspected. The whole is a composition of plane. The power of expression in the illustration of exciting movement and life is unusual . . . W. Helbig presents a picture of "Adam und Eva". The cubistically organized wood-cuts by Slodki are quite distinctive performances . . ."

NEW YORK: **February:** "Exhibition of Independent Painters" at the "Grand Central Gallery".

ZURICH: **March:** Hugo Ball writes in his diary: "Together with Tzara, I have taken over the rooms of the 'Corray Gallery' (Bahnhofstrasse 19). Yesterday I opened the 'Dada Gallery' with a 'Sturm'-exhibition. It is the continuation of the last year's cabaret-idea . . ."

March 23rd: Opening-celebration of the "Galerie Dada". Programme: Abstract dances (by Sophie Taeuber, verses by Ball and masks by Arp). — Frédéric Glauser: verses — Emmy Hennings: verses — Hans Heusser: compositions — Olly Jacques: prose by Mynona — H. L. Neitzel: verses by Hans Arp — Mme. Perottet: new music — Tristan Tzara: Negro verses — Claire Walter: expressionistic dances.

March 24th: Tristan Tzara's lecture about "L'expressionisme et l'art abstrait".

March 31rst: Lecture by Dr. W. Jollos about Paul Klee at the "Galerie Dada".

April 7th: Lecture by Hugo Ball about Kandinsky.

April 14th: Fête of the "Galerie Dada", II. Soirée ("Sturm"-Soirée).

April 28th: III. Dada evening "Abend Neuer Kunst" (Evening of New Art). Hugo Ball discovers in the audience Sacharoff, Mary Wigman, Clotilde von Derp, Marianne von Werefkin, Javlensky, Graf Kessler and Elisabeth Bergner.

April 9th to 30th: Exhibition at the "Galerie Dada" with works of Albert Bloch, Baumann, Max Ernst, Lyonel Feininger, Kandinsky, Johannes Itten, Kokoschka, Ottokar Kubin, Georg Muche, Maria Uhden.

BERLIN: **May:** Huelsenbeck's article "Der Neue Mensch" (The New Man), which he publishes in the "Neue Jugend", may be considered as a preparation for his dada activities in Berlin.

ZURICH: **May:** III. exhibition at the "Galerie Dada", presenting works of Hans Arp, Fritz Baumann, Chirico, Helbig, Janco, Klee, O. Lüthy, A. Macke, Modigliani, Prampolini, van Rees, Mme. van Rees, von Rebay, Hans Richter, A. Segal, Marcel Slodki and J. von Tscharner. On May 16th Hugo Ball writes in his diary: "To-morrow, Thursday, I shall do a guiding through our new exhibition of graphic art, embroideries and reliefs ... The debts of the gallery are 315 Swiss franks."

May 12th: Private soirée "Alte und Neue Kunst" (Old and New Art).

May 25th: Hans Heusser: Music evening with his own compositions.

June 7th: Hugo Ball writes in his diary: "Strange things happen — while we had our cabaret in Zurich, Spiegelgasse 1, there lived on the other side of the same Spiegelgasse, no. 6, if I am not mistaken, Mr. Ulianov-Lenin. Every evening he had to listen to our tirades and our music, whether he enjoyed it or not — I don't know. And while we opened our gallery in the Bahnhofstrasse, the Russians went off to Petersburg to get the revolution going.

July: "Dada" No. 1 appears.

December: "Dada" No. 2. appears.

1918

Mutiny of sailors at Kiel. Revolution in Germany and Austria. Peace of Brest-Litowsk. Truce, after eight millions of soldiers have been killed. Austrian Successor States are formed. Wilson's 14 points.

BÂLE: Foundation of the artists' club "Das Neue Leben" ("The New Life"). Its members among others are: Hans Arp, Fritz Baumann, Augusto Giacometti, Marcel Janco, Oskar Lüthy, Otto Morach, Jakob Mumenthaler, Anna Probst, Niklaus Stöcklin, Sophie H. Taeuber.

BERLIN: Publications of the journals "Club Dada" and "Der Dada". The most important collaborators: Johannes Baader, George Grosz, Richard Huelsenbeck. Raoul Haus-

mann, Franz Jung, John Heartfield, Walter Mehring, Gerhard Preiss.

COLOGNE: Max Ernst meets Baargeld.

PARIS: Aragon, Breton, Eluard, Soupault, Ribemont-Dessaignes receive copies of the Zurich dada journal and they are immediately interested in the dada movement.

BERLIN: **March:** First public dada-appearance. Huelsenbeck makes his first speech in the hall of the New Secession.

April: Dada arrangement with the participation of Huelsenbeck, Raoul Hausmann and George Grosz. The first German dada manifesto is read aloud by Huelsenbeck.

ZURICH: **July:** Tristan Tzara's "25 poèmes", with 10 wood-cuts by Arp, comes out in the "Collection Dada".

July 23rd: Soirée Tristan Tzara in the "Hall zur Meise".

September: Exhibition "Die Neue Kunst" (The New Art) in the art saloon Wolfsberg. (Hans Arp, Fritz Baumann, Marcel Janco, Hans Richter, P. R. Henning, Otto Morach and others). The "Zürcher Post" writes about the exhibition: "However the personal attitude to this kind of art maybe, there are two things, nobody can deny: a solemn conviction and artistic boldness".

December: "Dada" No. 3 appears. For the first time with the collaboration of Picabia, who has got to Zurich via Barcelona and Lausanne. Also with contributions by the Frenchmen: Dermée, Reverdy and Pierre-Albert Birot.

1919

The "Council of People's Delegates" in Germany, declared in November 1918, cannot risk to socialize the industry. Ebert, the social-democrat, makes common cause with the generals. Spartakus revolt in Berlin. Foundation of the Third International Soviet Republic in Hungary; Soviet Republic in Bavaria, suppressed by the social democrat Noske. Murder of Kurt Eisner. Conclusion of peace in Versailles, St. Germain, Neuilly. Mahatma Gandhi becomes leader of the Indian National Congress.

BERLIN: Dada manifesto against Weimar.

HANOVER: In Hanover, the dada movement is grouped round Kurt Schwitters and the publisher Paul Steegemann. Kurt Schwitters publishes his "Anna Blume".

COLOGNE: Hans Arp, Max Ernst and Baargeld are experimenting together. Foundation of the dada-group in Cologne. Baargeld publishes his pamphlet "Der Ventilator". Max Ernst and Baargeld bring out the "Bulletin D". At the same time a group called "Stupid" is formed in Cologne. Members as H. Hörle, Angelika Hörle, R. Raderscheidt, F. W. Seiwert belong to this group, which shows dadaist tendencies. Hans Arp and Max Ernst make the dada-group in Cologne — from the artistic point of

view — the most considerable one of Germany.

The journal "Der Ventilator" is prohibited by the British Occupation Army in the Rhineland.

ZURICH: At the end of 1919, Tristan Tzara leaves Zurich and goes to Paris.

A new world of strange and novel interpretation and combination of objects is growing out of the pre-dada "ready-mades" by Marcel Duchamp and the future creations of the dadaists. Their grand imagination and poetry are showing their signs in modern sculpture.

January: Exhibition "Das Neue Leben" (The New Life) in the Kunsthaus Zurich with works of Arp, Baumann, Augusto Giacometti, Janco, O. Lüthy, O. Morach, Francis Picabia, Sophie Taeuber and others. Marcel Janco writes in his preface of the catalogue for this exhibition, which is partially also shown in Bâle: "Art must and will return to life again. Since the Renaissance, art has become a private matter, devorced from life. Its artists were proud and felt themselves far above the level of other people. This senseless pride has chased us out of life and work into unproductive speculation. We long to depart from this pride. We are not only artists, we are people and are obliged to become an efficient power in life again. An ethically noble art does not belong to a brain only, but to the whole time, to the whole world. If art is done for one's own enjoyment, one neither does justice to all people nor to oneself. The exhibition shows attempts to lead art back to life. There are to be seen many new materials supplied, there are practically no 'paintings' in the usual sense. Our compositions had to destroy the old histories and anecdotes, they had to become more 'abstract' in order to grasp the material in a new, profound way. We want to find back to handicraft and architecture which have in this abstract sense the deepest affinity to our world."

On the occasion of this exhibition, the following lectures are given in Zurich and Bâle:

Otto Flake: Introduction into the appreciation of the new art

Tristan Tzara: "L'art abstrait" (abstract art)

Fritz Baumann: Was will "Das Neue Leben"? (What does "The New Life" want?)

Marcel Janco: Sur l'art abstrait et ses buts. (About abstract art and its aims).

February: Specimen 8 of Picabia's periodical "391" is published in Zurich.

PARIS: **March:** Foundation of the journal "Littérature" (edited by Aragon, Breton, Soupault). Tristan Tzara collaborates from No. 2 forward.

ZURICH: **April 9th:** Big dada arrangement in the "Hall zur Kaufleuten". Foundation of the group of the "artistes radicaux" (radical artists), with the following committee-members: Hans Arp (Alsace), Fritz Baumann (Bâle), Vi-

king Eggeling (Sweden), Augusto Giacometti (Zurich), Walter Helbig (Dresden), P. R. Henning (Berlin), Marcel Janco (Roumania), Hans Richter (Berlin) and Otto Morach (Zurich).
May: The dada-anthology ("Dada" No. 4—5) appears.
October: The only specimen of the dada journal "Der Zeltweg" appears.
1920
Inflation in Germany. The League of Nations begins its activities. Distribution of the colonial mandates. Kapp-outbreak in Germany. Spartakus revolt in the Ruhr.
BERLIN: Publication of the "Dada-Almanach". Hausmann and Huelsenbeck start a dada lecture trip to Dresden, Hamburg, Leipzig and later on to Prague.
GENEVA: Dada dance and an exhibition with works of Picabia, Arp and Ribemont-Dessaignes.
COLOGNE: Dada exhibition is closed by the police.
PARIS: **January 23rd:** First great dada arrangement at the "Palais des Fêtes", organized by the circle of the journal "Littérature", called "Premier vendredi de littérature".
COLOGNE: **February:** Publication of the "Schammade" with a very active participation of the Paris dadaists.
PARIS: **February 5th:** Dada arrangement in the "Salon des Indépendants"; dada manifestation in the "Université Faubourg St. Antoine" on the 18th of February.
At this time, the dada bulletin ("Dada" No. 6) appears in Paris.
The first number of «Proverbe», a journal edited by Paul Eluard, is published.
Max Ernst is suspended from the "Section d'or" (The Golden Section), a group of cubists and abstract artists, with members as Archipenko, Survage and Gleizes. Later on, all dadaists are excluded from this group.
March 27th: Dada manifestation in the "Salle Berlioz dans la Maison de l'Oeuvre". Publication of "Dada" No. 7 (Dadaphone), the last specimen of the periodical, founded by Tzara at Zurich.
No. 12 of "391" appears, on its title-page the "Mona Lisa with the moustache".
COLOGNE: Arp leaves Cologne.
PARIS: April: Publication of Picabia's "Cannibale", in which he attacks some of the dadaists.
From April 16th to 30th: Dada exhibition of Francis Picabia at the gallery "Au Sans Pareil".
Arp arrives in Paris.
May 26th: Great dada festival in the "Salle Gaveau". Dermée, Eluard, Picabia, Tzara, Breton, Soupault, Ribemont-Dessaignes and Aragon are active participators. This event represents the culmination of the Paris dada group.

Publication of the dada-specimen of "Littérature", enclosing 23 manifestos.
BERLIN: **June:** First great dada exhibition in the rooms of Dr. Otto Burchard's art-shop, called "Erste Internationale Dada-Messe" (First International Dada Fair). A most important exhibition with 174 exhibited objects, a culmination of the dada activities in Berlin.
1921
Working-class mischiefs in Hamburg, Central Germany and the Ruhr.
ITALY: Publication of the dada journal "Bleu".
PARIS: Within this year, Picabia and Breton withdraw from the dada movement. Fights inside the movement begin.
NEW YORK: **April:** Marcel Duchamp and Man Ray publish the only specimen of "New York Dada".
PARIS: **April 14th:** "Ouverture de la Grande Saison Dada" — an attempt for a fresh impetus, which fails.
May 13th: Dada manifestation in the "Salle des Sociétés Savantes", rue Danton, where the dadaists sit publicly in judgement on Maurice Barrès. In protest against this management, Picabia withdraws from the dada movement and attacks it.
Dada exhibition with works of Max Ernst at the gallery "Au Sans Pareil".
1922
Murder of Rathenau. Kemal Pasha proclaims the Turkish Republic. Mussolini's "March on Rome".
COLOGNE: Max Ernst leaves Cologne and settles in Paris. This step prepares the disolution of the Cologne dada group.
NETHERLANDS: Theo van Doesburg uses the pseudonymous name I. K. Bonset for his edition of a dada journal "Mecano".
PARIS: André Breton's plan to organize a "Congrès de Paris" of the whole intelligentsia and all artists causes a splitting of the dada group. Breton withdraws from the group. Tristan Tzara, who had fought against Breton, is left with Paul Eluard, Théodore Fränkel, Ribemont-Dessaignes and Erik Satie. The discrepancies cause distressing controversies, which degenerate into personal remarks. On the occasion of a meeting at the "Closerie des Lilas", Breton is called to account and this causes the official end of the Paris dada movement.
February: Picabia publishes a pamphlet "La Pomme de Pins", in which he attacks most of the dadaists.
April: In a counter-attack "Le coeur à barbe", Tzara and the rest of the group assail Breton and Picabia.
June: The last big dada exhibition "Salon Dada, Exposition Internationale" at the gallery Montaigne.
WEIMAR: **October:** Congress of the construc-

tivists (L. Moholy-Nagy, El Lissitzky, Max Burchartz, Cornelius von Eesteren, Alfred Kemeny, Hans Richter, Theo van Doesburg and others), with the participation of the dadaists Hans Arp and Tristan Tzara. At the time of the congress, the constructivists cannot indentify Theo van Doesburg with I. K. Bonset, the editor of the Dutch dada journal "Mecano".
1923
Proclamation of the Union of Socialist Soviet Republics. France occupies the Ruhr. End of the inflationary period in Germany. The German "Reichswehr" suppresses together with the social-democrats conclusively all revolutionary movements. Adolf Hitler's outbreak in Munich.
NEW YORK: Marcel Duchamp gives up his painting for just playing chess and making film-experiments.
PARIS: **July:** The last dada arrangement at the "Théâtre Michel". Music by Erik Satie, Auric, Stravinsky and Milhaud. Films by Hans Richter and Man Ray. The performance of Tzara's "Coeur à Gaz" ends with a scandal. Aragon, Breton and Péret demonstrate publicly against Tzara.
1924
Death of Lenin.
PARIS: The "Sept Manifestes" by Tristan Tzara appear as a book, with drawings by Picabia.
Publication of the first surrealistic manifesto by André Breton. Most of the dadaists join the surrealists.
1925
First surrealistic exhibition at the "Galerie Pierre" with works of Arp, Chirico, Max Ernst, Klee, Man Ray, Masson, Miro, Picasso and others.

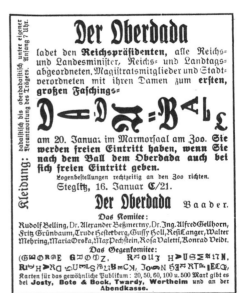

Der Oberdada (Berlin 1921)

ARAGON, LOUIS
* 3.10.1897 Paris. Poet and writer. Active participant in the dada movement. Later surrealist. s. B.

ARCHIPENKO, ALEXANDER
* 30.5.1887 Kiew. Sculptor. Mentionned by Tristan Tzara in "Dada" No. 6 in the list "Quelques Présidents et Présidentes".

ARENSBERG, WALTER C.
Active participant in the New York movement. Owns a large collection of modern art, which contents 30 works of Marcel Duchamp.

ARNAULD, CÉLINE
French poetess. Participant of the Paris dada movement. Friend of the poet Paul Dermée. Ed. per. "Projecteur". Paris, 1920.

ARP, JEAN (or HANS)
* 16.9.1887 Strasbourg (Alsace). Sculptor, painter and poet. Came to Paris in 1904 and was deeply impressed by the modern painting. Went to Weimar and attended the courses at the academy under Professor Ludwig von Hoffmann, 1905—1907. Spent some time at the Julian academy of Paris in 1908. Then went to Weggis, Switzerland, where he worked for some years in solitude. Met the painters W. Gimmi, W. Helbig, Oskar Lüthy with whom he foundet 1911 the "Modernen Bund" ("Modern league"). Was one of the organizers of the first exhibition "Der Moderne Bund" in Lucerne, showing works by Amiet, Arp, Friesz, Gauguin, Gimmi, Helbig, Hodler, Lüthy, Matisse, Picasso. Visited 1911 Kandinsky in Munich, who requested his collaboration at the book "Der Blaue Reiter" ("The Blue Rider"). Took part in the 2nd "Blauer Reiter" exhibition, Munich 1912, and the 2nd "Der Moderne Bund" exhibition, Zürich 1913. Contributed drawings to the Berlin periodical "Der Sturm" ("The Storm"). Took part in the

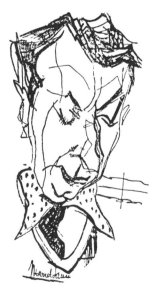

Marcel Janco: Portrait of Hans Arp. Drawing, 1919

"First German Autumn Saloon" at "Der Sturm" gallery, Berlin 1913. Met Apollinaire, Arthur Cravan, Max Jacob, Picasso, and Modigliani, in Paris 1914, the latter drawing his portrait. After the declaration of war he returned to Switzerland. Exhibited his first abstract works (rectangular forms), collages, and tapestries, together with works by Otto and Mme. van Rees, at the Tanner gallery, Zurich, November 1915. In this exhibition he met Sophie Taeuber, later he became her husband. Cofounder of the Zurich dada movement, 1916. Illustrated Tristan Tzara's "25 Poems" and Huelsenbeck's "Fantastic Prayers", the latter with wood-cuts which he called "Studies In Symmetry". In his reminiscenes "Dadaland" Arp writes: "I met Tzara and Serner at the 'Odeon' and the 'Café Terasse' in Zurich, where we were writing a cycle of poems called 'Hyperbole of the Crocodile-Hairdresser and the Walking-Stick'. This kind of poem was later called 'Automatic Poetry'". In 1917 he created his first abstract wooden reliefs. Exhibited at the first Zurich dada exhibition. In the Zurich dada-publications "Cabaret Voltaire", "Dada" 1 to 3, "391" (no. 8) there appeared illustrations, in "Dada" 4/5 and "Der Zeltweg" illustrations and poetries by Arp. 1919 in Cologne, foundation of the Cologne dada group together with Max Ernst and Johannes Baargeld. Contribution to the publication "Schammade". "Fatagaga" pictures, with Max Ernst. Short stay in Berlin, where he met El Lissitzky, Kurt Schwitters and other dadaists. Published "Die Wolkenpumpe" ("The Cloud Pump"), a series of poems; and "Der Vogel Selbdritt" ("The Bird Thrice With Itself"), poems and wood-cuts. Collective publication of "Dada in Tyrol, Au Grand Air, Der Sängerkrieg". In 1922 he married Sophie Taeuber. Collaboration at Kurt Schwitters periodical "Merz" in 1923. Published, with El Lissitzky, "Isms In Art", in which he defined dada: "Dadaism has launched an attack on the fine arts. It has declared art to be a magic opening of the bowels, administered an enema to the Venus of Milo, and finally enabled 'Laocoon and Sons' to ease themselves after a thousand-year struggle with the rattle-snake. Dadaism has reduced positive and negative to utter nonsense. It has been destructive in order to achieve indifference". Participation at the first collective exhibition of surrealists at the Pierre gallery, Paris, with de Chirico, Ernst, Klee, Man Ray, Masson, Miro, Picasso. Arp is one of the most consistent artists of our time. Inspired by a strong sense of responsibility he is ceaselessly striving for a form of art compatible with our century. Arp always opposed the conventional idea of a picture as a "framed rectangle". But in opposition to Picabia and Marcel Duchamp he regarded the destructive line of

the dada movement as a mere prelude to the invention of free forms. His experiments had a profound influence on modern architecture, home culture, and industrial design. Arp is an example for an artist's being able to change the sense of form of a whole generation by his experiments. In his dada period Arp was animated by a profound desire for simplicity and naturalness. He wrote in those days: "Works of art ought to remain anonymous in the great workshop of nature, like the clouds, mountains, seas, animals, men. People ought to return to nature; artists should work in communities, like the artists of the Middle Ages." (s. B.)

ARTISTES RADICAUX
Movement of artists living in Switzerland. Formed in 1919. Consisted mainly of artists of the "New Life" group, Basle, and a few dadaists. On April 11th, 1919, they promulgated a manifesto, signed by Arp, Baumann, Eggeling, Augusto Giacometti, Henning, Helbig, Janco, Morach, and Richter.
The group was also preparing the publication of its own periodical; but it did not appear, although galley proofs already existed. The group was also known under the name of "Association of Revolutionary Artists". The "constructivist" movement of Russian painters such as Gabo, Lissitzky, Malevich, Pevsner, Tatlin and others, was of a similar trend.

Ludwig Meidner: Portrait of Johannes Baader. Drawing

BAADER, JOHANNES
took an active part in the Berlin dada movement from 1918 to 1920. Was also known as the "Chief Dada" and "Dada Prophet". (s. B.)

BAARGELD, JOHANNES THEODOR
(Pseudonym for Alfred Grünwald)
German painter and poet. Founded, together with Max Ernst the Cologne dada group. Gave up painting in 1921. Lost his life in an avalanche in 1927. Editor of the periodical "Der Ventilator" ("The Fan") and collaborator at

a great number of dada publications ("Bulletin D", "Dada W/3" and others) s. B.

BALL, HUGO

* 22. 2. 1886 in Pirmasens (Germany), † 14. 9. 1927 San Abbondio. (Switzerland). Author, co-founder of the Zurich dada movement, he derived from a catholic family; joined the Max Reinhardt School of Dramatic Art in 1910, and was employed as stage director. The "Café des Westens" in Berlin became his meeting place with young poets: Johannes R. Becher, Georg Heym, Richard Huelsenbeck, Klabund, and others. Stage director at the Munich Chamber Theatre in 1913 and at the same time collaborator at the periodical "Revolution" (Publisher F. S. Bachmair, 1913) together with Seewald, J. R. Becher, Erich Mühsam. Soon after the outbreak of the war he emigrated with his wife, Emmy Hennings, to Switzerland. Both took employments — Ball as a pianist, his wife as a recitationist — in a variety group in the Niederdorf, the amusement quarter of Zurich. In February 1916 he founded the "Cabaret Voltaire" in the Spiegelgasse at Zurich. Met Arp, Janco, Tzara, and later Huelsenbeck and Serner. His intentions with regard to the "Cabaret Voltaire" he defined in the following words: "It is necessary to clarify the intentions of this cabaret. It is its aim to remind the world that there are people of independent minds — beyond war and nationalism — who live for different ideals." (From the contribution entitled "Lorsque je fondis le Cabaret Voltaire" = "When I founded the C. V." in the publication "Cabaret Voltaire", Zurich, 1916). Ball protested several times "against the humiliating fact of a world war in the 20th century". In the light of this, all static values of culture appeared to him to be questionable. Composed sound-poems, "verses without words". In 1917 he ceased to take an active part in the dada movement. Became co-editor of the newspaper "Freie Zeitung", Berne, which demanded a republic for Germany. Later he retired and went to live in the Ticino, where he was employed on a biography on Bakunin. From his dada period an unpublished novel exists: "Tenderenda, der Phantast". In his "Criticism of German Intelligence" (1919) he tried to present a profound analysis of the German state of mind. The reader of this work now realises that Ball has had forebodings of the shame of Hitlerism.

Perhaps his most significant book is a selection from his diaries called "Flucht aus der Zeit" (Munich, 1927). It is a fascinating report on the years of upheaval, 1913 to 1921, describing the path of this unique man from the stage ("Prelude — The Coulisse") via dadaism ("Romanticism — The Word and The Picture"), to a search for God and con-

version ("Of God's Rights and Man's — Flight to the Fundamentals"). "Flucht aus der Zeit" is, besides Tzara's "Chronique Zurichoise", the best documentary work about the Zurich dada movement. s. B.

BAUMANN, FRITZ

* 3. 5. 1886 Basel. † Swiss painter. Collaboration at the "Dada Almanach". Co-founder of the group of artists "Das Neue Leben" ("The New Life") in Basel. He worked later with dadaists in the group of "Artistes Radicaux".

BIROT, PIERRE-ALBERT

* 1885 Chalonnes (France). Sculptor. Editor of the periodical "SIC", Paris 1917, which adopted cubist and dadaist tendencies. Collaboration at other dadaist publications.

BOESNER, CARL

Dada photographer. Exhibited at the "First International Dada Fair", Berlin, 1920.

BONSET, I. K.

(Pseudonym for Theo van Doesburg)
Was his pseudonym for the major part of his work in the dada movement. Also signed "collages" with it. Ed. per. "Mecano".

Marcel Janco: Portrait of André Breton. Drawing, 1921

BRETON, ANDRÉ

* 18. 2. 1896 Tinchebray (France). French critic, writer and poet. At the beginning of world war I he was a student of medicine and particularly interested in psychiatry. In 1916 he met Jacques Vaché, a legendary precursor of dadaism. His first publications were influenced by Rimbaud. When Tristan Tzara

came to Paris from Zurich in 1916, Breton joined the Paris dada movement together with his friends, Paul Eluard and Philippe Soupault. The periodical "Littérature", of which Breton was co-founder, served the cause of the dadaists. Breton played an important part in the earler dada publications of Paris. In 1921 he broke with Tzara and the Parisian dadaists. Published his "Manifeste du Surréalisme" in 1914. Somewhat later, he was co-editor of the periodical "La Révolution surréaliste" (1924—29) and thus founded the school of literary surrealism, of which he became the most important theorist. s. B.

BRUITISME (NOISE MUSIC)

was the name given to the musical manifestations of the futurists and their successors. As early as 1909 Marinetti demanded in his futurist manifesto a music of machines and the big city. In 1913 Luigi Russolo outlined a systematology of noises, which he subdivided into six groups. Shortly afterwards the first public demonstration took place, at the Teatro Storchi of Modena, of the "Intonarumore" he had constructed. When Russolo conducted a noise concert at the Teatro dal Verme of Milan there was an uproar. In Satie's ballet, "Parade", a number of "bruitist" effects were used, such as the wail of sirens, the clatter of typewriters, the roar of aeroplanes and the whirr of electric generators. A futurist concert in 1921 presented another noise machine to the Parisians, called the "Bruiteur". In 1926 Nicholas Obuchow used noises as means of musical expression.

BUFFET, GABRIELLE

Picabia's wife. Took part in the dada movement.
s. B.

CABARET VOLTAIRE

During the first world war, Switzerland and more especially Zurich, became a place of retreat for refugees from all the countries of Europe. It was the ideal breeding ground for their manifestations against war, jingoism and outmoded aesthetical traditions. It was at Zurich that Lenin and his friends laid the plans for the Russian revolution, and there lived pacifist poets as Schickele, Leonhard Frank and Franz Werfel. A special group was formed by Hugo Ball and Emmy Hennings, German poets; Hans Arp, an Alsatian painter, sculptor and poet; and two Roumanians — Marcel Janco, a painter, and Tristan Tzara, a poet. Hugo Ball had at one time been stage director at the Munich "Kammerspiele"; later, at Zurich, he became pianist in a group of actors providing cheap entertainment in popular music halls. At the beginning of 1916 Ball rented an empty hall belonging to Ephraim Jan, an ancient Dutch sailor who was running a "Dutch Room" at the "Meierei"

("Dairy" inn) No. 1 Spiegelgasse, Zurich. There Ball planned to open his own cabaret together with his wife Emmy Hennings, at once poetess, recitationist, and vocalist. For a name they chose the somewhat suspicious-sounding epithet "Cabaret Voltaire". They asked Hans Arp, Marcel Janco, and Tristan Tzara, members of their circle to collaborate, and the cabaret was opened on February 5th, 1916. Its dark premises were artists' club, exhibition room, pub, and theatre, all rolled into one. The artists' performances consisted of the oddest until then never heard and seen works. Noise music, simultaneous poems recited by 4 to 7 voices speaking at once, bizarre dances in grotesque masks and fancy costumes, interrupted by readings of German and French sound-verses sounding like nothing on earth, and solemn incantations of texts by the mystic Jacob Böhme and of Lao-Tse. The walls were hung with pictures of artists whose names had been unknown until then: Arp, Paolo Buzzi, Cangiullo, Janco, Kisling, Macke, Marinetti, Modigliani, Mopp, Picasso, van Rees,

Cover for *Bleu* (Mantua 1921)

Slodki, Segal, Wabel, and others. On May 15th Ball published a pamphlet "Cabaret Voltaire", a collection of artistic and literary contributions (by Apollinaire, Arp, Ball, Cangiullo, Cendrars, Hennings, van Hoddis, Huelsenbeck, Janco, Kandinsky, Marinetti, Modigliani, Oppenheimer, Picasso, van Rees, Slodki, and Tzara). In his introduction Ball wrote these programmatic words: "When I founded the "Cabaret Voltaire, I was of the

opinion that there ought to be a few young people in Switzerland who not only laid stress, as I did, on enjoying their independence, but also wished to proclaim it. I went to Mr Ephraim, the owner of the "Meierei" restaurant and said: Please, Mr Ephraim, let me have your hall. I want to make a cabaret. Mr Ephraim agreed. So I went to some friends of mine and asked them: 'Please, let me have a picture, a drawing, an engraving. I want to have an exhibition to go with my cabaret.' And I went to the friendly press of Zurich and said: "Write a few notes. It shall be an international cabaret. We want to do some beautiful things.' And they gave me pictures, and they wrote the notes. So, on February 5th we had our cabaret. Mrs. Hennings and Mrs. Leconte sang French and Danish songs. Mr. Tristan Tzara recited Roumanian verses. A balalaika band played some charming Russian folk-songs and dances. Much support and sympathy came to me from Mr Slodki, who designed the poster for the Cabaret; from Mr Hans Arp, who placed at my disposal a few works by Picasso, in addition to his own works, and who also got me some pictures from his friends: O. van Rees and Arthur Segal. There was much assistance, too, from Messrs. Tristan Tzara, Marcel Janco and Max Oppenheimer, who willingly expressed their readiness to appear at the cabaret. We organised a Russian soirée, and soon after also a French one (with works by Apollinaire, Max Jacob, André Salmon, A. Jarry, Laforgue and Rimbaud). On February 26th Richard Huelsenbeck came from Berlin, and on March 30th we performed fabulous Negro music (always with the big drum, boom, boom, boom-drabatja mo gere drabatja mo boonooo...). Mr Laban was present at the performance and was quite enthusiastic. Thanks

to the initiative of Mr. Tristan Tzara, Tzara, Huelsenbeck, and Janco performed (for the first time in Zurich and, indeed, in the whole world) simultaneous verses by Messrs. Henri Barzun and Fernand Divoire, as well as a simultaneous poem of their own composition. For the little pamphlet we are publishing today we have to thank our own initiative and the assistance of our friends in France, Italy, and Russia. It is to exemplify the activities and the interests of the cabaret, whose whole endeavour is directed at reminding the world, across the war and the various fatherlands, of those few independent spirits that live for other ideals. The next aim of the artists united here is to publish an international periodical. This will appear at Zurich and will be called "DADA Dada Dada Dada Dada". (Hugo Ball. Zurich. May 15th, 1916). In this declaration the name of "Dada" is documented for the first time, and from here it was carried into the world. On July 14th the first Dada Soirée took place at the "Waage" hall; and in the same month the series of books, "Collection Dada", began to appear, first Tzara's "The first heavenly Adventure of Mr Febrifuge" illustrated by Marcel Janco. The following numbers were Huelsenbeck's "Fantastic Prayers" and "Schalaben Schalomai Schalamezomai", then Tzara's "25 Poems", all three illustrated by Arp. On March 17th, 1917, the 'Galerie Dada' was opened at No. 19 Bahnhofstrasse, and activities transferred there from the 'Cabaret Voltaire', which had been closed in the meantime. "Sturm-Soirées" were given, among them a performance of Kokoschka's play "Sphinx and Man-of-Straw", an "evening of new art", exhibitions of ancient and modern art, etc. From July, 1917, to May 1919, four numbers of the new periodical, "Dada", were published under the

Programme for the 8th Dada Soirée, Zurich, 9 April 1919

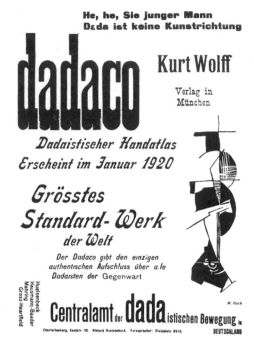

Prospectus for *Dadaco* (Munich 1920)

editorship of Tzara. In February, 1919, Picabia published No. 8 of his "vagabond periodical "391" with collaboration of the Zurich dadaists. October, 1919, saw the publication of the last Zurich dada periodical "Der Zeltweg" (the name of a street) at Zurich, edited by Otto Flake, Walter Serner, and Tristan Tzara. After the borders of the countries of Europe had been opened once more, links with Berlin, Cologne and Paris, were re-established. Huelsenbeck founded a dada-group in Berlin; Arp and Max Ernst one in Cologne. On Tzara's initiative a particularly active group sprang up in Paris. Dada extended to Holland (van Doesburg) and Schwitters founded "Merz", his own version of dada, at Hanover. Sparks flew over to Italy, to Czechoslovakia, to Yugoslavia, Spain, Russia and the United States. Dada had become an international movement. — To conclude, here are a few words on the publications of the Zurich dadaists. The young artists had discovered in Jul. Heuberger a printer who showed understanding for radical typographical experiments. The dadaists, unfettered by any tradition, tried to break up the rigid set, the regular run of typography, by using types and blocks of the most widely different grades. The layout of the sets was enriched by a lively rhythm of black and white, and a new effect, rather like a picture, was achieved. The joy of experimenting and creative imagination took the place of orthodox typographical tradition. Coloured paper was introduced to liven up the publications. Bizarre woodcuts by Arp, mysterious "mechanical

designs" by Picabia, reproductions of works by A. Giacometti, Kandinsky and Klee, woodcuts by Hans Richter, lithographs by Viking Eggeling and many other things more, adorned the periodicals and other publications. Marcel Janco and Hans Arp illustrated the poetical works of their friends with fine woodcuts, distinguished for their wealth of forms. Today these publications have become bibliophiles' gems, but their spirit and artistic awareness carry on and are revived again and again in many modern publications.

CANTARELLI, CINO
co-editor of the Italian periodical "Bleu", which had dadaist tendencies. One of the signatories of the "Dadaist Manifesto", Berlin, 1920.

CENDRARS, BLAISE
* 1. 9. 1887. French poet. His work and life had influence on the French dadaists. s. B.

CHADOURNE, PAUL
Took part in the dada movement in Paris.

CHARCHOUNE, SERGE
* 1888 Bougourouslan (Russia). Poet, painter, lithograph. Took part in the dada movement in Paris. Met Picabia 1916 in Barcelona.

CHIRICO, GIORGIO DE
* 10. 7. 1888, Volo (Greece), Italian painter. Together with Carlo Carrà founder of the "Pittura metafisica". Had some influence on dadaism, especially on Max Ernst.

CITROËN, HANS
Dutch painter, collaborated with the dada movement. Exhibited at the "First International Dada Fair", Berlin, 1920.

COLLAGE
(also "papier collé" or paste picture)
Kurt Schwitters defined his "Merz pictures" — which, after all, were nothing but collages — as follows: "A picture consisting of mutually incompatible parts united into a work of art with the aid of paste, nails, hammer, paper, rags, machine-parts, oil-paint, lace, etc."

CRAVAN, ARTHUR
(Pseudonym of Fabian Lloyd)
American precursor of dadaism. Was a poet and boxing champion. Followed Picabia to Madrid in 1916. Disappeared in Mexico, 1918. Ed. pre-dada periodical "Maintenant". s. B.

CREVEL, RENÉ
* 10. 8. 1900 Paris, † 3. 6. 1935 — suicide), French writer. Took part in the first dada group, Paris, was later surrealist.

CROTTI, JEAN
* 24. 4. 1878 Bulle (Switzerland). Painter. Took a passive part in the Paris dada movement. Belonged 1917 to the circle around Duchamp, Picabia and Man Ray in New York.

DADA
French for gee-gee, cock-horse, hobby-horse (Larousse, Cassel). There is some uncertainty about the finding of this word in a French-Ger-

man dictionary. "Authorship" is ascribed both to Tzara and to Huelsenbeck. Arp has his own version, as has Janco. Huelsenbeck relates that he found the word "Dada" together with Hugo Ball in a French-German dictionary when they were looking for a name to give to Madame Leconte, the singer of the "Cabaret Voltaire". Hugo Ball wrote in his book "Escape From Time" (18. 4. 1916): "Tzara is nagging me because of the periodical. My proposal to call it 'Dada' has been accepted . . . In Roumanian dada means 'yes yes', in French 'gee-gee' or hobby-horse. For Germans it is a symbol of gullibility and a procreative hankering after the perambulator."

DADAMAX, ERNST, see ERNST, MAX

DAIMONIDES
(Pseudonym for Dr. Carl Doehmann)
Took part in the Berlin dada movement. George Grosz wrote about him in his autobiography "A Little Yes and A Big No", page 133: "A certain Dr. Doehmann, a dermatologist by profession and therefore no dadaist in the orthodox sense of the word, was our family composer. His dada sounds were never committed to paper, he merely improvised. Moreover he wrote grotesque verses under the pen-name Daimonides." s. B.

DERMÉE, PAUL
* 1888. French poet. Took part in the Paris dada movement. Editor of "Z 1", Paris, 1920. (s. B.). Editor of the periodical "L'Esprit nouveau", 1919. (s. B.)

DIX, OTTO
* 2. 12. 1891 Unterhaus bei Gera. German painter. Exhibited at the "First International Dada Fair", Berlin 1920.

DOESBURG, THEO VAN
(Pseudonym for Christian E. M. Küpper) * 30. 8. 1883, Utrecht (Holland) † 7. 3. 1931 Davos (Switzerland). Dutch painter, architect and poet. Started painting in 1899 and wrote poems and played in his spare time. In 1917 he founded, together with Mondrian and the architect Oud, the "Stijl" group and the periodical "De Stijl», which went up to 87 numbers, ceasing publication in 1931, with the editor's death. In 1920—21 he went on publicity travels to Italy, Belgium, France and Germany, to propagate the ideas of "Stijl". On the invitation of Hans Richter and Viking Eggeling he visited Berlin and, in January, 1921, the "Bauhaus" at Weimar. Met the architects Taut, Gropius, Meyer, Mies van der Rohe and Le Corbusier. In April of the same year he founded a "Stijl" group at Weimar, which soon came in opposition to the Bauhaus. With his wife, Petra van Doesburg and Kurt Schwitters, he organized a "dada campaign" through the Netherlands, in 1922. Under the name of I. K. Bonset he published the dada-periodical "Mecano" (4 numbers: White, blue, red, yellow) in collaboration with Hans

Arp, Raoul Hausmann and Tristan Tzara, whom he had met at Hanover, while visiting Kurt Schwitters. (The latter published a report on the campaign in the memorial number of "De Stijl" in 1932.) Collaboration at the periodical "Merz" edited by Kurt Schwitters, on whose work he exerted great influence. s. B.

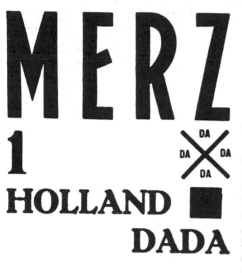

Cover for *Merz*, no. 1 (Hanover 1923)

DUCHAMP, MARCEL

* 28. 7. 1887, Blainville near Rouen (France) French painter, poet, experimentator in films and chess player. He is the brother of Raymond Duchamp-Villon, the sculptor, and of Suzanne Duchamp, the poetess and a half-brother of Jacques Villon. In 1911 he was a member in the painters' circle known as the "Golden Section", together with La Fresnaye, Léger, Metzinger, Picabia, and others. Influenced by cubism he painted the picture "The Chess Players" and the first studies for his "Nudes descending a Staircase". In the same year he created "The Coffee-Mill", important as regards to form and the part it played in the general development. Many problems of dadaism (mechanical drawings by Picabia, Max Ernst, etc.) and of surrrealism were anticipated in it. In 1912 he painted one of his main works, "Nudes descending a Staircase", shown for the first time in October of that year at the exhibition of the "Golden Section". In 1913 it was the hit of the New York "Armory Show". In 1914—15 he confused the public with a series of works which

he called "Ready-Mades". In 1914 he put his signature to a second-rate landscape reproduction by an unknown artist after adding a green and a red patch, calling the whole work "Pharmacy". "Ready-Mades" were banal objects of every-day use such as a bottle holder, a snow-shovel, etc., which he signed with his name after giving them titles totally unconnected with their functional use. In 1915 he went to the United States for the first time and soon became the centre of the circle of painters round the "Stieglitz" gallery. That group had adopted an "anti-art" attitude and was thus a movement parallel to Zurich dadaism. In 1917 Duchamp sent a "work" called "Fountain" to the New York "Independent Show", signed with the name "R. Mutt", — it was nothing but a common urinal. The "Ready-Mades" demonstrated his profound contempt for the bourgeois conception of art. Their descendants were in later years the "surrealist objects". In 1917 Duchamp edited the periodicals, "The Blind Man" and "Rongwrong", wich had an unmistakably dadaist character. "La vierge", "Mariée", "Passage de la vierge à la mariée", etc., pictures painted in 1912 — some on glass and others on canvas — were the points of departure for his monumental work; (painted on glass): "La mariée mise à nu par ses célibataires" ("The married woman stripped nude by her bachelors"), at which he worked from 1915 to 1923 and finally left unfinished, to devote himself to chess-playing and to mechanical and optical experiments (films) etc. In 1934 he published 93 facsimile drawings etc. preparatory studies to his unfinished monumental work, a fascinating insight into the structure and evolution of this unique creation. In 1920 he published, under the penname of Rrose Sélavy (arroser, c'est la vie), puns in No. 5 of the periodical "Littérature". With the same pseudonym he still signed lesser works. Together with Katherina Dreier he founded the "Société anonyme" for the propagation of modern art in America. Preference was given to anti-traditional, cubist, futurist and dadaist works. From 1942 to 1944, together with Max Ernst and André Breton, he edited the surrealist periodical "VVV", in New York. Through the charm of his personality and his works Duchamp has exerted great influence on young American artists. s. B.

DUCHAMP, SUZANNE

* 1889 Blainville (France) French poetess, sister of Marcel Duchamp. Took part in the dada movement in Paris.

DUX, HUGO

Czech dadaist. — Was appointed "Chief of dadaists" in Czechoslovakia at a dada manifestation held on February 26th, 1920 at Teplice.

ÉCOLE D'ARCUEIL (SCHOOL OF ARCUEIL)

This was not a "school" in the accepted sense, but an association of artists who had chosen Satie as their idol (Arceuil was the residence place of Satie). Members of this group were Henri Cliquet-Pleyel, Roger Desormière, Maxime-Jacob, and Henri Sauguet. For the continuation of the dadaist spirit this group became more important than the "Groupe des Six".

Marcel Janco: Portrait of Viking Eggeling. Drawing, 1919

EGGELING, VIKING

* 12. 10. 1880, Lund (Sweden). † 19. 5. 1925, Berlin. Swedish painter. Got to Paris in 1911 and met Modigliani, Othon Friesz and Kisling. In 1915 he met Arp and then went to Switzerland, where he made the acquaintance of Tristan Tzara who introduced him to the dada movement. In 1916 he began experimenting with abstract shapes and in 1918 went to Germany with Hans Richter, where the two experimented together for some time with abstract films.

Between 1919 and 1920 he created the two abstract scrolls "Horizontal-Vertical Mass" and "Diagonal-Symphonie", the fundamental work for the first "absolute" film, "Diagonal-Symphonie", wich he succeeded in producing in 1921 and which received its first public performance in Berlin, 1923. Hans Arp in his reminiscences "Dadaland", writes about Eggeling: "I made Eggeling's acquaintance in Paris, at the studio of Mme. Wassilieff, in 1915 . . . Eggeling was living at the Boulevard Raspail, in a sinister and damp studio. Opposite to him lived Modigliani. Eggeling was painting little in those days, he discussed about his art for hours. I met him again in

1917, at Zurich. He was exploring the rules of a plastic counterpoint, composing and sketching its first elements, tormenting himself to death. On big scrolls of paper he had put down some kind of hieratic writing consisting of exquisitely beautiful and well-proportioned figures. These figures grew, split up, multiplied, changed places; groups of them got entangled, disappeared and reappeared again in part, and ranged themselves in some imposing construction according to the architecture of vegetable forms. He called his papers 'Symphonie'."

EINSTEIN, CARL
* 26. 4. 1885 Berlin. German poet and art critic. Called a participant in the dada movement by Tristan Tzara in "Dada", No. 6. s. B.

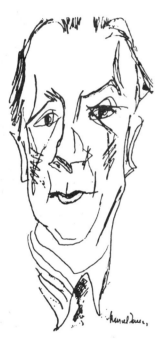

Marcel Janco: Portrait of Paul Eluard. Drawing

ELUARD, PAUL
(Pseudonym for Eugène Grindel)
* 14. 12. 1895 in Saint-Denis, s. Seine. † 18. 11. 1952. French poet. At the beginning of his creative work he was linked with the Paris dada movement, later with surrealism. Editor of the periodical "Proverbe". Collaborated in numerous dadaist publications. s. B.

ENTARTETE KUNST (DEGENERATED ART).
This was the slogan with which the Nazi government of Germany organised great excesses of vandalism against German art galleries in 1937. Thousands of pictures and engravings of the most famous German and foreign painters were seized. Part of these works were pilloried and ridiculed in the infamous travelling exhibitions "Degenerated Art", which were shown in nearly all the big cities

of Germany. At the "famous" auction sale (Fischer Gallery, Lucerne, June 30th, 1939), 125 works were knocked down by order of the German government, among them paintings by Braque, Chagall, Gauguin, van Gogh, Marc, Matisse, Modigliani, Picasso, etc. Thousands of important works succumbed to this medieval outrage. One of the central points of these exhibitions was the section "dadaism", containing works by Arp, Doesburg, Ernst, Dix, Grosz, Schwitters and others.

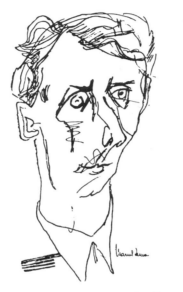

Marcel Janco: Portrait of Max Ernst. Drawing

Max Ernst: Drawing, 1919

ERNST, EUGEN
German dadaist. A signatory of the manifesto "Dadaists against Weimar".

ERNST, MAX
* 2. 4. 1891 in Brühl, near Cologne. Painter, poet. Studied philisophy at the Bonn university (1909—1911). Never had any formal artistic training. Exhibited at the First German Autumn Saloon "Sturm", Berlin, 1913, and in the same year went to Paris for the first time. There he came to know the work of Picasso and de Chirico. In 1914 he met Arp at the "Werkbund" exhibition, Cologne. Further exhibition at the "Storm" gallery, Berlin, in 1916. In 1919 he founded, together with Arp and Baargeld, the Cologne dada group and collaborated with Arp in the creation of the "Fatagaga" collages ("Fatagaga" = "Fabrication de tableaux garantis gazométriques" = "Manufacture of guaranteed gasometric pictures"). Co-editor of "Dada W 3" and "Schammade". Organized the dada-exhibition in the "Brauhaus Winter", which was closed by the police as contrary to "morals". In 1920 first exhibition of collages at the "Sans Pareil" gallery, Paris. Took part in the dada-meeting in Tyrol 1921, together with Arp, Breton and Tzara. Contribution to "Dada in Tirol, Au Grand Air, Der Sängerkrieg". Went to Paris in 1922. Contributor to many dadaist publications. Took an active part in the foundation of surrealism and became one of the leading surrealist painters. s. B.

J. Evola: Composizione. Woodcut ('Arte atratta' Collection Dada)

EVOLA, J.
Italian dadaist. Co-editor of "Bleu" the Italian periodical with dadaist tendencies. s. B.

FATAGAGA
Abbreviation for "Fabrication de tableaux garantis gazométriques» — Manufacture of guaranteed gasometric pictures. A series of collages created in collaboration, by Hans Arp and Max Ernst in Cologne, 1919.

FILM

Dada artists concerned with the problems of films were Marcel Duchamp, Viking Eggeling, Man Ray, and Hans Richter. Their experiments aimed chiefly at a solution of the problem of the "absolute film".

FLAKE, OTTO

* 29. 10. 1882 Metz. German writer and poet. Took part in the dada movement and contributed to dada publications. s. B.

FRAENKEL, THEODORE

* 27. 4. 1896 Paris. French writer and dadaist. Contributed to dadaist publications. Friend of Breton.

GIACOMETTI, AUGUSTO

* 16. 8. 1877 in Stampa, (Switzerland), † 1947. Swiss painter. Hans Arp wrote of him in "Dadaland": "In 1916 Augusto Giacometti had already 'arrived', yet he loved the dadaists and would often mingle with their demonstrations". He took part in the "Artistes Radicaux" group.

GLAUSER, FRIEDRICH

Swiss writer. Took part in the Zurich dada movement. Signatory of the Berlin dada manifesto, 1920. Later joined the foreign legion. Became a successful author of detective stories, which were turned into motion pictures in Switzerland ("Constable Studer" etc.) s. B.

GLEIZES, ALBERT

* 8. 12. 1881, Paris; † 1953 at St. Rémy (France). French painter and writer; one of the founders of the "Golden Section" group in Paris. Together with Metzinger he published the first book on cubism, "Du cubisme" (1912). In 1915 he exhibited at Barcelona and in the same year went to New York where he took contact with the Stieglitz group. In 1919 he went to Paris and sympathized at first with the dadaists, but in 1920 he published an article "L'affaire dada", in which he went on record as an opponent. s. B.

GROSZ, GEORGE

* 26. 7. 1893 Berlin. Painter, writer and caricaturist. Studied at the Dresden and Berlin academies. Contributed to satirical periodicals. Came to the Berlin dada movement in 1918. Edited the periodicals "Die Pleite" ("Bankruptcy") together with Wieland Herzfelde; "Jeder sein eigener Fussball" (Everyman his own Football") with Franz Jung; and "Der blutige Ernst" ("In Bloody Earnest"), with Carl Einstein. On his dada period he wrote in his book "Art In Danger": "Civilian again, I experienced in Berlin the rudimentary beginnings of the dada movement, the start of which coincided with the 'swede' period of malnutrition. The roots of this German dada movement were to be found in the recognation that it was perfectly crazy to believe that the spirit, or anything spiritual ruled the world. Dadaism was the only significant artistic movement in Germany for decades. Dadaism was no artificially fostered movement but an organic product, at its origin a reaction to the cloudlike ramblings of so-called sacred art. Dadaism forced artists to declare openly their position . . . What did the dadaists do? They said that it did not matter whether a man blew a 'raspberry' or recited a sonnet by Petrarca or Shakespeare or Rilke, whether he gilded jack-boot heels or carved statues of the Virgin. Shooting went on regardless, profiteering went on regardless, people would go on starving regardless, lies would always be told regardless — what was the good of art anyway? In those days we saw the mad final excrescences of the ruling order of society, and burst out laughing. We did not yet see that there was a system behind all this madness." George Grosz was the most pitiless caricaturist of the German bourgeoisie and of German militarism. In 1925 he approached that type of realism designated as "new matter-of-factness". In the U. S. A., where he went in 1932, his pictures assumed romantic, idyllic overtones. Looking back on it all, he wrote in his autobiography "A Little Yes And A Big No": "Artistically speaking we were 'dadaists' in those days. If that meant anything it was a disquiet, a dissatisfaction, a delight in mockery, that had all been fermenting a long time already. Every defeat, every upheaval gives birth to such movements. In another period we might have been flagellants . . . Huelsenbeck imported dada to Berlin, and it assumed immediately political features. The aesthetical side was preserved, but got more and more supplanted by a kind of anarchist-nihilistic politics, chiefly propounded by the writer, Franz Jung." s. B.

LE GROUPE DES SIX

This name designates a group of French musicians comprising Germaine Tailleferre, Georges Auric, Louis Durey, Arthur Honegger, Darius Milhaud and Francis Poulenc. Georges Auric and Darius Milhaud maintained contact with the Paris dada group.

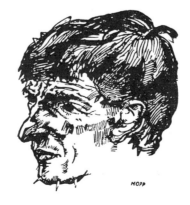

Mopp: Portrait of Ferdinand Hardekopf.
Drawing

HARDEKOPF, FERDINAND

* 15. 12. 1876 in Varel-on-Jade (Germany). † 26. 3. 1954 Zurich. German writer. Was in Zurich in 1916, contributed to "Dada" No. 3. s. B.

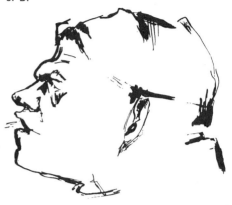

Hans Richter: Portrait of Raoul Hausmann.
Drawing, 1915

HAUSMANN, RAOUL

* 12. 7. 1886 Vienna. Painter, sculptor and writer. One of the founders of the Berlin dada movement, he was also called "Dadasopher". Author of a number of dada publications, poetical whimsies, experimented also upon photo-montages. Editor of the periodical "Der Dada", Berlin. s. B.

HEARTFIELD, JOHN

Took part in the dada movement in Berlin. Also known under the name of "Dada-Monteur" ("Dada Fitter".) Considerable expert of photo-montages. One of the editors of the Berlin periodical "Der Dada". Was the main organiser of the "First International Dada Fair", Berlin 1920. s. B.

HELBIG, WALTER

* 9. 4. 1878 Frankenstein (Germany). Swiss painter. Exhibited at the first dada exhibition, Zurich 1917. Later took part in the "Artistes Radicaux" group.

HENNINGS, EMMY

* 17. 2. 1885 at Flensburg (Schleswig). † 1948 at Magliaso (Ticino). Wife of Hugo Ball. Made his acquaintance in 1913 and went to Zurich with him in 1915, where she helped to found the "Cabaret Voltaire" and took part in its performances. The "Zürcher Post" wrote of her on 7. 5. 1916: "The star of the cabaret however, is Mrs. Emmy Hennings. The star of who knows how many nights and poems. Just as she stood before the billowing yellow curtain of a Berlin cabaret, her arms rounded up over her hips, rich like a blooming bush, so to-day she is lending her body with an ever-brave front to the same songs, that body of hers which has since been ravaged but little by pain." Emmy Hennings also published some poems and books. s. B.

HERZFELDE, WIELAND
Brother of John Heartfield. Founded the "Malik" publishing house, Berlin, which brought out a number of dadaist publications.

Der blutige Ernst (Berlin 1919)

Arbeiten und nicht verzweifeln!
SONDERNUMMER IV. DIE SCHIEBER.

HEUBERGER, JUL.
Printer of the Zurich dada publications. He maintained friendly contact with the dadaists there.

HEUSSER, HANS
* 6. 10. 1892 at Zurich. † 1954 at St. Gall. Swiss composer and pianist. Studied music at Zurich, then under Vincent d'Indy at the Paris Schola Cantorum. During the first world war he was employed as music master and conductor at various theatres in Switzerland. Took part in the Zurich dada events.

HILSUM, RENÉ
Director of the Edition "Au Sans Pareil", Paris, which edited a great part of the dada-publications in Paris. Also arranged an exhibition for dada artists.

HOECH, HANNAH
* 1. 11. 1889 Gotha. Painter, photo-montage artist. Contributed to the Berlin dada movement 1918—1920. In 1921 she took part in the Prague dada manifestation, together with Kurt Schwitters and Raoul Hausmann.

HODDIS, JAKOB VAN
* 1884 in Berlin. Lyric poet. Contributed to Zurich dada publications. Friend of Emmy and Hugo Ball. s. B.

HOERLE, ANGELIKA
* 1899 Cologne. † 1923. Painter. Wife of Heinrich Hoerle. Created "collages". Now and then contributions to different dada-publications in Germany.

HOERLE, HEINRICH
German painter and writer. Belonged to the Cologne group of "Progressive Artists" and was a friend of Max Ernst. He took part in the dada exhibition at the "Brauhaus Winter" and was a contributor to the periodical "Schammade", 1920. Later still in Cologne, he edited the periodical "a—z" (30 numbers, 1929—33), together with the painter Seiwert.

HUELSENBECK, RICHARD
* 23. 4. 1892 at Frankenau, Hessen (Germany). Now lives in New York under the name of Charles R. Hulbeck and practises psycho-analysis (Jungian system). Took a prominent part in the foundation of the Zurich and Berlin dada movements. He had been an expressionist poet and writer. Came to Zurich in February 1916 as a ware-resistor and immediately came into contact with the "Cabaret Voltaire". He returned to Berlin in January, 1917, initiating there the dada group (1918). Hugo Ball wrote of him, in his "Escape from Time", on February 11th, 1916: "Huelsenbeck has arrived. He pleads for an intensification of rhythm (Negro rhythm). He would best love to drum literature to perdition." Edited the "Dada Almanach", Berlin 1920, and wrote "En Avant, Dada", a history of dadaism, in the same year. The author of numerous other dada publications. He claims to this very day that dada is still existing, thus placing himself in direct opposition to the other founders of dadaism. s. B.

Der blutige Ernst (Berlin 1919)

HUIDOBRO, VINCENTE
* 1889 in Santiago de Chile. Poet, contributed to dada publications in Zürich, 1916/17; "North/South", Paris 1917; editor of the periodical "Creación, Revista Internacional del Arte", Madrid 1921. s. B.

JANCO, MARCEL
* 24. 5. 1895 at Bucharest (Roumania). Painter and architect. One of the founders of dadaism in Zurich. Made posters, decorations and masks for the "Cabaret Voltaire". From 1919 onwards editor of "Contimporanul", Roumanian avant-gardist art periodical. Is now living at Tel-Aviv, Israel. Founder of the Israelian artist village "Ein Hod". Hugo Ball wrote about Janco, in his book "Escape from Time", on May 24th, 1916: "At the moment Janco is especially close to me. He is a tall, slim man remarkable for his capacity to feel embarassed for other people's stupidity and oddness and then to ask forgiveness for them with a smile or some tender gesture. He is the only one among us who does not need irony to get over the times. When he thinks he is unobserved, a certain melancholic seriousness gives him an air of contempt and supercilious pompousness. For the new

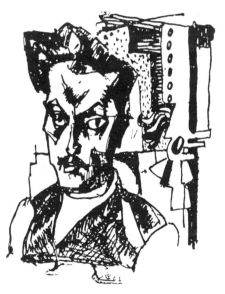

Marcel Janco: Self Portrait, 1922

soirée Janco has made a number of masks which are more than just skilful. They remind one of the Japanese or classical Greek theatre, and yet they are thoroughly modern. Being calculated for effect at a distance, they make a terrific impression in the relatively small compass of the cabaret ..." Hans Arp, a close friend of Janco, wrote of him, in his reminiscences "Dadaland": "In secret, in his quiet little room, Janco was devoted to a zig-zagging naturalism. I forgive him this hidden vice, for he has conjured up and defined the "Cabaret Voltaire" on one of his canvasses ... Do you still sing that diabolical song of the mill at Hirza-Pirza, shaking your gypsy's curls with a ferocious laugh, my dear Janco? I have not forgotten those masks you contrived for our dada manifestations. They were terrifying and mostly daubed with

a bloody red. With cardboard, paper, hair, wire and cloth, you manufactured your languishing embryos, your lesbian sardines, your ecstatic mice. In 1917 Janco created some abstract works, and they are continuing to increase in importance. He was a passionate man who had faith in the evolution of art." In 1919 Janco also took part in the foundation of the "Artistes Radicaux" group in Switzerland. He took part in dada exhibitions and illustrated a number of dada publications with wood-cuts. W. Jollos writes of Marcel Janco in the catalogue of the exhibition at the Wolfsberg gallery, Zurich: "...Janco's art, however, takes its forms from architectonics, which lends scale and sense to every member. The very wall, the thing stationary, has seized on the fairy tales of his scintillating flower beds. A creature is no longer lost, it marvels, smilingly, at the vision of some universal sense. The wall weaves a mantle of timelessness as a screen round the fears of solitude, that timelessness that is innate in the works and the will of modern art as aim and as gratification." s. B.

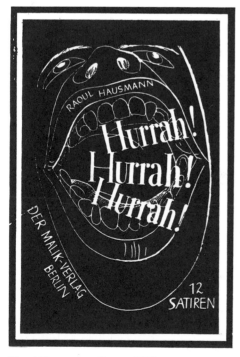

Raoul Hausmann: Cover, 1921

JARRY, ALFRED
* 1873 at Laval (France), † 1907. French writer and dramatist. His puppet play (Punch-and-Judy show), "King Ubu" had some influence on the French dada authors. He is thus called one of the precursors of dadaism. s. B.

JUNG, FRANZ
German writer, took an active part in the Berlin dada movement. George Grosz wrote of him in his autobiography "A Little Yes And A Big No": "Jung was a figure straight out of

Rimbaud, the prototype of the bold undaunted adventurer. He found his way to us and, being of a forceful nature, exerted his influence on the whole of the dada movement. He was a great drinker and wrote books in a style that was hard to read. He attained fame for a few weeks when, together with his helper, a sailor named Knuffgen, he captured a steamer in the middle of the Baltic, had brought it to Leningrad, and presented it to the Russians ... He was one of the most intelligent men I ever met, but also one of the unhappiest." Jung also was co-editor of the periodical "Club Dada", Berlin 1918. s. B.

Phantastische Gebete

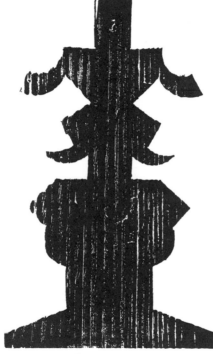

Verse von RICHARD HUELSENBECK mit 7 Holzschnitten von HANS ARP Colection DADA Zürich im Semptember 1916

Hans Arp: Cover

KANDINSKY, WASSILY
* 4. 12. 1886 in Moscow; † 13. 12. 1944 in Paris. Russian painter, poet and art theorist. Took no direct part in the dada movement, but his works were shown at several exhibitions of the dada gallery. Ball, especially, greatly revered the master, whose acquaintance he had made at Munich in 1912. "When we say Kandinsky and Picasso, we are not speaking of painters, but priests, not of artisans, but creators of new worlds, new paradises." ("Flucht aus der Zeit", p. 10) "In those days Munich had in its midst an artist who lent that city, by his sole presence, a precedence in modernity above all other German cities: Wassily Kandinsky. One may find this estimation exaggerated; but that is what I

felt at the time. What can be better, more beautiful for a city than to be the residence of a man whose work is the liveliest, most noble directive? When I made the acquaintance of Kandinsky, he had just published 'Das Geistige in der Kunst' and, together with Franz Marc, the 'Blaue Reiter', two programmatic books with which he founded expressionism, later to degenerate so considerably. The variety and thoroughness of his interests were astonishing, but even more so were the loftiness and delicacy of his aesthetic conception. He was chiefly occupied with the re-birth of society out of an unification of all artistic means and powers. He had never tried his strength in any branch of art without going entirely new ways, needless of mockery and laughter ..." (p. 12). On April 7th, 1917, Ball gave a lecture on Kandinsky at the dada gallery. "Yesterday I gave my talk on Kandinsky: I have realised a favourite plan of long standing. Art in its entirety: Pictures, music, dances, verses—they are all here now. Coray would like to print the lecture together with one given by Neitzel and a number of reproductions." ("Flucht aus der Zeit", p. 157).

KLEE, PAUL
* 18. 12. 1897 at Münchenbuchsee near Berne, † 29. 6. 1940 at Muralto-Locarno (Switzerland). Works by Klee were shown at several exhibitions of the "Cabaret Voltaire" and the "Galerie Dada". On March 31st, 1917, Waldemar Jollos gave a lecture on Klee at a small exhibition of the artist's works at the "Galerie Dada". Under April 1st, 1917, Ball wrote of him: "What irony, intensified to the degree of sarcasm, this artist must have for our empty, jerry-built epoch. There is perhaps no other person to-day who possesses himself to such an extent. He hardly ever divests himself of inspiration. The shortest link is maintained between an idea and the empty sheet. The far-reaching, dissipating extensions of hand and body that Kandinsky needs to fill the huge sizes of his canvases with paint must needs lead to waste and exhaustion. Elaborate clarifications, explanations are required: If it desires to maintain a unity and a soul, painting becomes a sermon or music." (Flucht aus der Zeit", p. 156).

KNOBLAUCH, ALFRED
* 25. 5. 1882 Harburg (Germany). Writer and poet from the circle "Der Sturm". s. B.

KÜPPER, CHRISTIAN E. M. see DOESBURG, THEO VAN

LACROIX, ADON
French painter, took part in the dada movement. Contribution to "Dada-Almanach".

LISSITZKY, EL
* 10. 11. 1890 at Smolensk, †1941 in Moscow. Painter. Studied at the Darmstadt technical college, 1909 to 1914, returned to Russia,

where he was influenced by Malevich and the constructivists. In 1919 he created a series of paintings and drawings which he designated by the collective name of "Proun". Became professor at the Moscow academy in 1921 and went to Germany in the same year. Together with Hans Richter and Hans Gräff, he published, 1923, the journal "G. Material zur elementaren Gestaltung". In 1925 he published, together with Hans Arp a book called "Kunstismen", in which a part is devoted to dadaism. s. B.

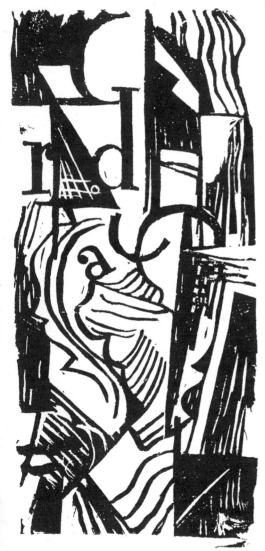

Raoul Hausmann: Construction A1. Woodcut

LITERATURE AND DADA

In poetry dada found the most consistent expression in the free word-and-sound dynamism of the poems of Hugo Ball, Hans Arp, Paul Eluard, Hausmann, Kurt Schwitters and Tristan Tzara. Christian Morgenstern, Paul Scheerbart, Lewis Carroll and others may be regarded as precursors, while in the neo-realist novels of Joyce, Dos Passos, and the

early Alfred Döblin the "simultaneous" method may be traced back to dadaism.

LUETHY, OSKAR

1885—1945. Swiss painter and architect. Member of "Der Moderne Bund" (together with Arp, Klee, Gimmi and others). He exhibited at the "Sturm" gallery, Berlin, in 1913, and at the first dada exhibition, Zurich 1917. He was one of the signatories of the "Dadaist Manifesto", Berlin 1920.

MALIK VERLAG, BERLIN

Avantgardist publishing house founded by Wieland Herzfelde. Published the periodicals "Der Dada" and other dadaist publications.

MARINETTI, FILIPPO TOMASO

* 22. 12. 1876 at Alessandria (Italy); † 2. 12. 1944 at Milan. Italian writer. He was the founder of futurism, which exerted a certain influence on dadaism. (The simultaneous method and the typographie).

MEHRING, WALTER

* 29. 4. 1896 in Berlin. German writer and poet. Took an active part in the Berlin dada movement. In 1920 he founded the "Political Cabaret" in Berlin, which had extreme left tendencies. In his book "The Lost Library", he wrote among other things: "Grosz brought me to dadaism ... Quite wrongly, people have presented dadaism as a philosophically clearly defined conception of the world. In reality the genuine dadaist is distinguished from others by the very fact that he had no conception, that everything that existed was to him just 'Dada'." s. B.

MERZ

On one of his first paste pictures Schwitters utilised a letterhead of the "Privat- und Kom-MERZbank", Hanover. The astonishingly simple word "Merz" thenceforward gave a name to all his painting, poetry, a periodical, etc. He himself wrote at the end of 1918: "... that all values exist only by virtue of their relation to one another and that all limitations imposed upon a material is petty. Out of this recognition I created "Merz", at first as the sum of single branches of art, MERZ-painting, MERZ-poetry... My final ambition is the unification of art and non-art to result in a universal MERZ philosophy of life." s. B.

MEYER, ALFRED RICHARD

* 4. 8. 1882 at Schwerin, Mecklenburg (Germany). Publisher and writer under the pen-name of "Munkepunke". Took part in the Berlin dada movement and was a member of the so-called "Dadaist Central Revolutionary Council".

MILHAUD, DARIUS

* 4. 9. 1892 at Aix-en-Provence (France). Composer. He took part in dadaist meetings at the Café Certa, Paris 1920 together with Erik Satie.

MOPP (= MAX OPPENHEIMER)

* 1885 in Vienna. Painter and designer. Was in Zurich in 1916 and appeared several times at the "Cabaret Voltaire". s. B.

PACH, WALTER

Mentioned by Tristan Tzara in "Dada" no. 6 in the list of "Quelques Présidents et Présidentes" of the dada movement. One of the organizers of the famous "Armory-Show" in New York 1913.

PANSAERS, CLÉMENT

Belgian writer. Contributed to "Littérature", Paris and published at Brussels a volume of poetry of dadaist leanings: "Le pan pan au cul du nègre". (1920).

PAPIERS, COLLÉS see "COLLAGES"

PARTENS, ALEXANDER

German dadaist. Contributed an article entitled "Dada Art" to the "Dada Almanach", Berlin 1920. The name is probably a pseudonym.

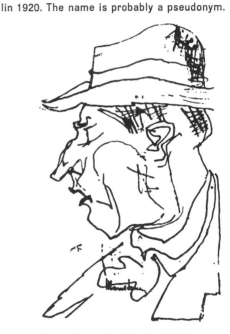

Marcel Janco: Portrait of Benjamin Péret. Drawing

PÉRET, BENJAMIN

* 4. 7. 1899 at Rezé, Loire (France). French poet. One of the first to join the Paris dada movement. Contributed to a number of dada publications. 1924—1928 edited together with Pierre Naville the periodical "La révolution surréaliste".

PHOTOGRAMME

Excludes the camera as mediator between source and recipient of light. Objects already existing — or made especially for the purpose — are placed, haphazardly or with some design, on a sensitive plate and left there for longer or shorter periods of time. Thus a variety of impressions are formed. Artists occupied with photogrammes were among others: Man Ray (Rayography), Christian

Schad (Schadography); László Moholy-Nagy, who was very much influenced by Kurt Schwitters' collages.

PHOTO-MONTAGE

Serveral dadaists made use of this combination of photography and painting or other graphic art. Photo-montages mostly represented a breaking-up of shapes. Photo-montage was mainly applied by the German dadaists: Baader, Max Ernst, George Grosz, John Heartfield, Hannah Höch, Man Ray, Raoul Hausmann.

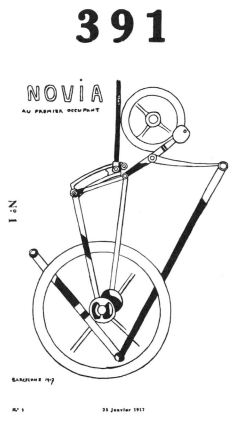

Francis Picabia: Cover for *391* (Barcelona 1917)

PICABIA, FRANCIS

* 22. 1. 1879 in Paris. † 1953 in Paris. Painter, drawer and poet, of Spanish descent. He studied at the Ecole des Beaux-Arts and at the Ecole des Arts décoratifs of Paris. Up to 1908 he painted impressionist pictures in the manner of Sisley. In 1909 he came under the influence of the cubists. Between 1911 and 1912 he took part in the Sunday meetings at Jacques Villon's studio at the village of Puteaux, together with Apollinaire, Gleizes, La Fresnaye, Léger, Metzinger, a.s.o., which led to the foundation of the "Golden Section". He exhibited at the latter's show. Was a close friend of Apollinaire. In February 1913, he went to the United States for the first time and exhibited at the "Armory Show". Stieglitz arranged an exhibition of his water-colours

at his gallery. In 1914 he was mobilised in France. In 1915 he went to the United States for the second time and collaborated with Marcel Duchamp. The periodical "291" of the Stieglitz group published proto-dada-works by Picabia, Catherine Rhoades and others. Towards the end of 1916 he turned up in Barcelona, where he met Cravan, Gleizes and Marie Laurencin. On January 25th, 1917, he published the first number of his periodical,

Francis Picabia: Self Portrait. Drawing, 1920

which he named "391" to recall the Stieglitz group's "291". In it he published his first "Mechanical Drawings" and false informations about friend and enemy. In the same year he went to America once more and there published further numbers of his periodical, assisted by Marcel Duchamp. In 1918 he made his appearance at Lausanne, where he published a book entitled "Poèmes et dessins de la fille née sans mère ("Poems and drawings of the girl born without a mother"). In February he took connection with the Zurich dada group and contributed to «Dada" No. 3. In 1919 he published No. 8 of his periodical "391" printed by Jul. Heuberger, the printer of the Zurich dadaists. He was represented in "Dada" No. 4/5. He returned to Paris, published further numbers of "391", and took part in dada demonstrations. In 1920 he published a periodical, "Cannibale" and in 1921, together with Breton and others, he dissociated himself from orthodox dadaists. Later he contributed to the periodicals and exhibitions of the surrealists. In 1949 a big retrospective exhibition was organised at the Drouin gallery Paris. The catalogue for the exhibition, titled "491", came out in the size of a newspaper. It contained articles by Bott, Breton, Cocteau, Desnos, Seuphor, Tapié and others. s. B.

PICASSO, PABLO

* 25. 10. 1881 at Malaga. Took unwittingly part in the first dada exhibition at the Cabaret Voltaire, Zurich, 1916. Arp, who knew Picas-

so, put some of his etchings at the disposal of the exhibition. Picasso's "papiers collés" were precursors of dadaist "collages".

Francis Picabia: Drawing from *Poemes et dessins de la fille née sans mère* (Lausanne 1918)

PRAMPOLINI, ENRICO

* 20. 4. 1895 at Modena (Italy). Painter, architect and graphic artist. As a futurist he nevertheless exhibited at the first dada exhibition, Zurich. One of his woodcuts appeared in "Dada" No. 3.

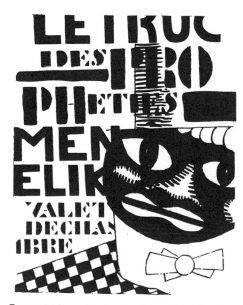

Fernand Léger: Illustration from Blaise Cendrars, *La fin du monde* (Paris 1919)

PREISS, GERHARD

German dadaist, one of the signatories of the dadaist manifesto. Berlin 1920.

RAY, MAN

* 1890 at Philadelphia (USA). Painter, photographer, film-designer. Most important American dadaist. Together with Duchamp and de Zayas he founded the New York dada group. Edited, tougether with Marcel Duchamp, one number of the periodical "New York Dada" in 1920. Came to Paris in 1921. Experimented above all with the mediums of photography and the film. Created the so-called "Rayographs" (photographs made without a lens), also known as "photogrammes". Dada exhibition of works by Man Ray in Paris, 1921. s. B.

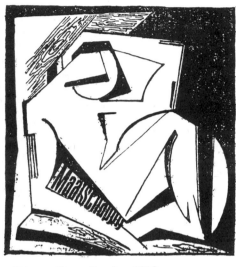

Otto van Rees: Drawing, 1916

REES, OTTO VAN

* 20. 4. 1884 Freiburg i. B. (Germany). Dutch painter. Together with Arp he exhibited abstract pictures at Zurich, 1915. Also took part in the first dada exhibition, Zurich 1917. One of the signatories of the "Dadaist Manifesto" Berlin, 1920. His wife, A. C. van Rees created tapestries with abstract designs.

REVERDY, PIERRE

13. 9. 1889 at Narbonne (France). French poet. In 1917 he edited the pre-dadaist periodical "Nord-Sud", to which contributed. among others, Apollinaire, Max Jacob, André Breton and Louis Aragon. s. B.

RIBEMONT-DESSAIGNES, GEORGES

* 1884. French painter and writer. Was very active in the Paris dada movement, occasionally serving as its secretary. His dadaist works were exhibited in Paris in 1920. Contributed to a number of dada publications. s. B.

RICHTER, HANS

* 1888. Painter, graphic artist, avantgardist, film-experimenter and -producer. First contacts with modern art in 1912 through the "Blauen Reiter" and in 1913 through the "Ersten Deutschen Herbstsalon" gallery "Der Sturm", Berlin. In 1914 he was

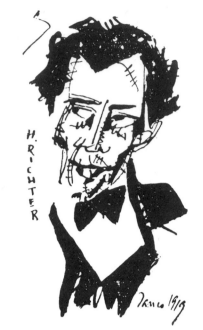

Marcel Janco: Portrait of Hans Richter. Drawing, 1919

influenced by cubism. Contributed to the periodical "Die Aktion", Berlin. First exhibition in Munich, 1916. "Die Aktion" published a special edition about Hans Richter. In the same year he went to Zurich and joined the dada movement. Richter propounded the thesis that the artist's duty was to be actively political, opposing war and supporting the revolution. First abstract works in 1917. Friendship with Viking Eggeling in 1918, the two experimented together (film). Was cofounder, in 1919, of the Association of Revolutionary Artists ("Artistes Radicaux") at Zurich. In the same year he created his first: "Prélude" (Orchestration of a theme developed in eleven drawings). In 1920 he was a member of the November group, Berlin, contributed to the Dutch periodical "De Stijl". In 1921 he made the first abstract film "Rhythme 21", which to-day is a classic of avantgardist films. About Richter's woodcuts and drawings Michel Seuphor wrote: "Richter's black-and-whites together with those of Arp and Janco, are the most typical works of the Zurich period of dada". From 1923 to 1926 Richter edited, together with Werner Gräff and Mies von der Rohe, the periodical "G. Material zur elementaren Gestaltung". Hans Richter wrote of his own attitude towards films: "I conceive of the film as a modern art form particularly interesting to the sense of sight. Painting has its own peculiar problems and specific sensations, and so has the film. But there are also problems in which the dividing line is obliterated, or where the two infringe upon each other. More especially, the cinema can fulfil certain promises made by the ancient arts, in the realisation

of which painting and film become close neighbours and work together."
Hans Richter finshed 1957 a film named "Dadascope" with original poems and prosa spoken by their creators: Jean Arp, Marcel Duchamp, Raoul Hausmann, Richard Huelsenbeck and Kurt Schwitters. s. B.

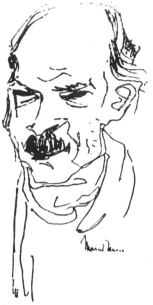

Marcel Janco: Portrait of Georges Ribemont-Dessaignes. Drawing

RIGAUT, JACQUES

1889—1929 French author. Contributed to a number of dada publications in Paris. He destroyed most his works before their publication. Committed suicide in 1929. s. B.

ROSSINÉ, DANIEL

Russian painter with an affinity to dadaism. Friend of Hans Arp.

SATIE, ERIK (in full ALFRED ERIC LESLIE)

* 17. 5. 1866 at Honfleur, Calvados, France; † 2. 7. 1925 in Paris). French composer. One of the most important rejuvenators of French music acting in the spirit of anti-romanticism and irony. Employed as a postal clerk at Arceuil (near Paris) he wrote numerous musical works of a very independent style and frequently with a provocative programme. The climax of this caricaturist tendency was the ballet, "Parade", performed by Diaghilew's Ballets Russes in Paris in 1917. This gave occation to a historic theatrical scandal. There is evidence of Satie's interest and participation in dada manifestations. By way of the "Groupe des Six" (s. th.) and the "School of Arceuil (s. th.) he has exerted an essential influence on the spirit of modern French music. s. B.

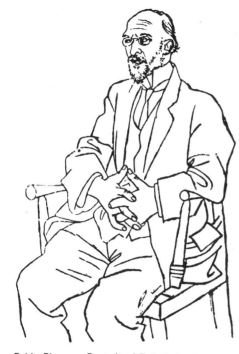

Pablo Picasso: Portrait of Erik Satie. Drawing

SCHAD, CHRISTIAN
* 1894 Miesbach. German graphic artist. Worked actively with the Zurich dada movement, 1916 to 1918. Created a great number of woodcuts and so-called "Schadographies" (Photogrammes), which appeared in Zurich dada publications. These photogrammes are a combination of collage, photogramme and photo-montage. s. B.

SCHIEBELHUTH, HANS HEINRICH
* 11. 10. 1895. Darmstadt. German poet and writer. His dadaist activity consisted in the editorship of the periodical "Der Zweemann", Hanover 1919—20. s. B.

SCHLICHTER, RUDOLF
* 6. 12. 1890 Calw. † 1955 German painter. At the first international dada fair, Berlin, 1920, he exhibited "a life-sized true-to-life puppet of a general, which was invisibly suspended from the ceiling high above the heads of the terrified and exasperated spectators" (George Grosz).

SCHMALHAUSEN, OTTO
Took part in the Berlin dada movement. George Grosz wrote of him: "Another member of the German dada movement was Schmalhausen, my brother-in-law. He has become part of dada history under the name of Dadaoz; he was also given the title of Dada-Diplomat, and as such he was seconded to me, the Propaganda-Dada".

SCHWITTERS, KURT
* 20. 7. 1887 at Hanover. † 8. 1. 1948 at Ambleside, Westmorland (England). German painter, sculptor and poet. Founder of "MERZ", a German variety of dadaism. After studying at the Dresden academy, a short period of military service behind the lines and two semesters of studies in architecture, he came to the "Sturm" at Hanover, where he exhibited his first abstract pictures. In 1919 he created his first "MERZ"-pictures, "consisting of mutually incompatible parts, blended into a work of art with the aid of glue, nail, hammer, paper, rags, engine-parts, oil-paint, lace, etc." The first MERZ-poetry, based on similar principles of formation, appeared in the "Sturm" in 1919; in the same year he established contact with the Zurich dadaists, who published some poems and a picture by him in their periodical "Der Zeltweg". In 1920 he published the lithographs, "The Cathedral" and "Schwitters' Sturm Picturebook". Met Hans Arp, Raoul Hausmann and Hannah Höch. In 1919—20 he created his big MERZ-pictures and many of his finest collages. At that time he also started the famous "MERZ-structure" at his house in Hanover, a painted plastic collage construction which grew in the course of the years through two storeys and down into a water cistern. "The Great Pillar", or "Cathedral of Erotic Distress", an important part of the edifice, contained the following elements: "Niblung Hoard", "Goethe Grotto", "Sexual Murder Den", "The Organ", "To the 10-per Cent War Disabled", "The Great Grotto of Love", a "Brothel", etc. In 1921 the Munich Goltz gallery organised a comprehensive Schwitters exhibition. During a dada and MERZ tour to Prague, together with his wife, Raoul Hausmann and Hanna Höch, he heard Hausmann's phonetic poem "fmsbw" for the first time. It became the germ of his "primordial Sonata", over which he was to work consistently until 1932. In 1922 he took part in the great Dada Congress at Weimar. In Holland he participated in the "Dada Campaign", together with Theo and Petra van Doesburg and contributed to "Mécano", the Dutch dada periodical. In 1923, he began editing the "MERZ"-publications, with contributions by Arp, Doesburg, Hausmann, Höch, Lissitzky, Mondrian, Picabia, Tzara and others. In 1927 he took up a post as publicity-man and typographer, then emigrated to Norway in the same year, where he began his second "MERZ-building" (It was destroyed in a fire accidentally started by playing children). In 1940 he escaped to England with his son Ernst before the invading German troops and was interned for months. After his release from internment camp he earned his livelihood with portrait painting, and besides created collages and sculptures. His house at Hanover, which contained the "MERZ-structure", was destroyed in an air-raid in 1943. A fellowship granted by the New York Museum of Modern Art enabled him to start a third "MERZ-structure", but it remained unfinished. s. B.

SCULPTURE AND DADA
Carola Giedion-Welcker, a recognised connoiseur of modern art and especially of dadaism, said in her book "Sculpture in the 20th Century" some very significant things about dadaist sculpture (p. XIII): "Dadaism has made a "metaphysics of banality" out of the discovery of the natural expressiveness and plastic liveliness of the thing anonymous, which makes its appearance nearly everywhere in the modern movement. The dethronement of the snobbish "Artistocratic work of art", with a capital A, the anarchist rebellion against all traditional clichés, against all authority that has spent itself, all these brought back to the arts those everyday realities they had never thought worthy of consideration. The first dada sculptures, exhibited by Marcel Duchamp and Man Ray in New York, 1917—1919; by Hans Arp and Max Ernst at Cologne, 1918—1919; by Raoul Hausmann in Berlin; by Kurt Schwitters at Hanover (Merz-sculptures), they were not merely a bourgeois bugbear, a protest against the blind reiteration of sterile formulas for beauty — they were also signposts to the entire plastic, unheeded reality of our surroundings, of the innate truthfulness of what was termed "ugly". There the plastic primeval principle seemed to be more readily grasped than in the carefully selected items. Just as with the "collages" (Picasso, Braque, Miro, etc.), the sole point was inventiveness. Material was nothing; invention and wit everything. Just as there the butt was the sophisticated sensualism of painting, so here the target was the senseless marble cult of the material." Artists who had affinities to dadaism and were occupied with sculpture were: Hans Arp, Theo van Doesburg, Marcel Duchamp, Max Ernst, Raoul Hausmann, Marcel Janco, Kurt Schwitters, Sophie Taeuber-Arp etc.

SEGAL, ARTHUR
* 13. 6. 1875 Jassy (Roumania) † 23. 6. 1944 London. Painter. Took part in the dada movement and exhibited at the "Cabaret Voltaire" exhibition, Zurich, 1916.

SERNER, WALTER
Austrian writer. Took an active part in the Zurich dada movement, contributing to many Dada publications. Editor, or co-editor of the periodicals "Sirius" and "Der Zeltweg" which appeared in Zurich. Hans Arp wrote of Serner in his book "Dada-Land": "Later we were joined by Dr. Serner, adventurer, detective novel writer, sophisticated dancer, skin specialist and gentleman-burglar." s. B.

SLODKI, MARCEL
* 11. 11. 1892 Lodz. Murdered by the Nazis in France. Ukrainian painter and graphic artist. Took an active part in the Zurich

dada movement. Painted posters for the "Cabaret Voltaire". Exhibited at the "Galerie Dada", Zurich 1917.

Hans Richter: Portrait of Walter Serner. Drawing, 1916

SOUPAULT, PHILIPPE
* 2. 9. 1897 at Chaville, near Paris. French poet and writer. Was influenced by Lautréamont, Rimbaud and Apollinaire. Took a leading part in the Paris dada movement and contributed to numerous dada publications. Was co-editor of the periodical "Littérature". He later became a surrealist. s. B.

SPENGEMANN, CHRISTOPH
Editor (with Schiebelhuth) of the periodical "Der Zweemann", Hanover, 1919—20. Friend of Kurt Schwitters.

STEEGEMANN, PAUL
German publisher of the series "Die Silbergäule", in which dadaist works of Arp, Huelsenbeck, Schwitters, Vischer a. o. appeared.

STIEGLITZ, ALFRED
* 1864 at Hoboken, N. J. (USA). † 1946. American photographer. The most important sponsor of modern art in the USA. He was the owner of the "Stieglitz Gallery" at 291 Fifth Avenue, New York and publisher of the periodical "291". He was the first one, who exhibited creations of Henri Rousseau, Picasso a. s. o. in his gallery.

STRAVINSKY, IGOR
* 17. 6. 1882 Oranienburg (Russia). Composer. Mentioned in Tzara's list "Quelques Présidents et Présidentes" in "Dada" no. 6.

Cover for *Der Marstall* (Hanover)

TAEUBER-ARP, SOPHIE
* 19. 1. 1889 at Davos (Switzerland). † 13. 1. 1943 at Zurich. Swiss paintress. Studied at St. Gall, 1908—1910, and Munich, 1911—1913. Made the acquaintance of Hans Arp in 1915 and participated in the Zurich dada movement. At the same time she attended courses at the Laban School of Dancing and performed at dada manifestations. Later she was appointed as a professor at the Zurich School of Applied Art, which post she kept until 1928. Married Hans Arp in 1921. Died in 1943 as a result of a tragic accident in Zurich. She was one of the most prominent representatives of abstract art. Her works, though simple in form, are rich in their inventiveness. Hans Arp wrote of her in his reminiscencies "Dadaland": "I met Sophie Taeuber at Zurich in December, 1915. Already in those days she had liberated herself from traditional art. In our works we first of all suppressed everything that was playful and tasteful. The personal note, too, we felt to be a nuisance and purposeless, for it had grown in a rigid, lifeless world. We were looking for new materials, which was not used generally. Each for himself and together we began to embroider, weave, paint and paste geometrical, static pictures. Impersonal severe constructions were born out of planes and colours. Accident was eliminated entirely. No stains, no cracks, no slivers, no faults of any kind, must disturb the clarity of our work. For our paper pictures we dis-

qualified even the scissors with which we had been cutting our work at first and henceforth used a paper cutting machine, for the scissors could too easily betray the life of the hand. In those large co-operative embroideries, textiles, paintings and paste works, we tried humbly to approach the pure lustre of reality. I would call this work the art of silence. It turns away from the surrounding world towards silence, innermost being, reality. Out of oblongs and squares we erected radiant structures to profoundest sorrow and to highest joy. Our work was to make the world simpler, to transform it and make it more beautiful ... At various periods of our lives Sophie Taeuber and myself created together, first at Zurich in the years 1917 to 1919 ..."

TSCHARNER, J. W. von
* 1886—1946. Swiss painter. Exhibited at the first dada exhibition, Zurich, 1917.

TZARA, TRISTAN
Pseudonym of Sami Rosenstock — wrote in Roumania also as "Samiro".
* 4. 4. 1896 in Moineste (Roumania). Poet and writer using the French language. He was one of the mental originators of dadaism. He had come to Zurich with the intention of studying mathematics. Together with Janco his fellow-countryman, he came into contact with Hugo Ball and Hans Arp and, even before the foundation of the "Cabaret Voltaire", he frequented the "Meierei" beer cellar at the Spiegelgasse 1, in which later the "Cabaret Voltaire" gave performances. Tzara took part in the performances of the "Cabaret Voltaire" and in 1917 assumed the editorship of the periodical "Dada".

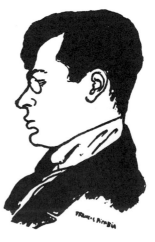

Francis Picabia: Portrait of Tristan Tzara. Drawing

In No. 3 the first "Dada Manifesto" appeared signed by Tzara, in which he negated all kinds and trends of contemporary art and advocated a "clean sweep", a "spring clearance" in art. By recognising the connections between society,

ZUR MEISE ZURICH

MARDI LE 23 JUILLET A 8 ½ HEURES DU SOIR

TRISTAN TZARA

LIRA DE SES ŒUVRES

ET LE

MANIFESTE DADA 1918

BILLETS A 4 ET 2 FRS

CHEZ KUONI & Co BAHNHOFPLATZ

Programme for a Tristan Tzara reading, Zurich, 1918

time and art he was enabled to play a decisive part in contemporary artistic criticism. Thanks to his organisational, and more especially his propagandistic capabilities, dada soon became a world-wide term. He was the prime mover, kept up a correspondence with half the world and did his best to make a movement out of dada. His contributions to nearly all dada publications of Zurich, Paris, New York, and Germany, are legion. The bibliography gives an idea of the extent of his widespread activity.

His numerous poetical works were illustrated by the greatest painters and sculptors of the age or were supplemented by original graphic contributions by Arp, Dali, Max Ernst, Juan Gris, Alberto Giacometti, Kandinsky, Klee, Henry Laurens, Masson, Matisse, Miro, Picabia, Picasso, Tanguy, etc. After he had been openly proclaiming his opposition to surrealism for many years, he joined that movement in 1929.

As dadaists in Russia Tristan Tzara names Zdanevitch, Krutchony and Terentiev, who were known under the collective designation "41°". For Spain Tzara quotes the names of Jacques Edwards, Guillermo de Torre, Lassa de la Vega, Cansino d'Assons; for Italy: J. Evola, Cantarelli, and Fiozzi. s. B.

VACHÉ, JACQUES
1896—1919. French writer. Met André Breton at Nantes in 1916 and exerted a lasting influence on him through his consistent negation of society. He committed suicide in 1919. s.B.

VAGTS, ALFRED
Writer. Named as a participant in the dadaist

movement by Tristan Tzara in "Dada" No. 6. Contributed to various dada publications.

VARÈSE, EDGAR
* 1885 Frenchman and naturalised American. About 1920 he had some affinity to the dada movement. Later he experimented in the sphere of noise music the best-known example being the score, "Ionization" (1931), which requires thirteen players on percussion instruments. Varèse's composition, "Deserts", (1955) consits of a mixture of "traditional" and "concrete" music and is called by the composer "organised sound". Varèse's experiments, extending over a full generation, form the bridge between the dada movement's "noise music" and the Paris "concrete music" of the fifties of the present century. (See Kurt Blaukopf: "Hexenküche der Musik". p. 146 et seq.)

VISCHER, MELCHIOR
* 7.1.1895 Teplitz-Schönau. German writer. Composed "Second Through Brain — a dada novel" (1920). s. B.

VORDEMBERGE-GILDEWART, FRITZ
* 1899 Osnabrück (Germany). Painter and architect. Influenced by van Doesburg. Contributed to the Dutch dada periodical "Mecano".

WIGMAN, MARY
* 1886. Dancer. Had some affinity to the Zurich dada movement. Disciple of R. von Laban.

ZAYAS, MARIUS DE
* Mexico. Graphic artist. One of the founders of the New York dada group. Friend of Alfred Stieglitz.

BIBLIOGRAPHY

ABBREVIATIONS

B.	=	Bibliographie, Bibliography
ca.	=	environ, ungefähr, approximate
Cat.	=	catalogue, Katalog
con.	=	contenu, Inhalt (beinhaltet), contents
contr.	=	contribution, Beitrag
ed.	=	éditeur (édition), Herausgeber (Verlag), editor (publisher)
etc.	=	et caetera, und so weiter, and so on
Ex.	=	exposition, Ausstellung, exhibition
in.	=	dans, in
illus.	=	illustré, illustriert, illustrated
incl.	=	inclus, einschliesslich, including
Ind.	=	voir Index, siehe Index, see Index
intr.	=	introduction, Einleitung
no.	=	numéro, Nummer, number
p.	=	page(s), Seite(n)
pl.	=	planche, Tafel, plate

per.	=	revue, Zeitschrift, periodical
s.	=	voir, siehe, see
vol.	=	volume, Band
■	=	contributions sur, Beiträge über, contributions about
Ja.	=	janvier, Januar, January
F.	=	février, Februar, February
Mr.	=	mars, März, March
Ap.	=	avril, April, April
My.	=	mai, Mai, May
Je.	=	juin, Juni, June
Jl.	=	juilliet, Juli, July
Ag.	=	août, August
Sept.	=	septembre, September
O.	=	octobre, Oktober, October
N.	=	novembre, November
D.	=	décembre, Dezember, December

A AESCHIMANN, PAUL. Le Dadaïsme. in: Montfort, Eugène, (ed.) Vingt-cinq ans de littérature française. vol. 1 p. 65—67. Paris, Librairie de France, 1925.

ALQUIE, FERDINAND. Philosophie du Surréalisme. Paris, Flammarion, 1956.

Anthologie Dada s. Dada 4/5.

ARAGON, LOUIS. Feu de Joie. Paris, Au Sans Pareil, 1920. Avec un dessin de Picasso.

ARAGON, LOUIS. Anicet, ou le Panorama. Paris, 1921.

ARAGON, LOUIS. Projet d'histoire littéraire contemporaine. Littérature (nouv. sér.) Paris, Sept. 1922. no. 4.

ARAGON, LOUIS. La peinture au défi. Paris, Corti, 1930. 32 p. 23 illus. Ex. de collages: Arp, Braque, Dali, Duchamp, Ernst, Gris, Miro, Magritte, Man Ray, Picabia, Picasso.

ARP, HANS. Neue französische Malerei. Ausgewählt von Hans Arp; eingeleitet von L. H. Neitzel, Leipzig, Verlag der Weissen Bücher, 1913.

ARP, HANS. Die Wolkenpumpe. Hannover, Paul Steegemann, 1920. 22 p. (Die Silbergäule vol. 52—53.) Ind.

ARP, HANS. Der Vogel selbdritt. Berlin, Privatdruck, 1920. Drucker Otto v. Holten.

ARP, HANS. 7 Arpaden. Hannover, Merzverlag, 1923. (Arp-Mappe, Zweite Mappe des Merzverlages = Merz no. 5) con. 7 Lith. Ind.

ARP, HANS. Der Pyramidenrock. Erlenbach-Zürich, Eugen Rentsch, 1924. 70 p. illus. Mit Porträt Arps von Modigliani.

Die Kunstismen. ed.: El Lissitzky & Hans Arp. Erlenbach-Zürich, Eugen Rentsch, 1925. 11 p. + 48 pl. incl. contr. «Dadaismus». Text: English, Français, Deutsch.

ARP, HANS. Weisst du schwarzt du. Zürich, Pra Verlag, 1930. 26 p. Mit 5 Klebebilder von Max Ernst. (Diese Gedichte wurden im Jahre 1922 geschrieben, die Klebebilder stammen aus dem Jahre 1929.)

ARP, HANS. Le Siège de l'air. Poèmes 1915—1945. Paris, Vrille, 1946 (Collection Le Quadrangle no. 1). Avec huit duo-dessins par Arp et Taeuber-Arp, et un avant-propos par Alain Gheerbrant.

ARP, HANS. On my way: poetry and essays 1912—1947. New York, Wittenborn, Schultz, 1948. (Documents of modern art no. 6, ed. Robert Motherwell.) contr.: C. Giedion-Welcker, G. Buffet-Picabia. B. by Bernard Karpel. incl. commentary on dadaism.

ARP, HANS. Collages. Paris, Berggruen, 1955.

ARP. HANS. Notes from a diary. in: Transition, New-York, Mr. 1932. no. 21.

ARP, HANS. Tibiis canere. (Zurich, 1915—20). in: XXe Siècle, Paris, Mr. 1938, p. 41—44, illus. (Peinture par Marcel Janco: Cabaret Voltaire.)

ARP, HANS. Dadaland. Zürcher Erinnerungen aus der Zeit des ersten Weltkrieges. in: Atlantis (Sonderheft), Zürich, 1948.

ARP, HANS. Dada was not a farce. s. Motherwell, p. 293—5.

ARP, HANS. Dada Fragments from Zurich. s. Motherwell, p. 219—225.

Huelsenbeck, Richard. Die Arbeiten von Hans Arp. in: Dada, Zürich, 1918, no. 3.

Tzara, Tristan. Les Poésies de Arp. in.: Dada, Zürich, 1919. no. 4—5

Erdmann-Czapski, Veronika. Hans Arp «Pyramidenrock»: Zur Entwicklungsgeschichte des Dadaismus. in.: Das Kunstblatt, Potsdam, Je. 1926. p. 218—21.

■ Ernst, Max, Arp. in.: Littérature, Paris, 1921, no. 19.

Schwitters, Kurt. Arp. in.: Merz, Hannover, Jl. 1923, no. 4.

Giedion-Welcker, Carola. J. Arp. in.: Horizon, London, 1946. no. 82.

Buffet-Picabia, Gabrielle. Jean Arp. Paris, Les Presses littéraires de France, 1952. (Collection «L'art abstrait» no. 3.)

Seuphor, Michel. Mission spirituelle de l'art à propos de l'œuvre de Sophie Taeuber-Arp et de Jean Arp. Paris, Berggruen, 1953.

Huelsenbeck, Richard. Der Plastiker Hans Arp. in.: Die Neue Zeitung, München, 12. Sept. 1954.

AUERBACH, ERICH. Vier Untersuchungen zur Geschichte der französischen Bildung. Bern, A. Francke, 1951.

Aventure. per. ed. R. Vitrac, Paris, 1921.

B BAADER, JOHANNES. Sonderausgabe Grüne Leiche. Flugblatt, Berlin, 1919. Ind.

BAARGELD, JOHANNES THEODOR. ed. Bulletin D. s. B.

BAARGELD, JOHANNES THEODOR. ed. Der Ventilator. s. B.

BALL, HUGO. Der Henker von Brescia. Drei Akte der Not und Ekstase. München, Bachmair, 1914.

BALL, HUGO. Flametti Oder vom Dandymus der Armen. Berlin, Erich Reiss, 1918.

BALL, HUGO. Zur Kritik der deutschen Intelligenz. Bern, Der Freie Verlag, 1919.

BALL, HUGO. Die Flucht aus der Zeit. München und Leipzig. Von Duncker & Humblot, 1927. Neue ed.: Luzern, Josef Stocker, 1946.

BALL, HUGO. Dada Fragments. s. Motherwell, p. 49—54.

BALL, HUGO. ed. «Cabaret Voltaire». s. B.

BALL, HUGO. Totenrede. in.: Die weissen Blätter. Leipzig, Ap. 1915. vol. 2. no. 4. p. 525—527. (Nachruf auf Hans Leybold, einem Vorläufer der deutschen Dadaisten.)

■ Hesse, Hermann. Nachruf auf Hugo Ball. in.: Die Neue Rundschau. vol. 38.

Fuchs, F. In memoriam Hugo Ball. in.: Hochland. vol. 25, 1927.

Bonset, I. K. Hugo Ball. in.: De Stijl, Leiden, 1928. vol. 8 no. 85/6 p. 97—102. (incl. «totenklage», «Wolken», «katzen und pfauen», «Gadji beri biba». Lautgedichte von Hugo Ball.)

Eugen Egger: Hugo Ball — ein Weg aus dem Chaos. Olten, 1951.

BARR, ALFRED. H., jr. (ed.) Fantastic art, dada, surrealism. New York, Museum of Modern Art, 3. ed. 1947. 271 p. illus. Essays by Georges Hugnet: «Dada», «In the light of Surrealism». Brief chronology by Elodie Courter & Alfred H. Barr., Jr. «The Dada and Surrealist movements 1910 to 1936, with certain pioneeers and antecedents». Reproductions of works from Dada artists: Arp, Baargeld, Duchamp, Max Ernst, Grosz, Raoul, Hausmann, Hannah Höch, Francis Picabia, Man Ray, Christian Schad, Schwitters, Sophie Taeuber-Arp. Originally

a catalog and text prepared for an exhibition of the same title held D. 1936—Ja. 1937.

BARR, ALFRED, H., jr., (ed.) Masters of Modern Art. New York, The Museum of Modern Art, 1955. Deutsche Ausgabe im Verlag Kurt Desch, München, 1956. Cont. comments on: Arp, Theo van Doesburg, Marcel Duchamp, Max Ernst, Grosz, Man Ray, Hans Richter, Schwitters, Alfred Stieglitz.

L'Affaire Barrès. in.: Littérature. Paris, Ag. 1921, no. 20. «Dada se constituait en tribunal révolutionnaire.»

BARTA, SANDOR. Mese a trombitakezü diákrol. 1918—1922. Mések és novellak. Wien, MA. 1922, 56 p. Dada-Fabeln und Kurzgeschichten in ungarischer Sprache. Dada fables and short stories in Hungarian.

Basel «Das Neue Leben». Vereinigung von Künstlern der jüngsten Schweizer Kunst. 1. Ex.: Winter 1918. 2. Ex.: Frühjahr 1919. (Hans Arp, Fritz Baumann, Augusto Giacometti, Marcel Janco, Otto Morach, Jakob Mumenthaler, Anna Probst, Sophie Taeuber, Paul Wilde). Ind.

Basel Ex. Kunsthalle Basel. Phantastische Kunst des XX. Jahrhunderts. 30. Ag.—12. O. 1952. Cat. 40 p. 12 pl. illus. (Hans Arp, Max Ernst, Picabia etc.)

BASLER, A., -KUNSTLER, CH., La peinture indépendante en France. 2 vol. Paris, 1929.

Bauhaus 1919—1928. Ed. Herbert Bayer, Ise & Walter Gropius, Teufen, Arthur Niggli & Willy Verkauf, 1955. USA-Edition at The Museum of Modern Art, New York, 1938. Enthält Material über: Contains comments on: Theo van Doesburg, Paul Citroën, George Grosz.

BAUR, JOHN, I. H., Dada in America: the machine and the subconscious. in.: Magazine of Art, New York, O. 1951, no. 6.

BAZIN, GERMAIN. Notice historique sur dada et le surréalisme. in.: Huyghe, René: Histoire d'art contemporain: la peinture. Paris, Alcan, 1935. p. 340—44.

BENET, RAFAEL. El futurismo comparado; el moviemiento dada. Barcelona, Ediciones Omega, 1949. (Colleccion Poliedro.) illus.

Berlin. Erste internationale Dada-Messe. Ex. Kunsthandlung Otto Burchard, 1920. Cat. «Veranstaltet von Marschall G. Grosz, Dadasoph Raoul Hausmann, Monteurdada John Heartfield. Ausstellung und Verkauf dadaistischer Erzeugnisse». 174 Ausstellungsobjekte. Ind.

Bern. Kunsthalle. 1956. Max Ernst Ex. 1919—1956. Cat. illus.

BIBLIOGRAPHY s. B. Karpel.

BILLE, EJLER. Picasso, Surréalisme, Abstrakt Kunst. Copenhagen, Helios, 1945. 286 p. illus.

BLAUKOPF, KURT. Hexenküche der Musik, Teufen, Niggli, 1956.

Bleu. per. ed. Cino Cantarelli, J. Evola, Aldo Fiozzi. Mantova (Italia) Ja. 1921. no. 3, «Dada» no. contr.: Tzara, Serner, Evola, Picabia, C. Arnauld, Eluard, Ribemont-Dessaignes, Aragon. Ind.

The Blind man. per. ed. Marcel Duchamp. New York, 1917. contr.: Bob Brown, G. Buffet, W. C. Arensberg, L. Eilshemius, C. Demuth, Mina Loy, Erik Satie, Alfred Stieglitz, H. P. Roché, C. van Vechten etc. Ind.

Blok. per. ed. Henry Strazewsky. Varsovia (Polska).

Der blutige Ernst. per s. Grosz.

BO. C., Antologia des Surrealismo. Milano, Edizione di Uomo, 1944, illus.

BOLLIGER, HANS. The dada movement. in.: History of modern painting from Picasso to surrealism. Geneva, Skira, 1950. p. 111—14, illus. Selected B. p. 207—8. Aussi ed. française.

BOSQUET, ALAIN. Surrealismus. 1924—1949. Texte und Kritik. Berlin, Henschel, 1950. 192 p.

BRETON, ANDRE. Mont de piété. Paris, Au Sans Pareil, 1919. Avec deux dessins d'André Derain.

BRETON, ANDRE & SOUPAULT, PHILIPPE. Les Champs magnétiques. Paris, Au Sans Pareil, 1921.

BRETON, ANDRE. Les Pas perdus. Paris, Gallimard, 1924. (Les documents bleus. no. 6). con.: Jacques Vaché, Deux manifestes dada, Pour dada, Max Ernst, Après dada, Lachez tout, Marcel Duchamp, Francis Picabia, Caractères de l'évolution moderne et ce qui en participe.

BRETON, ANDRE. Manifeste du Surréalisme. Paris, 1924.

BRETON, ANDRE. Le Surréalisme et la peinture. Paris, Gallimard, 1928. 72 p. illus. (Arp, Ernst, Picabia, Man Ray etc.)

BRETON, ANDRE. Dictionnaire abrégé du surréalisme. Paris, 1938. (avec Eluard.)

BRETON, ANDRE. Three Dada Manifestoes. s. Motherwell, p. 197—206.

BRETON, ANDRE, Marcel Duchamp. s. Motherwell, p. 207—211.

■ Gracq, J., André Breton, 1947.

Carrouges, M., André Breton et les données fondamentales du surréalisme, 1950.

Bédouin, J. L., André Breton. 1950.

BRION, MARCEL. Art abstrait. Paris, Albin Michel, 1956.

BUCHHEIM, LOTHAR-GUENTHER. Deutscher Expressionismus. Feldafing, Buchheim-Verlag, 1956.

BUFFET-PICABIA, GABRIELLE. On demande: Pourquoi 391? Qu'est-ce que 391? in.: Plastique, Paris 1937. no. 2.

BUFFET-PICABIA, GABRIELLE. Arthur Cravan and American Dada. in.: Transition, Paris, 1938, no. 27.

BUFFET-PICABIA, GABRIELLE. Dada. in.: Art d'aujourd'hui, Paris, 1950. no. 7/8.

BUFFET-PICABIA, GABRIELLE. Arthur Cravan and American Dada. And: Some Memories of Pre-Dada: Picabia and Duchamp. s. Motherwell. p. 13—17, 253—267.

Bulletin D. per. ed. J. T. Baargeld & Max Ernst, Köln, 1919. Nur eine Nummer erschienen. Gleichzeitig Ausstellungskatalog. Texte von Otto Freundlich, Max Ernst, Hoerle. Werke von H. Hoerle, Angelika Hoerle, Arp, Baargeld, Max Ernst, Paul Klee, A. Räderscheidt, F. W. Seiwert. Ind.

Bulletin Dada, s. Dada, no. 6.

C Cabaret Voltaire. Recueil littéraire et artistique. per. ed. Hugo Ball, Zürich, Je. 1916. (Buchdruckerei Jul. Heuberger). Seulement un no. contr.: Hugo Ball (Lorsque je fondis le Cabaret Voltaire. . .), Richard Huelsenbeck, Marcel Janco, Tristan Tzara (L'amiral cherche une maison à louer), Richard Huelsenbeck (Der Idiot), Tristan Tzara (La revue dada 2), Wassilij Kandinsky (Blick und Blitz: Sehen), F. T. Marinetti, Guillaume Apollinaire, Hans Arp, Francesco Cangiullo, Blaise Cendrars, Emmy Hennings, Jakob van Hoddis, M. Oppenheimer, Pablo Picasso, Marcel Slodki. Catalogue de l'exposition Cabaret Voltaire. (Adresse: Zürich, Meierei, Spiegelgasse 1.) Auch Ausgabe mit deutschsprachiger Einleitung. Ind.

Le Cannibale. Revue mensuelle sous la direction de Francis Picabia. per. Paris, Au Sans Pareil, 1920. Cette revue ne comporte que deux numéros, no. 1, 25 Ap. 1920, no. 2, 25. My. 1920. contr. Francis Picabia, Louis Aragon, Ribemont-Dessaignes, Tristan Tzara, Jean Cocteau, Paul Eluard, Soupault.

CASSOU, JEAN. Le dadaïsme et le surréalisme. in.: Huyghe, R. ed.: Histoire de l'art contemporain: la peinture, Paris, Alcan, 1935.

CENDRARS, BLAISE. Dix-neuf Poèmes élastiques. Paris, 1919.

CENDRARS, BLAISE. La Fin du monde, filmée per l'Ange N.-D. Roman. Paris, La Sirène, 1919. Avec composition en couleurs par Fernand Léger. Ind.

■ Levesque, J. H., Blaise Cendrars. 1948.

CIRLOT, JUAN EDUARD. Diccionnario de los Ismos. Barcelona, Buenos Aires, Argos, 1949. 414 p. illus.

Club Dada. per. ed. R. Huelsenbeck. Franz Jung, Raoul Hausmann. Berlin, 1918. Nur eine no. erschienen. Ind.

COENEN, FRANS. Dadaisme. in.: Groot-Nederland, Amsterdam, 1921. no. 2.

Collection Dada. ed. Tristan Tzara, Zürich, Paris, Roma, 1917—1922. s. Evola, Huelsenbeck, Picabia, Péret, Ribemont-Dessaignes, Tzara. Ind.

CONNOLLY, CYRIL. Surrealism. in.: Art News, New York. N. 1951. Part II. (Two pages on Dadaism) illus.

COWLEY, MALCOLM. The Religion of Art; a Discourse over the Grave of Dada. in.: The New Republic, New York, 10th Ja. 1934. p. 246—249.

CRAVAN, ARTHUR. Exhibition at the Independents. s. Motherwell, p. 3—13.

Le Cœur à barbe. Journal transparent. per. ed. Tristan Tzara, Paris, Au Sans Pareil, 1922. (Numéro unique.) Ind.

Contimporanul. per. ed. Marcel Janco, I. G. Costin, Jon Vinea. Bucuresti, 1922—1936.

CRAVEN, THOMAS. Modern Art. The Men. The Movements. The Meaning. New York, Simon & Schuster, 1940.

D Dada. per. ed. Tristan Tzara. Zürich, Paris, 1917—1920.

Dada no. 1, Zürich, 1917. contr.: Hans Arp, H. Guilbeaux, Marcel Janco, O. Lüthy, F. Meriano, N. Moscardelli, A. Savinio, Tristan Tzara. Ind.

Dada no. 2, Zürich, 1917. contr.: Apollinaire, P. A. Birot, G. Cantarelli, G. de Chirico, M. d'Arezzo, R. Delaunay, W. Helbig, Marcel Janco, W. Kandinsky, O .van Rees, Pierre Reverdy, E. Prampolini, Tristan Tzara, S. de Vaulchier. Ind.

Dada no. 3, Zürich, 1918. Contr.: H. Arp, Pierre Albert-Birot, Paul Dermée, F. Hardekopf, Jakob van Hoddis, Richard Huelsenbeck, Vincente Huidobro, Marcel Janco, Francis Picabia, E. Prampolini, Pierre Reverdy, Hans Richter, Giuseppe Raimond, Tristan Tzara. Ind.

Dada 4/5 (Anthologie Dada), Zürich, My. 1919. contr.: Aragon, Arp, Albert-Birot, Gabrielle Buffet, Jean Cocteau, Viking Eggeling, André Breton, Ferdinand Hardekopf, Raoul Hausmann, Richard Huelsenbeck, Kandinsky, Paul Klee, Picabia, Raymond Radiguet, G. Ribemont-Dessaignes, Hans Richter, Walter Serner, Ph. Soupault, Tristan Tzara. Il en existe deux éditions, presque semblables, l'une entièrement en

français, l'autre mêlée avec des textes en allemand. Ind.

Dada no. 6 (Bulletin Dada), Paris, 1920. Comprenant le programme de la matinée du Mouvement Dada, le 5 F. 1920 et des manifestes. Liste de «Quelques Présidents et Présidentes». Ind.

Dada no. 7 (Dadaphone), Paris, Mr. 1920. contr.: Louis Aragon, Céline Arnault, André Bréton, Paul Eluard, Paul Dermée, Jean Cocteau, Ribemont-Dessaignes, Francis Picabia, Ezra Pound, P.Soupault, Tzara. Ind.

Dada-Almanach. Im Auftrag des Zentralamts der deutschen Dada-Bewegung herausgegeben von Richard Huelsenbeck s. B. Berlin, Erich Reiss Verlag, 1920. 160 p. illus. contr.: Hans Arp, Johannes Baader, Hans Baumann, Citroën-Dada, Paul Dermée, Hugo Ball, Mario d' Arezzo, Max Goth, Daimonides, Raoul Hausmann, Richard Huelsenbeck, Vincente Huidobro, Adon Lacroix, Walter Mehring, Alexander Partens, Francis Picabia, Ribemont-Dessaignes, Philippe Soupault. Ind.

Dada-Club. per. ed. Huelsenbeck, Franz Jung, Raoul Hausmann. Berlin, 1918. Eine no. erschienen.

Dadaco. Dadaistischer Weltatlas, erscheint im Jahre 1920. München, Kurt Wolff Verlag, 1920. 4 p. illus. Prospekt für eine internationale Dada-Anthologie. (Nicht erschienen.) Ind.

Der Dada. Zeitschrift der Berliner Dada. per. ed. no. 1 und 2: Raoul Hausmann. no. 3: Grosz, Heartfield, Hausmann. (Auf Umschlag: Groszfield, Hearthaus, Georgemann.) Nur 3 no. erschienen. Angezeigt als «Zeitschrift der deutschen Dadaisten, einzig authentisches Organ der Dada-Bewegung in Deutschland». no. 3 mit der Verlagsangabe «Malik-Verlag». Ind.

Dada Intirol Augrandair. Der Sängerkrieg. Tarrenz B. Imst. 16. Sept. 1886—1921. Paris, Au Sans Pareil, 1921. 4 p. illus. contr.: Arp, Baargeld, Eluard, Ernst, Th. Fraenkel, Ribemont-Dessaignes, Soupault, Tzara etc.

Dadaisten gegen Weimar. Köln, 1919. Flugblatt, datiert 6. F. unterzeichnet von: Arp, Baader, Eugen Ernst, Grosz, Hausmann, Huelsenbeck, Janco, Franz Jung, A. R. Meyer, Tzara. Ind.

Dadaistisches Manifest. 1920. s. Dada-Almanach. English translation. s. Motherwell, p. 242—245.

Dada-Manifest 1949. s. Huelsenbeck.

Dada W./3. per. ed. Johannes Baargeld, Hans Arp, Köln, 1919.

Dada-Reklame-Gesellschaft. Berlin, Charlottenburg, Kantstrasse 118. Generalvertreter Huelsenbeck, Hausmann, Baader, Grosz, Herzfelde. o. J. 1 p. (Flugblatt) Ind.

Dada soulève tout. Une feuille volant paraît 12 Ja. 1921. (Dada inaugure l'année en nous annonçant que les signataires de ce manifeste habitent la France, l'Amérique, l'Allemagne, l'Italie, la Suisse, la Belgique etc. . . , mais n'ont aucune nationalité.)

Dada-Tank. no. 1. ed.: Dragan Alecsic, 1922. contr.: Alecsic, Tzara, Castor, Schwitters, Jim Rad.

DAIMONIDES. (Pseudonym Dr. Carl Döhmann) Zur Theorie des Dadaismus. s. Dada-Almanach. p. 54—62.

DERMEE, PAUL. Spirales. poèmes. Paris, ed. Birault, 1917.

Disk. per. ed. Karel Teige. Praha. 1923—34.

DOESBURG, THEO VAN. Klassiek. Barok. Modern. Antwerpen, ed. de Sikkel, 1920. En français: Paris. ed. Rosenberg, 1920.

DOESBURG, THEO VAN. X-Beelden. 1917—1920. in.: De Stijl, 1921.

DOESBURG, THEO VAN. Wat is Dada? Den Haag, Uitgave «De Stijl», 1923, 16 p.

DOESBURG, THEO VAN. Grundbegriffe der neuen gestaltenden Kunst. Uebersetzt von Max Burchartz. München, Albert Langen, 1925. (Bauhaus-Bücher no. 6) 40 p. 32 illus.

DOESBURG, THEO VAN. ed. Mécano. s. B.

DOESBURG, THEO VAN. ed. De Stijl. s. B.

■ Schwitters, Kurt. Theo van Doesburg und Dada. De Stijl, Ja. 1932. English translation s. Motherwell, p. 275—276.

DORIVAL, G., Les Etapes de la peinture française contemporaine. vol. III. Depuis le Cubisme 1911—1944. Paris, Gallimard.

DREIER, KATHARINA. Western Art and the New Era. New York, Brentano's, 1923.

391. per. s. Trois-cent-quatre-vingt-onze.

DUCHAMP, MARCEL. Boîte-en-valise; contenant la reproduction des 69 principals œuvres de Marcel Duchamp. New York, 1941. Leather box, with complete work in miniature. Edition of 20 copies advertised by Art of This Century Gallery, New York, 1943. Auflage von 20 Exemplaren angezeigt von der «Art of This Century Gallery, New York, 1943.

■ Kuh, Katherine. Marcel Duchamp. in.: Cat. 20th century art from the Louise and Walter Arensberg collection. Chicago Art Institute, 1949. p. 11—18. The largest group of Duchamps work in a private collection, now part of the Philadelphia Museum of Art. Die grösste Anzahl von Duchamps Werken in einer Privatsammlung, jetzt Teil des «Philadelphia Museum of Art».

View, Marcel Duchamp no. New York, Mr. 1945.

Lebel, Robert. Marcel Duchamp. Paris, Editions presses du livre Français, 1954.

E EINSTEIN, CARL. Die Kunst des 20. Jahrhunderts. Berlin, Propyläen, 1931 (Propyläen-Kunstgeschichte) p. 152, 176, 178, 181, 185, 646, 649. illus.

ELUARD, PAUL. Les Animaux et leurs hommes; les hommes et leurs animaux. Paris, Au Sans Pareil, 1920. «Avec cinq dessins d'André Lhote.»

ELUARD PAUL. Les Nécessités de la vie et les conséquences des rêves, précédé d'exemples. Paris, Au Sans Pareil, 1921.

ELUARD, PAUL. Répétitions. Paris, Au Sans Pareil, 1921. Poèmes, avec 11 dessins par Max Ernst. (350 ex. numerotés.)

ELUARD, PAUL. Les Malheurs des immortels; révélés par Paul Eluard et Max Ernst. Paris, Libraire Six, 1922. 43 p. illus. English translation: Misfortunes of the immortals. New York, Black Sun Press, 1943. 21 dessins de Max Ernst.

Proverbe. per. ed. Paul Eluard s. B.

L'invention. per. ed. Paul Eluard s. B.

■ Gaffé, R., Paul Eluard. 1945.

Hagen, F., Paul Eluard, Brüssel, 1949.

ERNST, MAX. Fiat modes. (Pereat ars.) 8 Original-Lithografien. Köln, Verlag der ABK, (1919). Aus der Anzeige in der «Schammade»: «Die Blätter wurden im Auftrag der Stadt Köln gezeichnet. Es ist dies der erste uns bekannte Fall, in dem eine Stadtverwaltung als Auftraggeber eines dadaistischen Kunstwerkes dasteht.»

ERNST, MAX. Les Malheurs des Immortels. s. Eluard.

ERNST, MAX. La femme 100 têtes. Roman en collages, précédé d'un avis d'André Breton. Paris, Editions du Carrefour, 1929. Nouvelle ed. Paris, Editions de L'Oeil, 1956. 332 p. 148 pl.

ERNST, MAX. Beyond painting, and other writings by the artist and his friends. New York, Wittenborn, Schultz, 1948 (Documents of modern art no. 7. ed. Motherwell, R.,) contr.: Arp, Breton, N. Calas, J. Levy, Matts, Ribemont-Dessaignes, Tristan Tzara. 204 p. illus. B. by Bernard Karpel.

ERNST, MAX. Gemälde und Graphik. 1920—1950. Stuttgart, 1951.

ERNST, MAX. Dada est mort, vive Dada! in.: Der Querschnitt, Frankfurt a. M., Ja. 1921.

ERNST, MAX. ed. Bulletin D s. B., Dada W./3. s. B. Die Schammade s. B.

■ Cahiers d'art: Max Ernst. Numéro special. Oeuvres de 1919 à 1937, Paris, 1937. contr.: A. Breton, Hugnet, Crevel, Tzara etc.

View: Max Ernst. Special number. New York, Ap. 1942. incl. Cat. of Valentine Gallery exhibition. B. and contr. by and on Ernst.

Berlin: Max Ernst (und George Muche). 37. Sturm-Ausstellung, Berlin, Ja. 1916.

Paris: Max Ernst. Exposition Dada. Paris, Galerie Au Sans Pareil, 1920. Cat. Préface d'André Breton. illus. Ind.

Europa-Almanach. ed. Carl Einstein, Paul Westheim. Potsdam, Gustav Kiepenheuer, ca. 1928. illus. con.: Erik Satie: Fetzen meines Lebens. p. 161—163 mit Porträtzeichnung von Picasso, Melchior Vischer: Fussballspieler und Indianer. p. 268—270.

EVOLA, J. Arte Asstratta: teoria, composizioni, poemi. Roma, P. Maglioni & G. Strini, 1920. (Collezione Dada.) Ind.

F FARNER, KONRAD. These, Antithese, Synthese. Bibliographie. Luzerner Kunstmuseum, 1935. 47 p. Bildet den Teil eines Kataloges für eine Ausstellung. I. Ideologische Situation der Gesellschaft. II. Periodica. III. Theorie. IV. Mathematik. V. Psychologie, Psychoanalyse. VI. Monografie. Ausgewählte Bibliographie über die Moderne Kunst mit besonderen Hinweisen auf den Dadaismus.

FERNANDEZ, JUSTINO. Dada. in.: Prometo, ensayo sobre pintura contemporáneo. Mexico, D. F., Editorial Porrua, 1945.

FISCHER, ERNST. Kunst und Menschheit. Essays. (Von der Notwendigkeit der Kunst.) Wien, Globus, 1949. p. 99—269.

FLAKE, OTTO. Die Stadt des Hirns. Roman. Berlin, S. Fischer, 1919.

FLAKE, OTTO. Ja und Nein. Roman. Berlin, S. Fischer, 1920. Schlüsselroman aus dem Züricher Dada-Milieu.

FLAKE, OTTO. Thesen. in.: Der Zeltweg. s. B.

Freie Zeitung. Bern, 1917—18. Mitherausgeber: Hugo Ball.

Freiland. per. Potsdam, 1921. no. 1 erschien 1. Jl. 1921. ed. «Freiland dada» (weitere no. sind dem Bibliographen nicht bekannt). Ind.

FRIEDMANN, H. & MANN, O., (ed.) Expressionismus. Gestalten einer literarischen Bewegung. Rothe-Verlag, 1956.

G. Material zur elementaren Gestaltung. per. ed. Hans Richter. 1923 bis 1926, no. 1—5/6.

G GASCOYNE, DAVID. A Short Survey of Surrealism. London, Cobden-Sanderson, 1935. On dadaism p. 23—44.

Gegenstand. Internationale Rundschau der Gegenwart. ed. El Lissitzky & Ilya Ehrenburg. Berlin, 1922. En Français: Objet. Russian: Vesch. Genève. Grand Bal Dada à Genève dans la salle communale de Plainpalais. 5. Je. 1920. (Programme.) Organisé par Walter Serner. Aussi Ex. à Genève avec Arp, Picabia, Schad, Ribemont-Dessaignes.

GEROLD, KARL GUSTAV. Deutsche Malerei unserer Zeit. Impressionismus, Kubismus, Dadaismus, Surrealismus, Neue Sachlichkeit, Abstrakte Malerei. München, Kurt Desch, 1956. 148 p. illus.

GIEDION-WELCKER, CAROLA. Poètes a l'écart; Anthologie der Abseitigen. Bern-Bümpliz, Benteli, 1946. con.: Arp, Ball, van Doesburg, Dermée, Picabia, Tzara etc.

GIEDION-WELCKER, CAROLA. Plastik des XX. Jahrhunderts. Volumen- und Raumgestaltung. Stuttgart, Gerd Hatje, 1955. 336 p. illus. B. von Bernard Karpel. English Edition: Contemporary Sculpture. London, Faber & Faber. New York, Wittenborn. Beste Darstellung der modernen Plastik mit besonderer Berücksichtigung des Dadaismus. Best survey of modern plastic art respecting dadaism especially.

GLAUSER, F., Dada. in.: Schweizer Spiegel, O. 1949.

GLEIZES, ALBERT. The Dada Case. s. Motherwell p. 298—303. En Français: in.: Action, Paris Ap. 1920, no. 3.

GRAUTOFF, OTTO. Formzertrümmerung und Formaufbau in der bildenden Kunst. Berlin. Ernst Wasmuth, 1919.

GROHMANN, WILLI. Bildende Kunst und Architektur zwischen den beiden Kriegen. Berlin, Suhrkamp, 1953.

GROSZ, GEORGE. Kleine Grosz-Mappe. 20 Originallithographien. Berlin-Halensee, Malik-Verlag, 1917.

GROSZ, GEORGE. Das Gesicht der herrschenden Klasse. 57 politische Zeichnungen. Berlin, Malik-Verlag, 1921 (Kleine revolutionäre Bibliothek no. 4).

GROSZ, GEORGE. Ecce homo. Berlin, Malik-Verlag, 1923. 84 pl.

GROSZ, GEORGE. Die Kunst ist in Gefahr. Drei Aufsätze. Berlin, Malik-Verlag, 1925. Am Titel: George Grosz & Wieland Herzfelde. Enthält Material zur Geschichte des Dadaismus in Deutschland.

GROSZ, GEORGE. Dadaism. in.: A little yes and a big no: the autobiographie of George Grosz. New York, Dial Press, 1946. p. 181—7. Includes contr. of Baader and Schwitters. Deutschsprachige Ausgabe: Ein kleines Ja und ein grosses Nein. Sein Leben von ihm selbst erzählt. Berlin, Rowohlt, 1955. illus. Im Kapitel IX: «Kunst und Wissenschaft» berichtet er über die Dada-Bewegung in Berlin (Huelsenbeck, Baader, Jung, Daimonides, Schwitters etc.).

Jedermann sein eigener Fussball. per. ed. George Grosz & Franz Jung. Berlin, 1919. Ind.

Der blutige Ernst. per. ed. George Grosz & Carl Einstein, Berlin, 1919. Ind.

Die Pleite. per. ed. George Grosz & Wieland Herzfelde. Berlin, Malik-Verlag, 1919—1924. Ind.

■ Däubler, Theodor. George Grosz. in.: Die weissen Blätter, Rascher, Zürich, N. 1916, no. 11. p. 167—170. Mit 7 Zeichnungen von George Grosz.

Wolfradt, Willi. George Grosz. Leipzig, Klinkhardt & Biermann, 1921. 15 p. illus. (Junge Kunst. no. 21.)

Fels, Florent. Grosz. in.: Propos d'artistes. Paris, La Renaissance du Livre, 1925. p. 75—84.

Ballo, Ferdinando. ed. Grosz. Milano, Rosa e Ballo, 1946. (Documenti d'arte contemporàneo.) contr.: Grosz, Dorfles, Bulliet, Dos Passos, Landau, Man Ray, Schiff, Serouya, Tavolato, Waldmann, Galtier-Boissière, Wolfradt. 79 p. 57 illus.

Hofbauer, Imre. George Grosz. London, 1948. 103 p. 85 pl.

Baur, T. H. John. George Grosz. New York, Whitney Museum of American Art, 1954. 67 p. illus.

GUGGENHEIM, PEGGY. ed. Art of this century. New York, Art of This Century (Gallery), 1942. 156 p. illus.

H HARDEKOPF, FERDINAND. Der Abend. Dialog. Leipzig, Kurt Wolff, 1913. (Der jüngste Tag vol. 4.)

HARDEKOPF, FERDINAND. Lesestücke. Berlin, Aktion, 1916. (Aktionsbücher der Aeternisten.) 64 p.

HARDEKOPF, FERDINAND. Privatgedichte. München, Kurt Wolff, 1921. (Der jüngste Tag.)

HAUSER, ARNOLD. Sozialgeschichte der Kunst und Literatur. München, C. H. Beck, 1953. 2 vol. English edition: The Social History of Art. London, Routledge & Paul Kegan, 1951. 2 vol. Im vol. 2 Hinweise auf den Dadaismus. In the 2nd vol. comment on dadaism.

HAUSMANN, RAOUL. Material der Malerei, Plastik, Architektur. Berlin, O. 1918. illus. mit 3 Holzschnitten. In 23 Ex. gedruckt.

HAUSMANN, RAOUL. Hurrah! Hurrah! Hurrah! Grotesken mit Einband und Illustrationen des Verfassers. Berlin, Malik-Verlag, 1920.

Der Dada. per. ed. Raoul Hausmann. s. B.

HEARTFIELD, JOHN Photomontagen zur Zeitgeschichte. I. Zürich, Kultur und Volk, 1945. con.: Alfred Durus: John Heartfield und die satirische Photomontage. Wolf Reiss: Als ich mit John Heartfield zusammen arbeitete. Louis Aragon: John Heartfield und die revolutionäre Schönheit. Anmerkungen: Dada, Dadaismus.

Der Dada. per. John Heartfield. s. B.

■ Farner, Konrad. John Heartfield's Photomontagen. in.: Graphis, Zürich, Ja. F. 1946. no. 13.

HAESAERTS, L. & P., Le mouvement expressioniste. Gand, 1935.

HAZAN, F., ed., Dictionnaire de la Peinture Moderne. Paris, Hazan, 1955.

HENNINGS, EMMY. Die letzte Freude. Gedichte. Leipzig, Kurt Wolff. (Der jüngste Tag vol. 5.)

HENNINGS-BALL, EMMY. Gefängnis. Roman. Berlin, Erich Reiss, 1919.

HENNINGS-BALL, EMMY. Das Brandmal. Berlin, Rowohlt, 1919.

HENNINGS-BALL, EMMY. Helle Nacht. Gedichte. 1920.

HENNINGS-BALL, EMMY. Hugo Ball, sein Leben in Briefen und Gedichten. Berlin, 1929.

HENNINGS-BALL, EMMY. Hugo Ball's Weg zu Gott. München, 1931.

HENNINGS-BALL, EMMY. Ruf und Echo. Mein Leben mit Hugo Ball.

HESS, WALTER. Dokumente zum Verständnis der modernen Malerei. Hamburg, Rowohlt, 1956. (Rowohlts Deutsche Enzyklopädie vol. 19.) Ueber Dadaismus s. p. 29, 119, 132, 133.

HILDEBRANDT, HANS. Die Kunst des 19. und 20. Jahrhunderts. Potsdam, Akademische Verlagsanstalt, 1924. p. 399—400, 416—17, 427 bis 428, 449.

Das Hirngeschwür. per. ed. Walter Serner. Zürich, 1919. (Nicht erschienen.)

HODDIS, JAKOB VAN. Weltende. Berlin, 1918 (Roter Hahn no. 19.)

Das Hohe Ufer. per. ed. Hans Kaiser. Hannover, 1920, contr.: Baader, Schwitters etc.

HUEBNER, F. M. Die neue Malerei in Holland. Leipzig, 1921. Ueber Theo van Doesburg etc.

HUELSENBECK, RICHARD. Schalaben, Schalomai, Schalamezomai. Zürich, Collection Dada, 1916. «Verse, mit 4 Zeichnungen von Hans Arp.»

HUELSENBECK, RICHARD. Phantastische Gebete. Zürich, Collection Dada, 1916. «Verse mit 7 Holzschnitten von Hans Arp.»

HUELSENBECK, RICHARD. Verwandlungen. Novelle. München, Roland-Verlag, 1918. 54 p.

HUELSENBECK, RICHARD. Azteken oder die Knallbude. Eine militärische Novelle. Mit einer handkolorierten Zeichnung von Georg Kolbe. Berlin, Reuss & Pollack, 1918. 53 p.

HUELSENBECK, RICHARD. Phantastische Gebete. Verse. Berlin, Malik-Verlag, Abteilung Dada, 1920. Mit Zeichnungen von George Grosz.

HUELSENBECK, RICHARD. En avant Dada. Eine Geschichte des Dadaismus. Hannover, Paul Steegemann, 1920. (Die Silbergäule vol. 50—51.) 44 p. English translation s. Motherwell p. 21—47. En Français (en partie) in.: Littérature. Paris, Sept. 1922. no. 4, p. 19—22. Ind.

HUELSENBECK, RICHARD. Dada siegt. Eine Bilanz des Dadaismus. Berlin, Malik-Verlag, Abteilung Dada, 1920. 40 p. Ind.

HUELSENBECK, RICHARD. ed. Dada-Almanach. s. B. Enthält u. a. das «Erste Dada-Manifest» in deutscher Sprache, vorgetragen auf der Dada-Soirée, April 1918. Als «Dadaistisches Manifest» auch als Flugblatt herausgegeben und in «Der Zweemann» s. B. abgedruckt. Enthält auch die «Erste Dada-Rede in Deutschland», gehalten von Richard Huelsenbeck im Februar 1918 in Berlin. p. 104—8. English translation of the «Dadaistisches Manifest» s. Motherwell. Ind.

HUELSENBECK, RICHARD. Deutschland muss untergehen! Erinnerungen eines alten dadaistischen Revolutionärs. Berlin, Malik-Verlag, 1920. illus.

HUELSENBECK, RICHARD. Doctor Billig am Ende. Ein Roman mit acht Zeichnungen von George Grosz. München, Kurt Wolff, 1921 129 p.

HUELSENBECK, RICHARD. China frisst Menschen. Roman. 1930.

HUELSENBECK, RICHARD. Der Traum vom grossen Glück. Roman Berlin. S. Fischer, 1933. 306 p.

HUELSENBECK, RICHARD. Mit Witz, Licht und Grütze. Auf den Spuren des Dadaismus. Wiesbaden, Limes-Verlag, 1957.

HUELSENBECK, RICHARD. Der neue Mensch. In: Neue Jugend. Berlin, My. 1917. no. 1.

HUELSENBECK, RICHARD. Zürich, 1916, wie es wirklich war. in.: Neue Bücherschau, Berlin D. 1928.

HUELSENBECK, RICHARD. Dada Manifesto 1949. New York, Wittenborn, 1951. 2 p. leaflet.

HUELSENBECK, RICHARD. Dada Lives! s. Motherwell, p. 227—281.

HUGNET, GEORGES. Petite anthologie poétique de surréalisme. Paris, Editions Jeanne Bucher, 1934.

HUGNET, GEORGES. L'aventure Dada. 1916—1922. Introduction de Tristan Tzara. Paris, Galerie de l'Institut, 1957. 101 p. 32 illus.

HUGNET, GEORGES. L'esprit dada dans la peinture. Cahiers d'Art, Paris, 1932, vol. 7, no. 1—2, p. 57, 65. no. 6—7, p. 281—285, no. 8 à 10, p. 358—364: 1934, vol. 9, no. 1—4, p. 109—114. English translation: s. Motherwell p. 123—196.

HUGNET, GEORGES. Dada. in.: Barr, Fantastic art, Dada, Surrealism. s. B. p. 15—34.

HUGNET, GEORGES. L'Aventure Dada. in.: Arts Spectacles. Paris, Mr. 1957. no. 610. illus.

HUIDOBRO, VINCENTE. Saisons choisies. Poèmes. Paris, Editions «La Cible», 1921. Avec un portrait par Picasso.

HUIDOBRO, VINCENTE. Manifestes. Paris, Editions de la «Revue Mondiale», 1925. 110 p.

HUIDOBRO, VINCENTE. Tout à coup. Poèmes. Paris, Au Sans Pareil, 1925.

Creación. per. ed. Vincente Huidobro. Madrid, 1921.

HUYGHE, RENE. ed. Histoire de l'art contemporain: la peinture. Paris, Alcan, 1935. illus. incl.: Jean Cassou, Le dadaïsme et le surréalisme. Germain Bazin, Notice historique sur dada et le surréalisme.

I ILIAZD (Ilia Zdanévitch). Ledentu le Phare. Paris, 1922.

L'invention no. 1 et Proverbe no. 6. per. ed. Paul Eluard. Paris. 1. Jl. 1921. s. Proverbe.

J JAKOVSKI, ANATOLE. Essais. Paris, Povolozky, 1935. 47 p. illus. incl.: Arp, Ernst, Giacometti, Taeuber-Arp etc.

JANCO, MARCEL. (Tristan Tzara). La Première aventure céleste de M. Antipyrine, avec des bois gravés et coloriés par M. Janco. s. Tzara.

JANCO, MARCEL. M. Janco: album. 8 gravures sur bois, avec un poème par Tristan Tzara. Zürich, Mouvement Dada, 1917.

Zürich. Ex. Galerie Wolfsberg. 1918. s. Zürich.

New York. Ex. Feigl Gallery. s. New York.

■ Tzara, Tristan. Marcel Janco. in.: Dada no. 1. s. B.

Werner, Alfred. Zurich in Tel-Aviv. (On Marcel Janco and Dada.) in.: The New Palestine, Ap. 1951.

JANIS, S., Abstract and Surrealist Art in America. New York, 1944.

JARRY, ALFRED. Gestes suivis des Paralipomènes d'Ubu. Paris, Sagittaire, 1920.

Jedermann sein eigener Fussball. per. no. 1 erschien 15. F. 1919, Malik-Verlag, Berlin (weitere no. sind dem Bibliographen unbekannt).

JUNG, FRANZ. Opferung. Roman. Berlin, Aktion, 1916.

JUNG, FRANZ. Jehan. Mühlheim a. d. D., Saturnen, 1919. Mit Titelholzschnitt von Marcel Janco.

K KARPEL, BERNARD. Did Dada Die? Critical Bibliography. s. Motherwell p. 319—377. Lists 423 items on Dadaism. Very important Bibliography on Dadaism with special attention to contributions in periodicals.

KASSAK, LUDWIG & MOHOLY-NAGY, LADISLAS. ed. Buch neuer Künstler. Wien, MA. 1922. 94 p. illus.

KERN, WALTER. Zürich 1914—1918. in.: Werk, Winterthur, My. 1943, no. 5. p. 129—133.

Knaurs Lexikon der Modernen Kunst. ed.: L. G. Buchheim. München, Knaur, 1955. illus. Verschiedene Stichwörter über Dadaismus und Dadaisten.

KNOBLAUCH, ADOLF. Dada. Leipzig, Kurt Wolff, 1919. (Der jüngste Tag, vol. 73/74.) Mit Holzschnitt von Lyonel Feininger. 76 p. Ind.

Köln. Dada-Vorfrühling: Gemälde, Skulpturen, Zeichnungen, Fluidoskeptik, Vulgärdilletantismus. Cat. der Dada-Ausstellung, Köln, Winter's Brauhaus, Ap. 1920. 4 p. (Arp, Baargeld, Ernst.) Ind.

Der Komet. per. Dresden u. andere Orte, 1918/1919. contr.: Baader, Franz Jung, Marcel Janco (Holzschnitte in no. 2). Auch als Redaktion: Zürich, Zeltweg 83 (Sitz der Dada-Bewegung) angegeben. Ind.

KREITLER, HANS. Psychologische Grundlagen des Kunstgenusses. Dissertation. Graz, 1956.

L LAKE, CARLTON & MAILLARD, ROBERT. ed. Dictionary of Modern Painting. New York, Tudor, 1956. 328 p. illus. Comments on dadaism and Dada artists.

LEMAITRE, GEORGES. From Cubism to Surrealism in French literature. Cambridge, Mass., Harvard Univ. Press; London, Oxford Univ. Press, 1947. (First edition 1941.) incl. Bibliography.

LISSITZKY, EL & ARP, HANS. Les Ismes de l'art — The Isms of Art — Die Kunstism 1914—1924. s. Arp

Littérature. per. ed. Aragon, Breton, Soupault, Paris, 1919—1921. Breton, Paris 1922—1924. in.: no. 12, My. 1920: Vingt-trois manifestes du mouvement dada. contr.: Arp, W. C. Arensberg, Aragon, Breton, Dermée, Céline Arnauld, Eluard, Picabia, Serner, Soupault, Ribemont-Dessaignes, Tzara. Ind.

The Little Review. per. New York. ca. 1922—1924.

M Ma. (Heute) per. ed. Ludwig Kassàk. Wien, 1918—1925.

Maintenant. per. ed. Arthur Cravan. Paris, 1913—1915.

MANGEOT, GUY. Histoire du Surréalisme. Bruxelles, 1934.

Manifest Proletkunst. Merz no. 2, Ap. 1923. Gezeichnet von Arp, Doesburg, Chr. Spengemann, Schwitters, Tzara. s. Merz.

Der Marstall. («Antizwiebelfisch».) per. Hannover, Steegemann, 1920. Ind.

MASSOT, PIERRE DE. De Mallarmé à 391. Paris, Au Bel Exemplaire. 1922.

MASSOT, PIERRE DE. The wonderful Book. Reflections on Rrose Sélavy. Paris, Imprimerie Ravilly, S. A. (1924?). 24 p.

MATARASSO, H. Surréalisme; poésie et l'art contemporain. Cat. de la Librairie H. Matarasso, Paris, 1949. 108 p. illus. Documents et livres importants sur dadaïsme.

Mécano. per. ed. I. K. Bonset (= Theo van Doesburg). Leiden, 1922 bis 1923. 4 no. (blau, gelb, rot, weiss). contr.: Arp, I. K. Bonset, Hausmann, Picabia, Ribemont-Dessaignes, Tzara etc. Ind.

MEHRING, WALTER. The lost library: the autobiography of a culture. New York, Bobbs-Merril, 1951. Contains chapter on dadaism. Deutsche Ausgabe: Die verlorene Bibliothek. Hamburg, Rowohlt, 1952. 243 p. Enthält Kapitel über Dadaismus.

Merz. per. ed. Kurt Schwitters. Steegemann, Hannover 1923—1932. no. 1: Holland-dada. no. 2: «i» contr.: Arp, van Doesburg & Manifest Proletkunst. no. 3: Merz-Mappe. 6 Lith. von Schwitters. no. 4: Banalitäten. contr.: Arp, Th. Fraenkel, Raoul Hausmann, O. Nebel, Rietveldt, Man Ray, Tzara et no. 5: 7 Arpaden (Arp-Mappe). no. 6: Imitatoren. contr.: Arp, Lissitzky, Mondrian, Schwitters, Tzara (über Arp). no. 7: Tapsheft. contr.: Arp, Gropius, Lissitzky und Vortrag Tzaras am Konstruktivisten-Kongress, Weimar, 1922. no. 8—9: Nasci. no. 10: Bauhaus-Buch. no. 11: Ty-re. (Typo-Reklame.) no. 12: Der Hahnpeter. Ein Märchen von Kurt Schwitters, illus. v. Käte Steinitz. no. 13: Die Lautsonate (sonate phonétique). no. 14—15: Die Scheuche. Von Theo van Doesburg, Schwitters & K. Steinitz. no. 16—17: Die Märchen vom Paradies von Schwitters & Steinitz. no. 20: Katalog der Werke Kurt Schwitters. Autobiographischer Text und Werkverzeichnis. no. 21: Erstes Veilchen-Heft. no. 22: Entwicklung. no. 24: Ursonate. no. 24: Ursonate.

Der Mistral. per. Zürich, 1915. contr.: Marinetti, Antoine Huré, Apollinaire, Ludwig Kassàk, Hugo Kersten etc.

MOHOLY-NAGY, SIBYL. Moholy-Nagy. A Biography. New York, Harper, 1950, 253 p. illus. On Dadaism. p. 22—27.

MOPP (Max Oppenheimer). Berlin, Werkkunst-Verlag. contr.: Max Osborn, Thomas Mann, Alfred Stix etc. Kleines Werkverzeichnis. illus.

MOTHERWELL, ROBERT. (ed.) The Dada Painters and Poets: An Anthology. New York, Wittenborn, Schultz, incl. 1951. (The Documents of Modern Art no. 8) 388 p. illus. Texts by: Arp, Ball, Breton, Buffet-Picabia, Cravan, Eluard, Huelsenbeck, Hugnet, Ribemont-Dessaignes, Richter, Satie, Schwitters, Tzara, Vaché etc. Bibliography by Bernard Karpel.

MYERS, BERNARD S. Modern Art in the making. New York, Toronto, London, Mc Graw Hill, 1950. illus.

N NADEAU, MAURICE. Histoire du surréalisme. Paris, Editions du Seuil, 1946. 2 vol. vol. 1: Histoire. vol. 2: Documents.

NEITZEL, L.-H. Neue Französische Malerei. s. Arp.

Neue Jugend. per. Berlin, Malik-Verlag, 1916—17. illus. contr.: Grosz, Herzfelde, Huelsenbeck etc. Wurde dann von der Zensur verboten. Ind.

NEWHALL, BEAUMONT. Bibliography of Abstract Art. in.: Cubism and Abstract Art. New York, Museum of Modern Art, 1936. p. 234 to 249.

Newhaven, Conn., Yale University Art Gallery, New Haven. Collection of the Société Anonyme. New Haven, Conn., Museum of Modern Art, 1950. 223 p. illus. Collection donated by Katharina Dreier and Marcel Duchamp includes bibliographical and biographical notes on: Arp, Sophie Taeuber, Jean Crotti, Marcel Duchamp, Suzanne Duchamp, Max Ernst, Angelika Hoerle, El Lissitzky, Man Ray, Picabia, Ribemont-Dessaignes, Hans Richter, Kurt Schwitters, Franz Wilhelm Seiwert, Käte Steinitz, Joseph Stella, van Doesburg.

New York Dada. per. ed. Marcel Duchamp & Man Ray. New York, 1921. One issue only. Ind.

New York. Brooklyn Museum. International exhibition of modern art, arranged by the Société Anonyme. New York, Société Anonyme-

Museum of Modern Art, 1926. 117 p. illus. s. Newhaven.

New York. Museum of Modern Art, New York. Checklist of Eluard and Dausse surrealist collection, 1935. Typescript list of dada and surrealist books, periodicals and ephemera donated to the Library of the Museum of Modern Art, New York, by Walter P. Chrysler, Jr. in 1935. (According to Bernard Karpel, Librarian, Museum of Modern Art, New York.)

New York. Museum of Modern Art, New York. Ex. Fantastic Art, dada, surrealism. D. 1936—Ja. 1937. s. Barr.

New York. Pierre Bères, incl., New York. Cubism, Futurism, Dadaism, Expressionism and the Surrealist Movement in Literature and Art. New York, Pierre Bères, 1948. Cat. issued for a special exhibition, with annotations by Dr. Lucien Goldschmidt.

New York. Feigl Gallery, New York. Marcel Janco. Exhibition O.-N. 1950. Cat. 8 p. illus. Biographical and bibliographical notes.

New York. Sidney Janis Gallery, New York. Kurt Schwitters: Merz-Bild, Merz-Relief, Merz-Konstruktionen. Exhibition. Cat. 1952. 8 p. illus. Preface «Kurt Schwitters 1887—1948» by Tristan Tzara.

New York. Sidney Janis Gallery, New York. Dada-International Exhibition. 15 Ap.—9 My. 1953. Cat. contr.: Jean (Hans) Arp, Richard Huelsenbeck (Charles W. Hulbeck), Tristan Tzara, Jacques-Henry Levesque. 212 exhibition-items.

Nord-Sud. Revue littéraire. per. ed. Pierre Reverdy, Paris, 1917. contr.: Apollinaire, Aragon, Breton, Max Jacob, Philippe Soupault etc.
Orbes. per. ed. Jacques-Henry Levesque. Paris, 1928. contr.: Arp, Duchamp, Ribemont-Dessaignes, Erik Satie, Soupault, Tzara etc. post-dada per.

O OZENFANT, AMEDEE & JEANNERET. La Peinture moderne. Paris. Crès, 1925.

OZENFANT, AMEDEE. Art. Paris, Boudry, 1928. Deutsche Ausgabe: Leben und Gestaltung. Potsdam, 1930. English Edition: Foundations of Modern Art. New York, 1931 (Paperbound ed.: New York, Dover Publications, 1952).

Le Pagine. Rivista Mensile. per. Napoli, 1917—18. contr.: Maria d'Arezzo, Nicola Moscardelli, Marcel Janco etc. Ind.

P PANSAERS, CLEMENT. Le Pan Pan au cul du nu nègre. Avec une gravure par l'auteur. Bruxelles, Ed. Alde. 1920.

PANSAERS, CLEMENT. L'Apologie de la Paresse. Anvers, 1921.

Paris. Galerie Au Sans Pareil, Paris, 1920. Max Ernst Exposition Dada. Cat. Préface André Breton. Ind.

Paris. Galerie Au Sans Pareil. Paris, 1920. Francis Picabia Exposition Dada. Cat. Préface Tristan Tzara. Ind.

Paris. Galerie Au Sans Pareil, 1920. Georges Ribemont-Dessaignes Exposition Dada. Cat. Préface par Tristan Tzara.

Paris. Librairie Six. Paris, 1921. Man Ray Exposition Dada. Cat. contr.: Aragon, Arp, Eluard, Ernst, Ribemont-Dessaignes, Soupault, Tzara. Ind.

Paris. Galerie Montaigne. Salon dada, exposition internationale, Cat. 1921. Cat. 16 p. illus. Arp, Aragon, Baargeld, Cantarelli, Charchoune, Eluard, Ernst, Evola, Fiozzi, Fraenkel, Mehring, Péret, Ray, Ribemont-Dessaignes, Rigaut, Soupault, Tzara, Joseph Stella, Vaché etc.

Paris. Galerie Goemans, 1930. La Peinture au defi. Ex. Arp, Ernst, Picabia, Man Ray. s. Aragon.

Paris. Galerie René Drouin, 1949. Ex. Francis Picabia. 1897—1949. Cat. «491» avec contr.: Breton, Buffet-Picabia etc.

Paris. Galerie Deux Iles, 1950. Ex. Hans Richter. Cat. 8 p.

Paris. Galerie des Deux Iles, 1950. Ex. Charles-Richard, Beate et Tom Hulbeck (Huelsenbeck). Peintures-Collages-Dessins. Cat. 16 p. illus. contr.: Jean Arp, Michel Seuphor.

Paris. Galerie de l'Institut. 1957. Ex. Retrospective Dada 1916—1922. Peintures, aquarelles, dessins, objets, collages de Hans Arp, Johannes Baader, J. T. Baargeld, Serge Charchoune, Jean Crotti, Suzanne Duchamp, Marcel Duchamp, Viking Eggeling, Max Ernst, Raoul Hausmann, Hannah Höch, Marcel Janco, Francis Picabia, Man Ray, Otto van Rees, G. Ribemont-Dessaignes, Hans Richter, Christian Schad, Kurt Schwitters, Sophie Taeuber.

PARTENS, ALEXANDER. Dada-Kunst. in.: Dada-Almanach. p. 84—90. s. B.

Pasadena, Cal., Pasadena Art Institute, 1944. Man Ray. Retrospective exhibition 1913—1944: paintings, drawings, watercolours, photographs. Cat. 8 p.

Pásmo. per. ed. Cartian Cernic, K. Teige. Brno (CSR) ca. 1922—25. contr.: Man Ray, Ribemont-Dessaignes, Kurt Schwitters etc.

PERET, BENJAMIN. Le Passager du transatlantique. Paris, Au Sans Pareil, 1921 (Collection Dada). Avec 4 dessins par Arp.

PERET, BENJAMIN. Au 125 du boulevard Saint-Germain. Paris, Edition Littérature, 1923. illus par Max Ernst.

PERET, BENJAMIN. Immortelle Maladie. Paris, Littérature, 1924.

PICABIA, FRANCIS. Poèmes et dessins de la fille née sans mère. Lausanne, Imprimeries Réunis, 1918. 18 dessins au trait. 78 p. Ind.
PICABIA, FRANCIS. L'Athlète des Pompes funèbres. Lausanne, 1918.
PICABIA, FRANCIS. Râteliers Platoniques. Lausanne, 1918.
PICABIA, FRANCIS. Pensées sans langage. Paris, Eugène Figuière, 1919. 119 p.
PICABIA, FRANCIS. Poésie Ron-Ron. 1919.
PICABIA, FRANCIS. Jésus Christ rastoquouère. Paris, Collection Dada, 1920. 66 p. Dessins par Ribemont-Dessaignes. Introduction par Gabrielle Buffet.
PICABIA, FRANCIS. Unique eunuque. Paris, Au Sans Pareil, 1920 (Collection Dada). Avec un portrait de l'auteur par lui-même et une préface par Tristan Tzara. 38 p.

La Pomme de Pins. per. ed. Francis Picabia. St. Raphael, 1922. Seulement un no. Ind.

391. per. ed. Francis Picabia. s. Trois-cent-quatre-vingt-onze.

Paris. Galerie Au Sans Pareil. Francis Picabia. Exposition Dada. s. Paris. Ind.

Cannibale. per. ed. Francis Picabia. s. B.

Little Review. per. Picabia no., New York, Spring 1922.

Paris. Galerie René Drouin. Ex. Picabia 1897—1949, 136 items, 1949. Cat. «491». contr.: Breton, Buffet-Picabia, Roché, Tapié et par Picabia: «50 ans de plaisir».

■ La Hire, Marie de. Francis Picabia. Paris, Galerie La Cible, 1920.

Breton, André. Francis Picabia. Barcelona, 1922.

Isarlow, G. Picabia, peintre. in.: Orbes, Paris 1929, no. 2.

Mas V. du., L'occultisme dans l'art de Picabia. in.: Orbes, Paris 1932, no. 3.

Buffet-Picabia, Gabrielle. Some Memories of Pre-Dada: Picabia and Duchamp. s. Motherwell. p. 253—267.

Philhaou-Thibaou, le. Suppl. illustré de «391». Paris 10. Je. 1921. Gérant: Perre de Massot. contr.: Dermée, Picabia, Funny Guy-Picabia (?), Ezra Pound, Gabrièle Buffet, Cocteau, Edgar Varèse, Georges Auric, Céline Arnaud, Duchamp, Picabia, Serner, Satie. Constitue réellment le no. 15 de collection complète de la revue «391».

PIERZL, WILHELM. Kunsterziehung als wesentliches Mittel der Menschenbildung. Leoben, Fritz Loew, 1957. Dadaismus p. 54.

Philadelphia. Museum of Art, 1954. The Louise and Walter Arensberg Collection: 20th Century Section. Cat. illus.

PLATSCHEK, HANS Dichtung moderner Maler. Dichtung und Graphik von Arp, Ernst, Schwitters etc. Wiesbaden, Limes-Verlag, 1956. 104 p. 27 illus.

Die Pleite. per. s. Grosz.

PRIEBERG, FRED K. Musik unterm Strich. München. 1956.

La Pomme de Pins. per. s. Picabia.

Projecteur. per. ed. Céline Arnauld. Paris, 1920. Unique numéro (26. My. 1920).

Proverbe. per. ed. Paul Eluard, Paris, 1920—21. (no. 1—6). s. L'invention.

PUTNAM, SAMUEL. ed. The European caravan: an anthology of the new spirit in European literature. New York, Brewer, Warren & Putnam, 1931. Partial contents: The birth of Dada. — Dada and the revolt against «literature». — The influence of dada on early after — war poetry — The death of dada.

R RAY, MAN. Les Champs délicieux. Album de photographies, avec une préface de Tristan Tzara. Paris, 1922.
RAY, MAN. Revolving doors, 1916—1917. 10 colorpl., Paris, Editions Surréalistes, 1926.
RAY, MAN. Photographies 1920—1934. Paris, Cahiers d'Art, 1934. Texts par Breton, Eluard, Tzara etc.
RAY, MAN. Le Retour à la Raison. in.: Film, 1923.
RAY, MAN. Dadaism. in.: Schools of twentieth century art. Beverly Hills, Cal., Modern Institute of Art, 1948.

■ Ribemont-Dessaignes, Georges. Man Ray. Paris, Gallimard, 1924. (Peintres nouveaux. 37.) 63 p. illus.

Paris. Man Ray. Exposition Dada. s. Paris.

Pasadena, Cal., Man Ray. Ex. s. Pasadena.

RAYMOND, MARCEL. From Baudelaire to Surrealism. New York, Wittenborn, Schultz, 1950. 428 p.

RAYNAL, MAURICE. Anthologie de la peinture en France. Paris, Editions Montaigne, 1927. English ed.: Modern French painters. New York, Brentano's, 1928.

RAYNAL, MAURICE. Histoire de la Peinture moderne. (History of modern Painting.) Geneva, Albert Skira, 1950. Tome III. De Picasso au Surréalisme. Du Cubism à Paul Klee.

READ, HERBERT. The Philosophy of Modern Art. London, Faber & Faber, 1952. 278 p.

Revolution. per. München, Verlag Heinrich F. S. Bachmair, 1913. Contr.: Hugo Ball, Emmy Hennings etc.

La Révolution Surréaliste. per. ed. Pierre Naville, Benjamin Péret, Paris, 1924—1929. contr.: Aragon, Eluard, Soupault etc.

REVERDY, PIERRE. Les Ardoises du Toit. 1919. Avec dessins de Braque.

REVERDY, PIERRE. Les jockeys camouflés. 1919. Avec dessins de Braque.

REVERDY, PIERRE. ed. Nord-Sud. per. s. B.

RIBEMONT-DESSAIGNES, GEORGES. L'Empereur de Chine, suivi de Le Serin muet. Paris, Au Sans Pareil, 1921 (Collection Dada).

RIBEMONT-DESSAIGNES, GEORGES. Histoire de Dada. La Nouvelle Revue Française, Paris, Je.—Jl. 1931. no. 36 et no. 37. English translation: History of Dada in Motherwell, p. 99—122.

Paris. Galerie Sans Pareil. Ex. Ribemont-Dessaignes. s. Paris.

RICHTER, HANS. Filmgegner von Heute — Filmfreunde von Morgen. Berlin, 1929.

RICHTER, HANS. Origine de l'avant-garde allemand. in.: Cinémato-graphe, My. 1937.

RICHTER, HANS. A History of the avantgarde. in.: Art in cinéma; ed. by Frank Stauffacher, San Francisco, Museum of Art, 1947.

RICHTER, HANS. Dada XYZ. s. Motherwell, p. 283—289.

RICHTER, HANS. Easel-Scroll-Film. in.: Magazine of Art. New York. F. 1952. p. 78—86. illus.

RICHTER, HANS. Vita private del movimento «dada». in.: La biennale di venezia. Numero sette, Ja. 1952. p. 16—21, illus.

RIESS, CURT. Die Dadaisten treten auf. In der Artikelserie: Café Odeon. Zürichs Treffpunkt mit der Welt. in.: Die Weltwoche. Zürich. vol. 24. no. 1191 p. 19. no. 1192. p. 19. 7. und 14. Sept. 1956.

RIGAUT, JAQUES. Papiers posthumes. Paris, Au Sans Pareil, 1934.

RIVIERE, JAQUES. Reconnaissance à Dada. in.: Nouvelle Revue Fran-çaise. Ag. 1920.

ROH, FRANZ & TSCHICHOLD, JAN. Foto-Auge. Stuttgart, Akademi-scher Verlag, 1929. 18 p. 76 pl.

Rongwrong. per. ed. Marcel Duchamp. New York, 1917.

ROTHSCHILD, EWALD F., The meaning of unintelligibility in modern art. Chicago, University of Chicago Press, 1934.

S SADOUL, G., Avantgarde in der Welt. in.: Filmforum, 1952. vol. no. 5.

SALMON, ANDRE. L'Art vivant. Paris, G. Crès, 1920.

SATIE, ERIK. Le Piège de Méduse. Comédie lyrique. Paris, Galerie Simon, 1921. Ornée de gravures sur bois de George Braque.

SATIE, ERIK. Mémories d'un amnésique. In: Journal de la Société Musicale indépendante, Paris, 15. Ap. 1912, 15. F. 1913.

SATIE, ERIK. Notes sur la musique moderne. in.: L'Humanité, 11. O. 1919.

SATIE, ERIK, Memories of an Amnesic (Fragments) s. Motherwell, p. 17—19.

SATIE, ERIK. Fetzen meines Lebens. in.: Europa-Almanach. s. B. p. 161—163.

■ Chennevière, Rdhyar D. Erik Satie and the Music of Irony. in.: Musi-cal Quarterly. O. 1919.

Pierre = Daniel Templier: Erik Satie. Paris. 1932.

SCHAD, CHRISTIAN. Zehn Holzschnitte. Mappe. Zürich, Sirius-Ver-lag, 1916.

SCHAD, CHRISTIAN. Vier Holzschnitte. in.: «Die weissen Blätter», Leipzig, N. 1915. vol. 2. no. 11.

■ Hermann-Neisse, Max. Christian Schad. in.: Die weissen Blätter. Zürich, Ja. 1917. vol. 4. no. 1. p. 76—77.

Die Schammade. per. ed. Max Ernst, Johannes Baargeld. Köln, 1920. Nur eine Nummer erschienen. Auf Umschlag: «Dadameter — Dillet-tanten erhebt euch». contr.: Aragon, Arp, Baargeld, Breton, Eluard, Hoerle, Huelsenbeck, Picabia, Ribemont-Dessaignes, Serner, Sou-pault, Tzara. Text en allemand et en français. Ind.

SCHIEBELHUTH, HANS. Der Hakenkreuzzug. Neodadaistische Unge-dichte. Darmstadt, 1920 (Die kleine Republik). 20 p. illus.

SCHIEBELHUTH, HANS. Wegstern. Weimar, Erich Lichtenstein, 1921. 48 p.

SCHINZ, ALBERT. Dadaism. in.: The Bookman, 1922. no. 55 p. 63—65.

SCHINZ, ALBERT. Dadaisme: poignée de documents sur un mouve-ment d'égarement de l'esprit humain après la Grande Guerre. North-ampton, Mass. in.: Smith College Studies in Modern Languages, 1923. vol. 5, no. 1, p. 51—79.

SCHMELLER, ALFRED. Surrealismus. Wien, Rosenbaum, 1955. (Zeit und Farbe. ed. Heinrich Neumayer.) illus. Ueber Dadaismus p. 6—8.

SCHMIDT, GEORG. (ed.). Sophie Taeuber-Arp. Basel, Holbein, 1948. 152 p. illus. con.: Erika Schlegel-Taeuber, Emmy Ball-Hennings, Hugo Ball, Hans Arp, Gabrielle Buffet-Picabia, Camille Bryen, Was-sily Kandinsky, Hugo Debrunner, Hugo Weber. Catalogue de l'œuvre de Sophie Taeuber-Arp. B.

SCHMIDT, PAUL FERDINAND. Geschichte der modernen Malerei. Stuttgart, Kohlhammer, 1952. Ueber Dadaismus. p. 226, 227, 231, 339.

SCHWITTERS, KURT. Anna Blume. Dichtungen. Hannover, Paul Stee-gemann, 1919. (Die Silbergäule, vol. 39—40.) 37 p.

SCHWITTERS, KURT. Die Kathedrale. 8 Lithographien. Hannover, Paul Steegemann, 1920. (Silbergäule, vol. 41—42.) Ind.

SCHWITTERS, KURT. Die Blume Anna. Berlin, Verlag Der Sturm, 1923. p. 32. Titel: «elementar. Die Blume Anna. Die neue Anna Blume, eine Gedichtsammlung aus den Jahren 1918—1922. Einbecker Poli-turausgabe von Kurt Merz Schwitters.»

SCHWITTERS, KURT. August Bolte. Berlin, Verlag Der Sturm, 1923. 46 p. Titelblatt: Tran. no. 30, August Bolte (ein Lebertran).

SCHWITTERS, KURT. Merz-Mappe. s. Merz.

SCHWITTERS, KURT. Der Hahnpeter. s. Merz.

SCHWITTERS, KURT. Die Lautsonate. s. Merz.

SCHWITTERS, KURT. Die Scheuche. s. Merz.

SCHWITTERS, KURT. Die Märchen vom Paradies. s. Merz.

SCHWITTERS, KURT. Katalog. s. Merz.

SCHWITTERS, KURT. Erstes Veilchen-Heft. Eine kleine Sammlung von Merz-Dichtungen. s. Merz.

SCHWITTERS, KURT. Ursonate. s. Merz.

SCHWITTERS, KURT. Die scheuche Märchen. Hannover, Apossverlag, 1925. (Zusammen mit K. Steinitz & van Doesburg.)

SCHWITTERS, KURT. Memoiren Anna. Blumes in Bleie. Freiburg, Schnitter, 1922.

SCHWITTERS, KURT. ed. Merz — per. s. B.

SCHWITTERS, KURT. Konsequente Dichtung. in.: G, Ja. 1924, no. 3.

SCHWITTERS, KURT. Merz. in.: Der Ararat. 1921. no. 2—3. English Translation in Motherwell, p. 55—65.

SCHWITTERS, KURT. Theo van Doesburg und Dada. in.: De Stijl, Ja. 1932. English Translation in Motherwell, p. 273—276.

■ Nebel, Otto. Kurt Schwitters. Berlin, Verlag Der Sturm. (Sturmbilder-buch IV.) Einleitung von O. Nebel. Autobiographischer Text von Kurt Schwitters. 32 p. illus.

Spengemann, Christoph. Die Wahrheit über Anna Blume. Hannover, Der Zweemann Verlag, 1920. Mit dem Bildnis Kurt Schwitters.

Vordemberge-Gildewart, F., Kurt Schwitters (1887—1948). illus. in.: Forum, Amsterdam, 1948. no. 12. p. 356—62.

Giedion-Welcker, Carola. Kurt Schwitters. in.: Die Weltwoche, Zürich, 15. Ag. 1947. En Français aussi: «Hommage à Kurt Schwitters». in.: K (Revue de la Poésie) 1949, no. 3 (Numéro spéciale avec. contr. par Arp.).

Arp, Hans. Kurt Schwitters in.: «Onze peintres, vue par Arp.» Zürich, Girsberger, 1949. illus.

Thomas, Edith. Kurt Schwitters. in.: L'Art abstrait. Paris, Maeght, 1949.

Moholy-Nagy, Sibyl. Moholy-Nagy. s. B. p. 22—25, 99—103. On Schwitters.

New York. Sidney Janis Gallery. Ex. Schwitters. s. New York.

Bolliger, Hans. Résumé chronologique de la vie et de l'œuvre de Kurt Schwitters. in.: Kurt Schwitters-collages. Paris, Berggruen, 1955.

SEDLMAYR, HANS. Die Revolution der modernen Kunst. Hamburg, Rowohlt, 1955. (Rowohlts Deutsche Enzyklopädie. vol. 1.) Ueber Dadaismus s. p. 47, 54, 56, 76, 112, 118, 129.

SENECHAL, CHRISTIAN. La Révolte: de dada au surréalisme. in.: «Les Grands courants de la littérature française contemporaine.» Paris, E. Malfère, 1933. p. 379—86.

SERNER, WALTER. Letzte Lockerung. Manifest Dada. Hannover, Paul Steegemann, 1920. (Silbergäule vol. 62—64.) 45 p. Ind.

Sirius. per. ed. Walter Serner. s. B.

Das Hirngeschwür. per. ed. Walter Serner. (Nicht erschienen.) s. B.

Der Zeltweg. per. ed. Walter Serner. s. B.

SEUPHOR, MICHEL. L'art abstrait, ses origines, ses premiers maî-tres. Paris, Maeght, 1949. illus.

SEUPHOR, MICHEL. Dictionnaire de la Peinture Abstraite. Paris, Hazan, 1956.

SEUPHOR, MICHEL. L'internationale Dada. in.: L'Oeil. Lausanne, Noël 1956. no. 24. p. 64—75. illus.

Sic. Sons, idées, coleurs, formes. Revue mensuelle puis bi-men-suelle. per. ed. Pierre Albert-Birot. Paris, 1916—1919. no. 1—54. contr.: A. Breton, L. Aragon, Ph. Soupault, G. Gabory, Apollinaire, Reverdy, Tzara etc.

Die Silbergäule. «Eine radikale Buchreihe.» Hannover, Verlag Paul Steegemann, ab 1922. s. Arp, Huelsenbeck, Schwitters, Serner, Vischer. Ind.

Sirius. Monatsschrift für Literatur und Kunst. per. ed. Walter Ser-ner, Zürich, 1915—16. contr.: Serner, P. Altenberg, Th. Däubler

etc. illus.: Arp, Kubin, Picasso, Schad etc.

SMITH, HORATIO. ed. Columbia dictionary of modern European literature. New York, Columbia University Press, 1947. 899 p. With sections ref. to some poets of the dada era.

SOERGEL, ALBERT. Satyrspiel nach der Tragödie-Dada! in.: Dichtung und Dichter der Zeit. Neue Folge: Im Banne des Expressionismus. p. 623—634. illus. Ueber Schwitters p. 620—623. Leipzig, R. Voigtländer, 1925.

SOUPAULT, PHILIPPE. Aquarium. Poèmes. 1917.

SOUPAULT, PHILIPPE. Rose des Vents. Paris, Au Sans Pareil, 1920 Avec 4 dessins par Marc Chagall.

SOUPAULT, PHILIPPE. Westwego. Poèmes. 1922.

SOUPAULT, PHILIPPE. Le Profil de dada. in.: Labyrinthe, Paris, 15 F. 1946. no. 17.

De Stijl. per. ed. Theo van Doesburg: Leiden, Clamart, Meudon, 1917—1932. contr.: Arp, Hugo Ball, Ribemont-Dessaignes, Man Ray, Hans Richter, Schwitters etc.

■ Scuphor, Michel. De Stijl. in.: L'Oeil. Lausanne, O. 1956. p. 32—39. illus.

Jaffè. De Stijl. Amsterdam, Meulenhoff, 1956.

Der Sturm. per. ed. Herwarth Walden. Berlin 1910—1932. contr.: Arp, Breton, Eluard, Hardekopf, Hausmann, Franz Jung, Walter Mehring, A. R. Meyer, L. H. Neitzel, G. Ribemont-Dessaignes, Schwitters, T. Tzara etc. Spezial no.: La vraie jeune France. Avec contr. et illus.: Tzara, Philippe Soupault, Louis Aragon, G. Ribemont-Dessaignes, André Breton, Paul Eluard, Man Ray. vol. 13, no. 3. Mr. 1922. Ind.

T TEIGE, KARL. Svét, ktery voni. Praha, Odeon, 1930. 239 p. Beinhaltet verschiedene Kapitel über Dadaismus. Contains different chapters on dadaism. Od romantismu k dadaismu — Dada — O dadaistech — O humoru, clownech a dadaistech.

The Times Literary Supplement. «The Dada Movement.» London, 23 O. 1953. p. 669, 670, 671.

TOPASS, JAN. Essai sur le nouveau modes de l'expression plastique et littéraire: cubisme, futurisme, dadaïsme. in.: La Grande Revue, 1920. no. 103, p. 579—97.

391. per. ed. Francis Picabia. Barcelona, New York, Zürich, Paris. 1917—1924. no. 1—19. Ind.

291. per. ed. Alfred Stieglitz. New York, 1915—16. no. 1—12. contr.: Marcel Duchamp, Picabia, Man Ray, Marius de Zayas etc. Ind.

TZARA, TRISTAN. Vingt-cinq poèmes. Zürich, Collection Dada, 1916. (Imprimé par J. Heuberger.) 50 p. illus. Avec dix gravures sur bois par H. Arp.

TZARA, TRISTAN. La Première aventure céleste de Monsieur Antipyrine. Zürich, Collection Dada. Jl. 1916. Avec des bois gravés et coloriés par Marcel Janco.

TZARA, TRISTAN. Cinéma calendrier du cœur abstrait. Paris, Au Sans Pareil, 1920. (Collection Dada.) 19 bois par Arp. 150 ex. «achevé d'imprimer en juin 1920 par v. Holten, Berlin». Ind.

TZARA, TRISTAN. De nos oiseaux. Poèmes. Paris, Editions kra, 1923. Dessins par Arp. Ind.

TZARA, TRISTAN. Sept manifestes dada. Paris, Jean Budry, ed. du Diorama, 1924. 97 p. English translation, s. Motherwell. p. 73—98.

TZARA, TRISTAN. Mouchoir de nuages. Paris, Galerie Simon, 1925. illus. de Juan Gris.

TZARA, TRISTAN. Vingt-cinq-et un poèmes. Paris, ed. de la revue Fontaine, 1946. 63 p. illus. Dessins de Hans Arp.

TZARA, TRISTAN. Morceaux choisis. Paris, Bordas, 1947. 310 p.

TZARA, TRISTAN. An introduction to Dada. New York, Wittenborn, Schultz, 1951. 4 p.

TZARA, TRISTAN. Inzwischen-Malerei. (On s'approche du point de tangence.) Vorwort im Katalog der 1. Dada-Ausstellung, Zürich, Galerie Coray, D. 1916—Ja. 1917. Uebersetzt aus dem Französischen von Hugo Ball. Gekürzt erschienen auch in «Der Zeltweg», s. B. (Uebersetzt von Walter Serner.)

TZARA, TRISTAN. Chronique Zurichoise, 1915—1919. s. Dada-Almanach p. 10—29. English translation in Motherwell, p. 235—241.

TZARA, TRISTAN. Le Cœur à Gaz. Pièce de théâtre en 3 actes. s. Der Sturm.

1. Performance: 1. Aufführung: Galerie Montaigne (Théâtre des Champs Elysées) Paris, 10. Je. 1921, avec Philippe Soupault (Oreille), G. Ribemont-Dessaignes (Bouche), Théodore Fraenkel (Nez), Louis Aragon (Oeil), Benjamin Péret (Lou), Tristan Tzara (Sourcil).

TZARA, TRISTAN. Conference sur dada. s. Merz.

TZARA, TRISTAN. Memoirs of dadaism. in.: Edmund Wilson, Axel's castle, a study in the imaginative literature of 1870—1930. New York, Scribner, 1931. s. B.

TZARA, TRISTAN. L'Esprit dada dans la peinture. in.: Cahiers d'Art, Paris, 1937. no. 1—3.

TZARA, TRISTAN. Lecture on Dada. s. Motherwell, p. 246—251. Deutsch: Merz. no. 7. s. B.

Dada — per. ed. Tristan Tzara. s. B.

Le Cœur à Barbe. per. ed. Tristan Tzara. s. B.

Der Zeltweg. per. ed. Tristan Tzara. s. B.

U URBANITZKY, GRETE VON. Eine Frau erlebt die Welt. Roman. Wien, Zsolnay, 1931. p. 242—245. Milieuschilderung Dada Zürich.

V VACHE, JACQUES. Lettres de guerre. Préface d'André Breton. Paris, 1919. Nouv. ed. Paris, 1949. Ind.

Der Ventilator. per. ed. J. T. Baargeld. Köln, 1919.

Vertical. per. ed. Guillermo de Torre, Jacques Edward. Madrid, 1920.

VIAZZI, GLANCO. Dadaismo e surrealismo. in.: Domus, O. 1944. no. 202, p. 378—82, illus.

VISCHER, MELCHIOR. Sekunde durch Hirn, ein dada-Roman. Hannover, Paul Steegemann, 1920. (Die Silbergäule vol. 59—61.) Umschlagzeichnung von Kurt Schwitters.

W WEDDERKOP, H. VON. Dadaismus. in.: Jahrbuch der Jungen Kunst, Leipzig, Klinkhardt & Biermann, 1921. p. 216—224. Auch in «Cicerone», 1921, vol. 13, p. 422—430.

WILSON, EDMUND. Music ho! New York, 1934.

WILSON, EDMUND. Axel's Castle. A Study in the Imaginative Literature of 1870 to 1930. New York—London, Charles Scribner, 1954 (1931). 319 p. con.: Tristan Tzara: Memoirs of Dadaism. (1922). p. 304—312.

WINKLER, W., Psychologie der modernen Kunst. Tübingen, Alma Mater Verlag, 1951. 303 p. illus. Ueber Dadaismus, p. 29, 40, 63, 71, 164, 168, 275.

Wrong-Wrong. per. ed. Marcel Duchamp, New York, 1917. Only one number.

WYSS, DIETER. Der Surrealismus: eine Einführung und Deutung surrealistischer Literatur und Malerei. Heidelberg, Schneider, 1950.

Z Z 1. per. ed. Paul Dermée. Paris, Mr. 1920. Numéro unique. con.: Arnauld, Aragon, Dermée, Eluard, Breton, Picabia, Ribemont-Dessaignes, Soupault, Tzara.

ZAHN, LEOPOLD. Dadaismus oder Klassizismus? in.: Der Ararat, 1920, p. 50—52.

Der Zeltweg. per. ed. Otto Flake, Walter Serner, Tristan Tzara. Zürich, Verlag Mouvement Dada, N. 1919. 32 p. Nur eine no. erschienen. contr.: Hans Arp, Fritz Baumann, Viking Eggeling, Otto Flake, Augusto Giacometti, W. Helbig, Richard Huelsenbeck, Marcel Janco, Hans Richter, Christian Schad, Kurt Schwitters, Walter Serner, Sophie Taeuber, Tristan Tzara, Alfred Vagts, Umschlag: Holzschnitt von Hans Arp. (Letzte Dada-Publikation in Zürich.) Ind.

ZERVOS, CHRISTIAN. Histoire de l'Art contemporain. in.: Cahiers d'Art, Paris, 1938. 447 p. illus.

Zürich. Kunsthaus Zürich, 1912. Moderner Bund. Zweite Ausstellung. Cat. Holzschnitt, 6 Initialen und Vignetten von Hans Arp. Ind.

Zürich. Galerie Tanner. 14.—30. N. 1915. Ex. Otto van Rees, Hans Arp, A. C. van Rees-Dutilh: Moderne Wandteppiche, Stickereien, Malereien, Zeichnungen. Cat. Vorwort von Hans Arp. illus. Ind.

Zürich. Galerie Coray, Zürich. Ja. Fe. 1917. 1. Dada-Ausstellung.

Zürich. Galerie Wolfsberg. Sept. 1918. Ex. Arp, Richter, Janco etc. Ind.

Zürich. Kunsthaus Zürich. 1929. Ex. Peinture et sculpture abstraite et surréaliste.

Zürich. Galerie Wolfsberg. 1929. Ex. Peinture et sculpture abstraite. Cat. Einleitung von Tristan Tzara. illus. Ind.

Der Zweemann. per. ed. Christof Spengemann, Hans Schiebelhuth. Hannover, 1919—20.

291. per. s. Twohundred nintyone

GENERAL INDEX